The Philosopher,
the Priest,
and the Painter

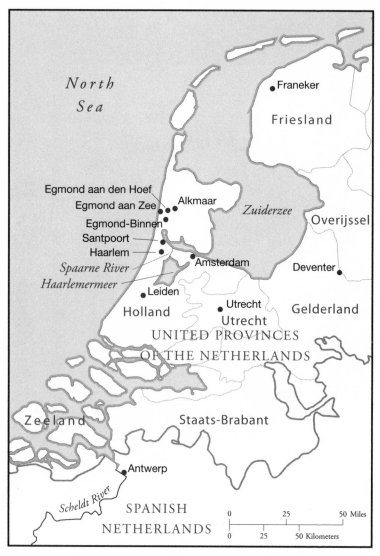

North
Sea

Franeker

Friesland

Egmond aan den Hoef
Egmond aan Zee
Egmond-Binnen
Santpoort
Haarlem
Spaarne River
Haarlemmermeer

Alkmaar

Zuiderzee

Overijssel

Amsterdam

Deventer

Leiden

Utrecht

Gelderland

Holland

Utrecht

UNITED PROVINCES
OF THE NETHERLANDS

Zeeland

Staats-Brabant

Antwerp

Scheldt River

SPANISH
NETHERLANDS

| 0 | 25 | 50 Miles |
| 0 | 25 | 50 Kilometers |

FRONTISPIECE. The Netherlands in the seventeenth century

The Philosopher, the Priest, and the Painter

A PORTRAIT OF DESCARTES

Steven Nadler

PRINCETON UNIVERSITY PRESS
Princeton and Oxford

Jacket art: Frans Hals. *René Descartes* (1596–1650), 1649. © SMK Photo. Courtesy of the
National Gallery of Denmark, Copenhagen.

All Rights Reserved

Library of Congress Cataloging-in-Publication Data

Nadler, Steven M., 1958–
The philosopher, the priest, and the painter : a portrait of Descartes / Steven Nadler.
p. cm.
Includes bibliographical references and index.
ISBN 978-0-691-15730-6 (hardcover : alk. paper)
1. Descartes, René, 1596–1650. 2. Philosophers—France—Biography. 3. Philosophy,
Modern. 4. Europe—Intellectual life—17th century. I. Title.
B1873.N34 2013
194—dc23 [B]
 2012038718

British Library Cataloging-in-Publication Data is available

This book has been composed in Sabon LT Std

Printed on acid-free paper. ∞

Printed in the United States of America

10 9 8 7 6 5 4 3 2 1

For Jane, Rose, and Ben

Contents

Illustrations

HALFTONES

Acknowledgments

This book benefited enormously from the kindness and generosity of many friends, colleagues, and total strangers, all of whom took time away from their own projects to read the entire manuscript or individual chapters, or to respond to my inquiries (which often came via an email out of the blue). I am, first of all, indebted to several fellow scholars of early modern philosophy (and longtime friends) for their comments, corrections, and suggestions: Jean-Robert Armogathe, Desmond Clarke, Tom Lennon, Han van Ruler, Alison Simmons, Red Watson, and especially Theo Verbeek, who provided copious remarks on earlier drafts and seems to have found every careless error I made (or so I hope).

I also consulted with a number of art historians whose knowledge of seventeenth-century Dutch art and culture was an invaluable resource to this rank amateur: Arthur Wheelock and Henriette de Bruyn Kops (both of the National Gallery, Washington, DC) gave of their time to meet with me and answer some questions, while Seymour Slive helped point me in the right direction on certain matters. Above all, my thanks to Pieter Biesboer (former director of the Frans Hals Museum, Haarlem), who read through the whole manuscript and provided some essential help and necessary emendations. My thanks, as well, to the curators Dominique Thiébaut and Jacques Foucart (both of the Louvre) and Eva de la Fuente Pedersen (Statens Museum for Kunst, Copenhagen), who responded to my inquiries about their collections. I also want to thank my friends and colleagues in the

Department of Art History here at the University of Wisconsin–
Madison, who invited me to present some of this material at a
departmental colloquium and who sat patiently while an inter-
loper struggled to act and sound like an art historian. I espe-
cially appreciate the useful advice on the book (and lessons on
how to look at paintings) that I received from Suzy Buenger and
Gene Philips.

In addition, I am very grateful to a number of other col-
leagues (at Wisconsin and elsewhere), scholars, and friends
for their help: Susan Bielstein, Wim Cerutti, Rob Howell, Ben
Kleiber, Shannon Kleiber, Henriette Reerink, Russ Shafer-Landau,
Larry Shapiro, and Henk van Nierop.

Tanya Buckingham and her colleagues in the Cartography
Lab at the University of Wisconsin did a terrific job (and showed
great patience with me) on the map that they prepared of the
United Provinces in the seventeenth century.

Finally, my thanks to Rob Tempio, my editor at Princeton
University Press, for having faith in what is, admittedly, a rather
eccentric project (and who now owes me lunch at Katz's); to
Debbie Tegarden, also at the press, for all her help along the
way; and to Jodi Beder for outstanding copyediting that re-
sulted in a greatly improved manuscript.

Research on this project benefited from funds provided by
the Wisconsin Alumni Research Foundation (WARF) Professor-
ship, which I was fortunate to have been awarded; and from a
semester's leave at the Institute for Research in the Humanities
supported by the College of Letters and Science, University of
Wisconsin–Madison.

This book is dedicated, with great love, to my wife Jane, and
our children Rose and Ben.

The Philosopher,
the Priest,
and the Painter

CHAPTER I

Prologue: A Tale of Two Paintings

On the third floor of the Richelieu Wing of the Louvre in Paris is a gallery devoted to "Holland, First Half of the 17th Century." "Room 27" is not one of the museum's more traveled venues. Visitors, if they stop to see the artworks in the room, do not stay long. There are none of the Louvre's world-famous masterpieces here: no *Mona Lisa*, Winged Victory, or Venus de Milo. There are not even any of its better known and often reproduced paintings; Gericault's *The Raft of the Medusa* and Delacroix's *Liberty Leading the People* are in the Sully Wing, while Caravaggio's *Fortune Teller* is in the Denon Wing. Although Richelieu Salle 27 is devoted to seventeenth-century Dutch art, there are no Rembrandts or Vermeers or Ruisdael landscapes on its walls. Not even the most ardent fan of Dutch Golden Age art will find much here that is exciting.

Most of the artists represented in this room are second tier at best. While some of the works are finely executed and charming in subject matter, many of the painters' names will probably be familiar only to specialists. There is a *Landscape with St. John Preaching* by Claes Dirckszoon van der Heck, *Jesus with Mary and Martha* by Hendrik van Steenwyck, a *Basket of Flowers* by Balthazar van der Ast, an ice-skating scene by Adam van Breen, and a "festive gathering" by Dirck Hals. The gallery

has a number of history paintings and ancient landscapes by Cornelis van Poelenburgh, as well as Jacob Pynas's *The Good Samaritan.* Visitors who know Dutch history will be drawn to Michiel van Miereveld's portrait of Johan Oldenbarneveldt, the liberal leader of the province of Holland until he was accused of treason by his political enemies and beheaded in 1618.

Room 27 is also home to a portrait that, to some viewers, will seem very familiar. On the west wall hangs a canvas in a gilded frame depicting a man of middle age. Attired in a large, starched white collar folded over the neckline of a black coat, he looks like a typical Dutch *burgher.* He has dark shoulder-length hair, a moustache with a patch of beard just under his lower lip, a long aquiline nose, and heavy-lidded eyes. In his right hand he is holding a hat, as if he has just removed it. On his face is a quizzical expression as he stares outward to meet the viewer's gaze. It is the most famous image of the presumed sitter, who is identified by the label as René Descartes, the great seventeenth-century French philosopher, mathematician, and scientist (color plate 9). The painting, once owned by the Duke of Orléans and acquired by Louis XVI in 1785, was long believed to be by Frans Hals, the seventeenth-century Dutch master. While many outdated and less than authoritative sources continue to say that the life-size portrait is by Hals, the Louvre—on the basis of the work's painterly qualities and in the light of dominant scholarly opinion—has downgraded it. It is now identified as a *"copie ancienne d'un original perdu,"* and is said to be *"d'après Hals,"* or "a copy of a Hals."[1] Is it really a portrait of Descartes? Many seventeenth-century Dutch paintings acquired their titles long after they were painted, often in catalogues in the following century and on no basis other than a dealer's fancy. In the case of this canvas, however, there are good reasons to believe that the label is correct, and it has long been the image used whenever a picture of Descartes is needed.

About six hundred miles northeast of Paris, in a museum in a park in the center of Copenhagen, there hangs a panel that, while smaller, bears a remarkable resemblance to the painting in the Louvre. This portrait, owned by the National Gallery (Statens Museum) of Denmark, depicts what is undeniably the same person in an identical pose (color plate 8). The Copenhagen painting, oil on oak, also bears the title *Portrait of René Descartes*. The painting does not have the finish of the Parisian portrait. Where the Louvre canvas has a fine, smooth surface, the Copenhagen panel is coarse. The paint is handled roughly, and in some places it appears to have been applied with a thick brush or laid on as impasto. The sitter's visage bears the same skeptical expression, but this time it is sculpted out of many short, visible brushstrokes and discrete touches of layered, un-blended color rather than drawn carefully. The features of Descartes's face and the details of his clothing in this portrait seem to have been painted quickly, and the work as a whole might be mistaken for a sketch rather than a finished composition. In the Louvre painting the right side of the philosopher's face is illuminated by a smooth, uniform light. By contrast, on the Copenhagen panel the light reflected around the eyes and nose is captured by only a few distinct daubs of yellow painted over a rosy cheek built up from a number of crimson, orange, and red strokes. The carefully wrought beard in Paris is replaced in Copenhagen by nothing more than two swipes of black with a few lines of grey. And whereas in the Louvre Descartes has five well-defined fingers holding a hat, in the Statens Museum's portrait in its current condition (and some believe it to have been cropped at some point) there is a three-pronged, flesh-colored mass loosely representing only fingertips.

Unlike their French colleagues, the Danish curators confidently proclaim the painter of *their* Descartes portrait to be Frans Hals himself. While there is no direct evidence (such as

a signature) or extant contemporary documentation (a letter or record of commission) to confirm this identification with certainty, neither is there any good reason to doubt it. The scholarly community, for the most part, agrees with the Copenhagen museum (on the basis of stylistic analysis) that its painting is by Hals and (on the basis of historical considerations) that it is of Descartes; meanwhile, most Hals experts have concluded that the Louvre painting, as well as nearly identical paintings in the Museum of Art in Helsingborg, Sweden, and at the University of Amsterdam, are copies of the Copenhagen portrait and painted by artists other than Hals.

Like Renaissance Italy, the Netherlands in the seventeenth century offers one of those great moments in early modern European history when artistic and intellectual culture, fed by economic growth and technological advancement, bloomed with remarkable brilliance. Painting, science, philosophy, and religious and political thought flourished during the Dutch Golden Age under the relatively tolerant watch of the Republic's regent class. It was not always a peaceful realm, and the first seventy years of the United Provinces, as the Dutch federation was officially called—from 1579 (when the Union of Utrecht was signed) to 1648 (when the struggle for independence from Spain was formally concluded by treaty)—were characterized by warfare with foreign powers and domestic strife over confessional and political affairs. Moreover, the famed (and often mythologized) Dutch toleration had its limits, waxing and waning over the course of the century. But the general freedom of Holland's urban culture and the prosperity of its mercantile economy, combined with an unusual richness of domestic and imported resources and talent, allowed for great progress in the study of

nature, the development of liberal ideas about society and faith, and the crafting of great and enduring works of art. It was an ideal place for a metaphysically inclined scientist—and in this period, philosophy included what we now call "science," under the rubric of "natural philosophy"— to settle in order to pursue his projects in peace.

René Descartes, a Frenchman, spent most of his adult life in the Netherlands; Frans Hals never left his homeland. The portrait of Descartes painted by Hals represents the meeting on Dutch soil—and oak panel—between a foreigner who was the greatest philosopher in a century full of great philosophers, and a local artist who was arguably the greatest portrait painter in a century full of great portrait painters.

The precise circumstances surrounding Hals's portrait of Descartes are somewhat obscure. Although Descartes, in his extant correspondence, talks appreciatively about his adopted homeland and the various activities that kept the Dutch so busy, he does not say anything about their insatiable appetite for paintings. Apparently, he collected a small number of works to decorate the many dwellings he occupied over the years as he moved around the country.[2] However, while he does at one point comment on the way in which he has been depicted by another artist, he nowhere mentions sitting for Hals.

As for Hals, while there are among his works portraits of Dutch writers, his local Haarlem patrons generally preferred the life of business to the life of the mind. There were a multitude of skilled painters in Holland—the Dutch Republic as a whole had, by far, the highest number of painters per capita in all of Europe. If Descartes or someone who knew him well did happen to want his portrait done, why did the commission come to Hals? The painter may have been well known, in Haarlem and beyond, for portraiture, but he also had a reputation for

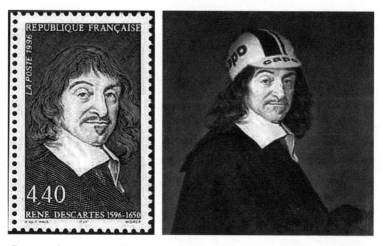

FIGURE 1. Postage stamp, France FIGURE 2. Advertisement, with cycling cap.

being difficult to work with. Who, then, brought the two men together? What are the circumstances that led to this minor but highly intriguing work in the oeuvre of a major Dutch master?

Exploring such art historical and biographical questions about a painting might seem an odd way to frame a book about a philosopher. But Hals's image of Descartes, now *the* image of Descartes (primarily by way of the Louvre copy), has become quite familiar. Indeed, it has become *too* familiar. While Descartes's famous phrase "I think, therefore I am" has been transformed by overuse, parody, and misunderstanding into a kind of all-purpose slogan easily adapted for a variety of occasions, philosophical and otherwise, Hals's depiction of the philosopher has been devalued almost to the point of anonymity by seemingly endless reproduction and caricature in a wide variety of media: innumerable book covers, works of fine and decorative art, commercial and editorial illustrations, even lowbrow entertainment.

One of the goals of this book is to restore to Hals's portrait of Descartes some of its originality and luster by reconstructing the biographical and historical contexts of its production. At the same time, such a project is a prime opportunity for presenting Descartes and his philosophy to a broad audience. The true story behind Hals's painting, as familiar as that image has become, can well serve as the scaffolding for an accessible study of Descartes himself. Just as "I think, therefore I am" represents only the starting point of a grand philosophical project that became the dominant intellectual paradigm of the seventeenth century, Hals's small painting can provide entrée to the life and mind of the ambitious thinker it so effectively portrays.

This is not a biography in the conventional sense. Most of Descartes's life, including much that happened during the decade on which this book is focused, lies outside the scope of its story. Nor is this book intended to be another detailed analytic study of Descartes's philosophy. There are many scholarly monographs exploring Descartes's work in epistemology, metaphysics, natural philosophy, and mathematics; there are also a number of fine general introductions to his thought, as well as several recent biographies. As valuable as such academic studies are, I would rather take my lead from Hals. The Haarlem artist has given us a small, intimate portrait of a great thinker. I want to do the same: a presentation of Descartes and his ideas in the form of a small, intimate portrait, a rendering of those years that culminated in some groundbreaking philosophical doctrines and a modest but intriguing work of art.

Descartes belongs as much to the intellectual culture of the Dutch Golden Age as he does to the grand history of Western philosophy whose development he so strongly influenced. It thus seems perfectly appropriate, if a bit unorthodox, to use a seventeenth-century Dutch painting as a portal into his world.

The Philosopher

On the west coast of Holland facing the North Sea are three small villages all bearing the name "Egmond," after the noble family to which the lands once belonged. Egmond aan Zee (Egmond by the Sea), the oldest and situated on the shore, was originally a fishing settlement, and has long been a popular resort because of its beaches. Over the centuries, it periodically suffered from heavy flooding—in 1570, it lost fifty houses to the sea; during a storm in 1741, another thirty-six houses and the village church disappeared into North Sea waters (color plate 1).

No more than a few kilometers east of Egmond aan Zee is Egmond aan den Hoef, so called because of the castle "Op den Hoef" (On the Hoof) that the Count of Egmond built in the eleventh century. As various armies swept through the Low Countries during the next five centuries, the castle was destroyed and rebuilt several times; today, its remains are in the center of the town, surrounded by a park and a small lake that is the vestige of the count's moat.

Egmond-Binnen (Inland Egmond), the smallest of the villages and south of Egmond aan den Hoef, is separated from the coast by farms and dunes. In the mid-tenth century, a Benedictine abbey was built in Egmond-Binnen, for which reason it was also known as Egmond de Abdij. Standing just a few kilometers

from where the Count of Egmond later built "Op den Hoef," the abbey was founded by Dirk I, Count of Holland. Along with the castle, it was destroyed in 1573, the victim of the political and religious passions that fueled the long Dutch war for independence.

The seventeen provinces of the Low Countries were at one time territories belonging to the dukes of Burgundy. Given their distance from Burgundy, they were usually ruled in absentia, with the reigning duke appointing a *stadholder* (literally, "placeholder") to govern each province. At the end of the fifteenth century, these northern lands came under Hapsburg dominion through the marriage of Mary of Valois, Duchess of Burgundy, to Maximilian I, the Holy Roman emperor. Their son, Philip the Fair, who became Duke of Burgundy, then married Juana de Loca ("Joanna the Crazy"), the third child of Ferdinand of Aragon and Isabella of Castille and whose nickname derived from rumors of insanity. This matrimonial union brought Spain into the Hapsburg family holdings. In 1555, the Netherlandish and Iberian properties were passed on by Maximilian's grandson and imperial successor Charles V (also King Charles I of Spain) to his son, Philip. Although Philip decamped from the Netherlands in 1559 to assume the throne of Spain (as Philip II), he—like the dukes before him—continued to rule his valuable northern territories from a distance, and he did so with a heavy hand.

It was not long before these provinces revolted against Philip's efforts to check local governance. They were also incited by his ruthless pursuit of Catholic domination of a population that in some areas was increasingly Calvinist and in others was simply protective of religious freedom (including the freedom not to belong to any religious confession at all).[1] Among other oppressive measures, the Spanish king continued his father Charles's efforts to purge his Netherlandish dominions of heretics. Through a series of royal edicts, all forms of Protestant

worship were condemned. Moreover, to insure the purity of faith among Catholics, both Charles and Philip encouraged a vigorous Inquisition to root out those who strayed from Roman Catholic orthodoxy.

By the mid-1560s, the inhabitants of the Low Countries had had enough. What began as an effort at conciliation and reform by the local nobles and gentry—who sought primarily to abolish the Inquisition and to moderate the heresy laws, as well as to recoup their own traditional privileges—soon became a full-scale revolt by the masses. While the uprising faltered in its opening stages in the face of superior Spanish forces, it was not long before seven of the rebellious provinces, under the brilliant leadership of William of Orange (also known as William the Silent)—and aided by the fact that Spain had to fight a war with England, France, and the Ottomans at the same time—were able to turn things around and achieve at least de facto sovereignty as a federation. By 1579, the provinces of Holland, Utrecht, Groningen, Zeeland, Gelderland, Overijssel, and Friesland were bound together in the Union of Utrecht to form the United Provinces of the Netherlands; the commercially important provinces of Flanders and Brabant, although signatories to the Union treaty, were quickly reconquered by Spain and, with the other southern provinces, made up the Spanish Netherlands. While the war would drag on for another seventy years, the Dutch eventually won their independence as a nation, with the Reformed Church as its privileged (if not established) religion.

As part of the campaign to turn the confessional tables, one of the first things that the Protestant forces did in their struggle for independence was to lay waste to centers of Catholic worship. Cathedrals, parish churches, abbeys, and private chapels were either completely destroyed or cleansed of all traces of

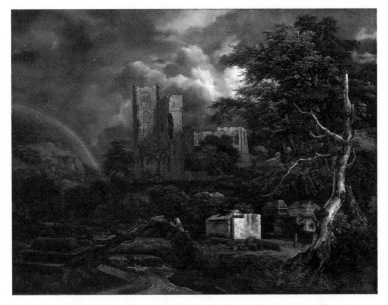

FIGURE 3. Jacob Isaacksz van Ruisdael, *The Jewish Cemetery*, ca. 1654–55
(Detroit Institute of Arts, USA/The Bridgeman Art Library)

"idolatrous" imagery. Grand medieval structures, once the site of Catholic rites, were transformed into proper Reformed sanctuaries, with crucifixes, sculptures, paintings, and altars stripped from the walls.

The villages of Egmond suffered during these years. The Count of Egmond's castle was destroyed by the rebel armies, lest it serve the Spanish as a fortress during the siege of Alkmaar.[2] Neither were the gothic quarters of an austere monastic order, even in an out-of-the-way coastal village, something to be spared during the turmoil of the late sixteenth century. For many centuries after, however, the picturesque ruins of Egmond continued to inspire Dutch imaginations—if not Dutch piety—and they can be seen in a number of works of seventeenth-century

Dutch art. To judge from a painting of the Jewish cemetery at Ouderkerke by the great landscapist Jacob van Ruisdael, in which he imaginatively incorporated the abbey's remains, all that was standing in the 1650s were some outer stone walls of the main building and the skeleton of its tower.

In 1649, one year after the ratification of Dutch independence with the Peace of Münster, there was a French gentleman living in one of the small houses in the vicinity of the abbey's ruins, among the fields just beyond Egmond de Abdij. This voluntary exile, who came from a Catholic family of the *noblesse de robe*, was known to identify himself as the "Sieur du Perron" (Lord of Le Perron, after a small family estate in the Poitou region). He had arrived from France over twenty years earlier, settling in the Netherlands while the war was still raging. What he now sought beside the windy dunes of a coastal village in a land struggling for political and religious sovereignty was simply some peace to pursue his philosophical and scientific studies. Why a Catholic believed he would find a tranquil life in an increasingly militant Reformed nation at war with a Catholic empire is something of a mystery.

———

The quiet country house in Egmond de Abdij was not René Descartes's first domicile in the Netherlands. He had, in fact, been living a peripatetic life in the Dutch Republic since moving there just before he began to make a name for himself in the world of science and the transnational Republic of Letters.

Descartes was born in the village of La Haye in Touraine in 1596.[3] His father, Joachim Descartes, was a lawyer and royal counselor, serving under Henri IV and, after that king's assassination in 1610, Louis XIII. At the age of ten, Descartes was sent to the town of La Flèche for his schooling. For the next ten years he was enrolled in the royal college established there

in 1603. This was one of several important Jesuit colleges in France, all serving to prepare young men for university studies in one of the three higher disciplines: theology, medicine, or law. Descartes's education was typical of the period and conformed to the standard Jesuit course of study. After several years of pre-paratory courses in grammar, rhetoric, and classical humanities (as well as music, diction, dance, and fencing), students went on to advanced work in mathematics, rhetoric, physics, and philosophy. The science, logic, ethics, and other disciplines taught at La Flèche were all thoroughly informed by Aristotelian philosophy, although distilled through centuries of textual commentary and theological purification by medieval Christian thinkers into late Scholastic form. Descartes and his fellow students studied modes of syllogistic reasoning, engaged in disputations over topics in metaphysics and theology, and were examined in scientifically antiquated but religiously acceptable theories of the cosmos.

Although Descartes later said to a correspondent that "nowhere on earth is philosophy better taught than at La Flèche,"[4] he in fact found the Jesuit curriculum to be generally useless, even stultifying. Looking back on the education he received as a young man "at one of the most famous schools in Europe," Descartes wrote that

from my childhood I have been nourished upon letters, and because I was persuaded that by their means one could acquire a clear and certain knowledge of all that was useful in life, I was extremely eager to learn them. But as soon as I had completed the course of study at the end of which one is normally admitted to the ranks of the learned, I completely changed my opinion. For I found myself beset by so many doubts and errors that I came to think I had gained nothing from my attempts to become educated but increasing recognition of my ignorance.[5]

Classical syllogisms, he insisted, while good for putting into demonstrative form, and thus persuading others of, something that is already known, contribute nothing to the discovery of new truths. They had a deadening effect on independent thinking, since they did not encourage original inquiry. Meanwhile, the philosophical authors he was forced to read in school seemed to have abandoned the search for certain knowledge and showed more deference to authority—both to Aristotle and to the Church—than to truth. Their theories appeared to be grounded not in reason and the intellect but in fantasy. "In my college days I discovered that nothing can be imagined which is too strange or incredible to have been said by some philosopher."[6]

Descartes finished at La Flèche in 1614. Intending to follow his father, his brother, and other family members into a legal career, he studied civil and canon law at the University of Poitiers, from which he graduated in 1616. However, he was not yet ready to enter royal service. Little is known of Descartes's life immediately after he finished his law degree. He may have undertaken medical studies at this time as well. But by 1618 he had decided that much more was to be learned by traveling and studying "from the great book of the world" than by reading dry Scholastic texts or poring over Galenic treatises in medicine. A journey to other lands would, he believed, better allow one to "raise one's mind above the level of mere book learning and become a genuinely knowledgeable person."[7]

The first stop on Descartes's edifying itinerary was the Netherlands. Despite—or, perhaps, because of—the fact that the Dutch were still at war with Spain, this was a natural destination for a man of his intellectual ambitions and curiosity. Even fifty years after the start of the revolt, the United Provinces were still less a sovereign nation than a small confederacy of provinces fighting for its independence. Nonetheless, they had

become a major European center of trade, science, and higher learning. A laissez-faire attitude toward commerce and a relatively tolerant intellectual and religious environment allowed the United Provinces quickly to grow into one of the continent's most progressive and cosmopolitan societies.

The Dutch Republic had at this time three major universities (in Leiden, Franeker, and Groningen, all important institutions of humanistic scholarship), an extraordinary tradition of innovative engineering (allowing the Dutch to reclaim vast tracts of land from the sea), a superb military (especially its navy), and a flourishing mercantile economy. Amsterdam, in particular, was a vibrant crossroads and entrepôt, brimming with goods of all kinds and people of all nationalities. French, Germans, English, Italians, Poles, even Portuguese Jewish merchants could be found in the streets along its canals and the taverns in its squares. Raw materials and products from all parts of the world came through Amsterdam and other Dutch ports, keeping their refineries operating and filling their warehouses: wood and grain from the Baltic, fruits from north Africa and the Levant, sugar from Brazil, salt from the Caribbean, and spices from Indonesia. The Dutch East India Company, chartered in 1602 by the States General, had a monopoly on trade in Asia; a few years after Descartes's arrival in 1618, the Dutch West India Company gained similar control over trade in the New World. If one was intent in the seventeenth century on studying "the great book of the world"—not to mention applied and theoretical sciences, commerce, mathematics, manufacturing, medicine, and engineering—there was no better place to start than the Dutch Republic.

Still, 1618 was a difficult time to be immigrating to Holland. The Twelve Years' Truce with Spain, signed in 1609, was still in effect when Descartes arrived—overland by coach, through

the still-loyal Spanish Low Countries—but the religious and political world of the United Provinces was undergoing one of its periodic upheavals.

———

Just a few months after Descartes arrived in Holland, the leaders of the Dutch Reformed Church convened the Synod of Dordrecht, a seminal event of early modern Dutch history. The ecclesiastic gathering met from November 1618 to May 1619 to consider what to do about heresy within the Church. They were troubled, in particular, by the followers of Jacob Arminius, a theology professor at the University of Leiden. In 1610, these liberal ministers had issued a "remonstrance" in which they set forth their unorthodox views on a variety of sensitive theological questions. The Arminians, or "Remonstrants" as they were called, explicitly rejected the strict Calvinist doctrines of grace and predestination. Where more orthodox theologians insisted that no one living after the Fall of Man could possibly do good or achieve eternal blessedness without God's freely given and unearned grace, distributed to the elect independent of merit, the Remonstrants believed that a person had the capacity to contribute through good action to his own salvation. They also favored a separation between matters of conscience (which should be left to individuals) and matters of politics (to be managed by civil authorities), and they distrusted the political ambitions of their conservative Calvinist opponents. Like many reformers, the Arminians saw their crusade in moral terms. In their eyes, the true liberating spirit of the Reformation had been lost by the increasingly dogmatic, hierarchical, and intolerant leaders of the Dutch Reformed Church.[8]

The Remonstrants had on their side Johan Oldenbarneveldt, the advocate or general secretary (later called the "grand pensionary") of the States of Holland, the province's governing

body composed of representatives from the cities and towns. Because of the size and importance of Holland relative to the other provinces—a first among equals—whoever was the leader of that province's government essentially held the most powerful political office in the Dutch Republic, often (depending upon personality) surpassing in influence even the stadholder, whose own domain extended across several provinces. (The stadholder was also the commander-in-chief of all Dutch military forces, and by tradition—especially for the weaker provinces—a symbol of Dutch unity; the position was ordinarily given by most of the provinces to members of the House of Orange-Nassau.)

With Oldenbarneveldt's intervention, what was initially a doctrinal dispute among the Calvinist clergy and the university theology faculties quickly took on political overtones. The States of Holland, urged on by Oldenbarneveldt, upheld the right of the Remonstrants to continue preaching and to bring forward their opinions within the public church, which in turn antagonized the Remonstrants' opponents. The Counter-Remonstrant theologians, led by the Leiden professor Franciscus Gomarus, accused the Arminians of being covert papists taking their lead from Rome, while Oldenbarneveldt's political enemies saw in his support for the liberals an opportunity to label him a traitor working on behalf of Spain, the Catholic enemy.

Within a few years, the Remonstrant–Counter-Remonstrant battle over theology became intertwined with conflicting views on domestic affairs and foreign policy. The opposing camps disagreed on whether civil authorities had the right to legislate over the Church and to control what it taught. And they fought over how to conduct the struggle with Spain and how to respond to the recent Protestant uprisings in France. The Remonstrants sought peace and wanted to stay out of French affairs, while the Counter-Remonstrants were in favor of pursuing the war without compromise and aiding their French coreligionists by

all available means. There was frequent, and sometimes quite violent, persecution of Remonstrants in a number of Dutch cities, and many Arminian sympathizers were stripped of their offices and perquisites. By 1617, the Holland stadholder himself, Prince Maurits of Nassau, had entered the fray on the Counter-Remonstrant side. This was a calculated political move by the prince. He hoped thereby to oppose Oldenbarneveldt's policies, especially any peaceful overtures to Spain, as well as to gain support from orthodox religious leaders for his domestic agenda (which involved increasing the stadholder's own authority across provinces and thereby centralizing power in the Republic).

When the delegates to the Synod of Dordrecht met in late 1618, they reiterated their commitment to freedom of conscience in the Dutch Republic, enshrined in Article Thirteen of the Union of Utrecht: "Every individual should remain free in his religion, and no man should be molested or questioned on the subject of divine worship." The Counter-Remonstrants controlled the gathering, however, and they made heavy-handed use of their advantage. They set forth the dogmas of the Reformed Church concerning grace and atonement, and they succeeded in passing a resolution that restricted public worship and office holding to orthodox Calvinists. There was a purge of Remonstrants in the Church and municipalities at all levels. Meanwhile, Oldenbarneveldt's enemies mercilessly prosecuted him. In the spring of 1619, he was convicted of treason and beheaded.

Just as the French Catholic Descartes arrived in the Dutch Republic to broaden his horizons, the generally tolerant young nation was entering one of its occasional, usually brief, but sometimes violent periods of religious and intellectual intolerance.

———

Soon after he landed in the Netherlands in the spring of 1618, Descartes, like many other young French noblemen, joined the

army of Maurits, Count of Nassau. The stadholder, a son of William the Silent (and shortly to become the Prince of Orange, after the death of his older brother), was also a brilliant military man. When he assumed the stadholdership of Holland and Zeeland, in 1585, he began introducing modernizing reforms into the Dutch armed forces and turned them into a professional soldier corps with the latest in field discipline and engineering. Maurits was particularly interested in what science could do for his army, and his military service thus provided Descartes a good opportunity to study such things as military architecture and the physics of moving bodies (especially ballistics).

While stationed in Breda, a city near the border with the Spanish-ruled southern provinces, Descartes met Isaac Beeckman, a medical doctor and accomplished mathematician (and failed Calvinist preacher). The two men quickly bonded over shared interests in mathematics and science. They challenged each other with a variety of problems in algebra, geometry, physics, and especially music. While the friendship later soured over Descartes's suspicion that Beeckman was taking credit for his ideas, the relationship was of great consequence for Descartes's own intellectual development. Much of Descartes's mature work in algebraic geometry and mathematical physics was inspired by his early meetings with and instruction from Beeckman.

Soon after Beeckman returned home to Middelburg—he later took up positions at the Latin schools in Utrecht, Rotterdam, and Dordrecht—Descartes resumed his travels and departed for Denmark and the German lands. From mid-1619 until the spring of 1622, he wandered throughout the principalities and bishoprics of the Holy Roman Empire, staying in Frankfurt, Prague, Neuburg, and other towns, and perhaps serving some time in the army of the Duke of Bavaria—"drafted," he said some years later, "because of the wars that are still being waged there."[9]

It was an eventful three years, with Descartes witnessing the coronation of one emperor, the Catholic Ferdinand II, and possibly participating in the battle to dethrone a rival claimant to the throne, the Protestant Frederick of Bohemia. By the time he returned to France, in 1622, Descartes had seen a good part of Central Europe, experienced war as a soldier, made significant progress as a mathematician, and probably learned some Dutch and German as well.

Still, Descartes remained restless. After little more than a year in France, part of which he spent in Paris, Descartes was off again to continue his geographical and intellectual wanderings. He wrote to his older brother, Pierre, in March 1623 to announce his plans to travel to Italy, "a voyage beyond the Alps [being] of great utility for learning about business, acquiring some experience of the world, and forming some habits . . . not had before." If such a trip did not make him richer, he added, "at least it would make [me] more capable."[10] In the end, he did not depart until September, after settling some affairs, including selling off some of his inherited properties.

Descartes went to Italy through Switzerland, taking time to explore what was for him an exotic land. As his earliest biographer Adrien Baillet, whose *La Vie de monsieur Descartes* was published in 1691, describes the journey,

> It would have been easy for him to find in Basel, Zurich, and other cities philosophers and mathematicians capable of talking with him. But he was more curious to see the animals, the waters, the mountains, and the air of each region, with its weather, and generally whatever was furthest from human contact, in order better to know the nature of those things that seem the least known to ordinary scholars [*au vulgaire des sçavans*].[11]

Sometime before the winter of 1624, Descartes was in Rome. His itinerary also took him to Venice, Florence, and possibly

Loreto, to which he is supposed to have pledged to make a pilgrimage. He learned something of the intellectual life of Italy, particularly its scientific communities, although he said he did not get to meet Galileo, whom he would later describe as "philosophizing much better than most, in that he abandons as much as he can the errors of the Schools and tries to examine physical matters through mathematical reasoning."[12] The Italian climate, however, did not suit him. This Frenchman did not like the heat and humidity of Italy in the warm months. Writing to his friend Guez de Balzac in 1631, and recalling how uncomfortable he had been when passing through these Mediterranean lands, he said,

> I do not know how you can like so much the air of Italy, with which one so often breathes in pestilence, and where the heat of the day is always unbearable and the coolness of the evening so unhealthy, and where the darkness of night obscures robberies and murders.[13]

Descartes shared such worries again several years later with another friend who would soon be undertaking his own voyage to Italy. The theologian and mathematician Marin Mersenne was the center of a broad intellectual network, running his own international province within the larger Republic of Letters. From his quarters in Paris, where he was a Minim friar, he corresponded with philosophers, theologians, mathematicians, and scientists across Europe. Mersenne was friend and collaborator with some of the greatest minds and leading personalities of the first half of the seventeenth century—Galileo, Étienne Pascal (a mathematician and father of Blaise), the Epicurean philosopher Pierre Gassendi, the Sorbonne theologian (and, later, Jansenist leader) Antoine Arnauld, the English thinker Thomas Hobbes, and many others.

In the 1630s and 1640s, Mersenne would function as a kind of midwife to Descartes's philosophical thought and helped usher

some of his writings into print. He was, in effect, Descartes's Paris-based philosophical manager and advisor, and as his literary sentinel Mersenne often ran interference with correspondents and publishers. Concerned about the well-being of the irreplaceable Mersenne, Descartes told him that Italy is "a country that is very unhealthy for the French. Above all, one should eat very little there, for their victuals are too nourishing."[14]

After a year and a half in Italy, Descartes returned to France by way of the mountainous Piedmont region.[15] While going over the Susa Pass near the French border during the spring thaw, he witnessed an avalanche. Writing some years later in his treatise on meteorology about the nature of thunder in storms, he said "I remember having seen some time ago, in the Alps, around the month of May, when the snows were warmed and made heavier by the sun, the slightest movement of the air was sufficient to cause a great mass suddenly to fall, which was called, I believe, avalanches, and which, echoing in the valleys, closely imitated the sound of thunder."[16]

By the summer of 1625, Descartes was back in Paris, where he stayed—aside from a brief sojourn in Brittany—until late 1628. He had come a long way from the Jesuit-trained young man with a law degree pondering what career path to take. He remained unsure of how to make his living; his inheritance and the income from the sale of properties were not sufficient to insure a livelihood. While he seems still to have been considering a position as a counselor in royal service, he was reluctant to take up the career being urged upon him by his family.[17] But by the mid-1620s, Descartes did at least have a better sense of his true vocation.

———

Paris in the seventeenth century was an important center of philosophical and scientific activity. While the Dutch Republic,

especially Amsterdam, certainly had its attractions for the intellectually curious, and it is not hard to understand why the young Descartes thought to begin the expansion of his horizons there, the Parisian scientific community benefited from well-established institutions and abundant resources. Despite occasional efforts at censorship by the city's *parlement*, often provoked by the theologians at the Sorbonne ever on guard against libertine thinking and subversive ideas, the innovative pursuit of new knowledge flourished in the city's colleges, university faculties, and academies. Paris held great allure for the period's philosophers, mathematicians, physicists, astronomers, engineers, and chemists, not to mention poets, dramatists, and humanist scholars. Throughout the century, and especially after the establishment of the Académie des Sciences in 1666, the city attracted such important foreigners as the Englishmen Hobbes and Kenelm Digby, the Dutch scientist Christiaan Huygens, the German polymath Gottfried Wilhelm Leibniz, and the Italian astronomer Giovanni Cassini.

While many of Descartes's scientific contemporaries were devoted to the orthodox paradigm of late Scholasticism, defending neo-Aristotelian metaphysics and traditional (and religiously safe) doctrines of nature, there was no shortage of post- or anti-Aristotelians. These progressive theoreticians and experimentalists, with whom Descartes cast his lot, were opposed to what they regarded as sterile medieval theories and committed to a clear and, just as important, pragmatic understanding of the world's phenomena. With its philosophical life supported by royal and private patronage, and home to the far-reaching networks of Mersenne and others, Paris—more so than Rome, Florence, Bologna, London, Oxford, Leiden, Salamanca, and other great centers of traditional learning and new inquiry—was for a long time the intellectual capital of Europe. Everyone who was anyone in philosophy and the sciences wanted to be there.

It was during the early decades of this fervent and creative intellectual environment that Descartes pursued his first serious mathematical projects and devoted himself to the search for a proper method of discovering philosophical and scientific truth. He worked on problems in geometrical optics, including formulating the law of refraction, and conducted experiments to determine the physical nature of light. These years in Paris are also when Descartes worked on his first philosophical treatise, *Rules for the Direction of the Mind (Regulae ad directionem ingenii)*. The *Rules*—which Descartes put aside in 1628 and which were not published in his lifetime—contains a method for "directing the mind with a view to forming true and sound judgments about whatever comes before it."[18] The work is, in effect, a manual for how to achieve true and certain knowledge in any discipline. Mathematics, primarily arithmetic and geometry, represents the paradigm of knowledge because of its method of starting with absolutely certain first principles and proceeding by lucid demonstration to indubitable conclusions (or what Descartes calls "certain and evident cognitions"). But Descartes is confident that other sciences—all of "human wisdom"—can acquire that same degree of certainty, well beyond the mere probabilities (and, hence, controversies) provided by Scholastic thinkers. "Of all the sciences so far discovered, arithmetic and geometry alone are . . . free from any taint of falsity or uncertainty." This is because "the deduction or pure inference of one thing from another can never be performed wrongly by an intellect which is in the least degree rational." Arithmetic and geometry are "much more certain than other disciplines" because "they alone are concerned with an object so pure and simple that they make no assumptions that experience might render uncertain; they consist entirely in deducing conclusions by means of rational arguments."[19]

This does not mean that, for Descartes, arithmetic and geometry are the only disciplines worth studying. Nor does it

imply that other disciplines must be reduced to mathematics. Rather, the mathematical disciplines set the standard, and one should strive for the same degree of certainty in other fields, especially the science of nature. This can be done, Descartes believed, if only one follows a systematic method and proceeds, step by step, according to proper order. Ideally, such a method would involve breaking down complex problems into simpler constitutive problems, and these into yet simpler ones, until one reaches the most simple and basic of all; then, reversing order, one need only resolve those more fundamental questions until one arrives at the original question to be answered. Discovering the anaclastic, for example, which is the shape of a line (such as the surface of a lens) "in which parallel rays are refracted in such a way that they all intersect in a single point after refraction,"[20] requires knowing the law of refraction (the relation between the angle of incidence and the angle of refraction). It also demands understanding—in order—the differences in media (water vs. air) through which light passes, the way in which powers generally are propagated through media, the nature of light, and ultimately what is a natural power (of which light is an instance). At every step, one can achieve greater clarity, and thus ease of solution, by representing the matter at hand in more accessible terms. This is best done, Descartes suggests, through the use of intelligible models, by translating things into abstract magnitudes or quantities—for example, depicting them as mathematical figures. It is easier to compare and draw conclusions from lines, shapes, and symbols than from a direct examination of various empirical phenomena. Through such modeling, difficult problems in physics can be represented by the more tractable problems of mathematics. Descartes's rules thus

> show us how to abstract determinate and perfectly understood problems from particular subjects and to reduce them to the point where the question becomes simply one of discovering certain magnitudes

on the basis of the fact that they bear such and such a relation to certain given magnitudes.[21]

Descartes left the *Rules* uncompleted, and he eventually abandoned many of its particular methodological recommendations. But the search for a reliable method for discovering truth and certainty in the sciences became his lifelong project and informed all of his later philosophical writings.

———

Descartes says that during these years he made a concerted effort at conventionality, "appearing to live like those concerned only to lead an agreeable and blameless life, who take care to keep their pleasures free from vices, and who engage in every honest pastime in order to enjoy their leisure without boredom." But the public life of leisure was only a cover for more private and ambitious interests. All the while he never stopped "pursuing my project, and I made perhaps more progress in the knowledge of truth than I would have if I had done nothing but read books or mix with men of letters."[22]

Despite the attractions of Paris for a modern philosopher, the city was not very conducive to Descartes's "project." Nor would anywhere else in France be much better. In his native milieu, with its family obligations (including what must have been pressure from his father to find himself a respectable occupation) and interruptions—from friends, colleagues, even inquisitive strangers—there were too many distractions for a scientist intent on making progress in the knowledge of nature. Reflecting back many years later, he wrote:

> As many people know, I lived in relative comfort in my native country. My only reason for choosing to live elsewhere was that I had so many friends and relatives whom I could not fail to entertain, and that I would have had little time and leisure available to pursue the

studies which I enjoy and which, according to many people, will contribute to the common good of the human race.[23]

Once again, Descartes felt he had to leave his homeland. But his departure from France in 1629 was motivated not by curiosity and wanderlust but by a desire for peace and quiet. His destination this time, as it had been ten years earlier, was the United Provinces of the Netherlands. It would, in fact, turn out to be a permanent move: Descartes never again made his home in France, and he returned there from his self-imposed exile for only a few short visits. Writing in his *Discourse on Method* a few years later, while living in Amsterdam, he says that

> as I was honest enough not to wish to be taken for what I was not, I thought I had to try by every means to become worthy of the reputation that was given me. Exactly eight years ago this desire made me resolve to move away from any place where I might have acquaintances and retire to this country, where the long duration of the war has led to the establishment of such order that the armies maintained here seem to serve only to make the enjoyment of the fruits of peace all the more secure.

It was not only the orderliness and security of the Dutch Republic that made it an attractive locale for Descartes to pursue his studies. The Netherlands was perhaps the most densely populated country of Europe at the time, and Amsterdam, while much smaller than Paris, was hardly less lively a city. The difference was that the Dutch, among whom Descartes had few acquaintances, were so focused on going about their own business that they had little interest in the doings of a French intellectual abroad.

> Living here, amidst this great mass of busy people who are more concerned with their own affairs than curious about those of others, I have been able to lead a life as solitary and withdrawn as if I were

in the most remote desert, while lacking none of the comforts found in the most populous cities.[24]

All Descartes wanted was to be left in peace to do his work, and that was exactly what he found among his busy Dutch neighbors.

He moved around quite a bit during his early years in the country. After a brief stay in a castle in Franeker, a university town in the far north, he lived in Amsterdam for six months, then in Leiden for two months (perhaps because it was home to the leading Dutch university), then back in Amsterdam until the summer of 1632. This was followed by almost two years in Deventer, a town in the eastern province of Overijssel. In March 1634, he moved back to Amsterdam, settling for a year in a house on the Westermarkt.

To protect his privacy throughout these changes of address, he asked Mersenne not to reveal his location to anyone. "I do not so much care if someone suspects where I am, just as long as he does not know the exact place."[25] He even suggested that Mersenne engage in a little subterfuge to put anyone off his trail. "If someone asks you where I am, please say that you are not certain because I was resolved to go to England."[26]

———

In late 1633, just before the third move to Amsterdam, Descartes was finally ready to present to the public a substantive scientific treatise. For some years he had been working on a variety of topics in physics. These included questions as general as the causal origin of the cosmos, the nature of matter, and the laws of motion; and more particular ones, such as the explanation of gravity and of the tides. He had also resolved, at least to his own satisfaction, a number of problems in optics and the science of light. He investigated the formation of the colors of the rainbow and the process of visual sensation, and achieved

some expertise in anatomy and how the human body worked (what he calls "all the main functions in man"). Writing to Mersenne from Amsterdam in 1629, when he had begun the project after abandoning the *Rules*, Descartes boldly said that his treatise would contain nothing less than "all the phenomena of nature."[27] Its title, appropriately, was *Le Monde*, or *The World*.

The planned work—which, in fact, was to be part of a larger treatise that would also include an essay on the human being, titled *L'Homme*—was informed by the theory of nature promoted by the new mechanistic science. According to the centuries-old Aristotelian account of natural phenomena, the bodies studied by physics were "hylomorphic" corporeal substances, consisting of matter (in Greek, *hyle*) and form (*morphé*). The substantial form—an immaterial, soul-like item united with the matter—accounted for the unity and identity of a physical thing, explaining why *this* parcel of matter (say, a tree) is different in nature from *that* parcel of matter (a horse). The substantial form explained, often in a causal manner, the essential properties and characteristic behavior of a substance. A tree, for example, is composed of a certain type of matter that looks and behaves in treelike ways (spreading roots, growing upward, sprouting leaves) because of the essence or substantial form of tree ("tree-ness") that animates it. Similarly, horses act in horselike ways (such as galloping and whinnying) because their matter is informed by the substantial form of horse. And the soul of a human being is the substantial form that animates the human body and brings about characteristic human activities (especially reasoning).

Explanations in medieval and early modern Aristotelian science[28] also appealed to a wide variety of what they called "real qualities," likewise distinct from matter and sometimes called "accidental forms" (to distinguish them from substantial forms).[29] These qualities were true causal powers inhering

in bodies and were responsible for a host of observed features and behaviors. On some accounts, there were the four primary qualities of hot, cold, wet, and dry, and the so-called "secondary" qualities that resulted from the proportion and mixture of the primary ones. The latter included both sensible qualities and what came to be called "occult" qualities. Heaviness, for example, was a sensible quality of the motive variety. A heavy body falls toward the earth because it is endowed with *gravitas*, "heaviness," while some bodies, like fire, float upwards because they are endowed with *levitas*, "lightness." The visual appearances of things were explained by other kinds of sensible qualities. Why, asks the Spanish Jesuit Francisco Suarez, is a swan white (*albus*)? Because of the presence in it of whiteness (*albedo*).[30] And so it goes: one body is hot because of the higher proportion of the primary quality *calor*, or "heat," in it, while another body is red because it has the sensible visual quality *rubeus*. If the hot body becomes cold, or the red body becomes blue, it is because of some change in real qualities—a diminution in the proportion of heat to cold, or an exchange of the quality red for the quality blue.[31]

The paradigmatic occult quality—so called because Scholastic authors were less clear about the underlying causal process that explained the observed behavior—was magnetism: the lodestone attracts iron because it possesses the magnetic quality. (Such a model of explanation was easily parodied by Molière in his play *Le Malade imaginaire*; when Thomas, the degree candidate in medicine, is asked by his examiners to explain why opium causes sleep, he responds "Because it has the dormitive virtue, which makes one sleep." Upon hearing this, his teachers enthusiastically praise his perspicuity.)

None of the forms or qualities employed by Scholastic thinkers were reducible to mere "motion of parts";[32] they operated

in their own immaterial (and apparently inscrutable) manner. By contrast, Descartes's physical universe is a strictly mechanical one. Bodies consist of extended matter alone, devoid of any active immaterial forms or qualities behaving like "little souls" (as he mockingly calls them) directing their movements. The phenomena of nature are explained solely by the motion and contact of parts of matter of varying sizes and shapes. Thus, heavenly bodies move around the center of the cosmos not because of some mysterious attractive power operating over great distances, but because they are swept along by the vortex of finer matter within which they are embedded ("just as boats that follow the course of a river," to use Descartes's metaphor). Visual sensations are generated in the human soul by motions translated from an external body through the intervening medium (the subtle matter) until they impinge on the surface of the eye and are communicated by the optic nerve to the brain. The falling of a body to the ground is not explained by a form or quality in the body that moves it, as if intentionally, toward its natural resting place; nor does it happen by some occult force acting on the body over empty space. Rather, gravity is caused by the downward pressure exerted on terrestrial bodies by the smaller, quicker, and therefore upward-moving microscopic bodies—the "more subtle matter"—of the "heaven" surrounding the earth and permeating its atmosphere.

The Cartesian world, then, is like a machine (albeit without the design), operating according to basic and perspicuous physical principles that can be described, at least in principle, with mathematical precision. The general physical (if not metaphysical) assumptions of this anti-Aristotelian model of nature, in one form or another, grounded all of the great science of the seventeenth century: from Galileo's physics, to Robert Boyle's corpuscular chemistry, to the mechanics of Huygens, Leibniz,

and Newton. All these natural philosophers, despite important differences in their respective sciences of nature, and equally important differences in their philosophies of science, subscribed to the basic mechanistic world picture.[33]

Descartes was certainly concerned about how his theories would be received by those who were less progressive in such matters, especially religious authorities. In speculating on the origins of the cosmos, he was afraid of being drawn into potentially dangerous debates about whether the universe is created or eternal, finite or infinite. By rejecting Aristotelian modes of explanation, he was also ruling out ways in which theologians had long accounted for various doctrines of the faith. Certain Scholastic theories used to explicate Church mysteries—such as the Incarnation and Eucharistic transubstantiation—had become nearly as much a part of Catholic dogma as the mysteries themselves. Descartes thus considered publishing his new treatise anonymously. He told Mersenne that "I wish to do this principally because of theology, which has been so subordinated to Aristotle that it is almost impossible to explain another philosophy without it seeming initially to be contrary to faith."[34]

To Descartes's conservative religious contemporaries, however, the most striking and problematic feature of *The World*—had he published it—would have been his rejection of the geocentric model of the universe in favor of the Copernican heliocentric model.

Descartes knew this. It explains, in part, why he decided to present his account of the universe as simply "a fable." He says in the treatise that he is not talking about this actual world, but "another world—a wholly new one which I shall bring into being before your mind in imaginary spaces."[35] He hoped that by presenting his Copernican cosmology as just a hypothetical fiction—the way a cosmos *might* be constructed—he would be

afforded some protection from theological critics who would otherwise attack him for expounding a doctrine that he knew was regarded by the Catholic Church as "contrary to Holy and Divine Scripture."

His faith in this ruse was shaken when he learned about the recent condemnation of Galileo. At the end of 1633 Descartes was about to send *The World* to Mersenne for publication, "as a New Year's gift." He quickly changed his mind when, after looking for a copy of Galileo's *Dialogue on Two Chief World Systems* in bookstores in Amsterdam and Leiden, he discovered that all published copies had been burned in Rome and that Galileo had been convicted by the Catholic Church of heresy and punished. As he wrote to Mersenne, "I was so astounded at this that I almost decided to burn all my papers or at least to let no one see them. For I could not imagine that he—an Italian and, as I understand, in the good graces of the Pope—could have been made a criminal for any other reason than that he tried, as he no doubt did, to establish that the earth moves." Descartes concedes that if that view is false, then "so too are the entire foundations of my philosophy." The heliocentric model "is so closely interwoven in every part of my treatise that I could not remove it without rendering the whole work defective."[36] Moreover, Descartes reminded his friend, Galileo himself had used the maneuver of presenting that model as a mere hypothesis; if that did not save a Florentine who was friendly with the pope, it was unlikely to save Descartes. Rather than incur the wrath of the Church, Descartes decided not to publish *The World* after all. "I have decided to suppress the treatise I have written and to forfeit almost all my work of the last four years in order to give my obedience to the Church, since it has proscribed the view that the earth moves." This was, in fact, not so much an act of faithful obedience by a devoted Catholic as a safe and

self-interested tactic within his general strategy to preserve his "repose and peace of mind."[37]

———

Given Descartes's professed desire for a quiet life, it is odd that he spent so much time in his first decade in the Netherlands residing in cities. He seems to have had a particular affection for Amsterdam. At one point he wrote to Balzac, who was planning his own sojourn in the Dutch Republic, to persuade him also to make Amsterdam his home rather than "even the most beautiful places of France or Italy." Descartes acknowledges the charms of a country retreat, but confesses that it lacks many of the conveniences of a city; moreover, the solitude in the country is never as great as one wishes, with the constant and incommodious interruptions by one's "little neighbors."

> By contrast, in this great city where I am, there is no one, except myself, who is not engaged in commerce. Everyone is so consumed with the pursuit of his own profit that I could live my whole life without ever being seen by anyone. I go out walking every day among the confusion of a great many people, with as much liberty and quiet as you could find in your alleys; and I look at the people I see here not otherwise than as the trees found in your forests, or as the animals that pass through. Even the noise of their disturbances does not interrupt my reveries any more than would the sound of a small stream.

In Amsterdam, Descartes boasts, the ships arrive laden with the products of the Indies and many items that are still rare in Europe.

> Where else in the rest of the world could . . . all the commodities of life and all the curiosities that might be wished for be so easily found as here? In what other country might one enjoy so complete a lib-

erty, or sleep with less disquiet, since there are armies on the march explicitly to safeguard us; or where else are poisons, betrayals, and calumnies less known, and can there still be found the remaining innocence of our ancestors?[38]

Descartes is obviously intoxicated by this bustling Dutch port city. Or at least so he pretends in 1631 to the friend whom he is trying to entice to join him there. Nonetheless, the relative solitude and anonymity that he enjoyed in a foreign city—full of people too occupied with their own business to pay him any mind—proved to be insufficient for his work. In the spring of 1635, Descartes was off again. For a number of months he tried the less hectic but still urban environs of Utrecht, another university city, followed again by the even more placid Leiden, but it still was not good enough. He wanted something more remote and isolated. Despite the undeniable inconveniences and nosey neighbors, Descartes needed, above all, a place in the country.

The Priest

Around the time that Descartes was relocating among the major cities in Holland and Utrecht, seeking a peaceful place to pursue his research, a certain Dutch Catholic priest was also on the move. The independent-minded cleric was hoping to find a city in which to carry out his pastoral duties undisturbed by his order's ecclesiastic superiors. He eventually found his calling in the diocese of Haarlem, his childhood hometown. This was not far from the small, rural village in which Descartes, just a few years later, was to set up house for good. The lives of the philosopher and the priest would soon intersect, and the warm and lasting friendship that developed between them would be of great personal and intellectual consequence for both.

———

The city of Haarlem sits on the banks of the Spaarne River. In the seventeenth century, this waterway flowed off the Haarlem-mermeer, or Haarlem Lake, and ran through the town, cutting off its eastern quarter. (In the nineteenth century, in an effort to control flooding as well as gain new arable land, the lake was drained.) The river then emptied into the IJ Bay, from which boats had access to the Zuiderzee and, eventually, to the North Sea. The riverbanks around Haarlem were lined with windmills,

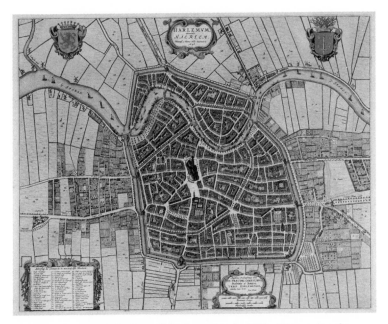

FIGURE 4. Pieter Wils, *Map of Haarlem*, 1646, *Stedelijke Atlas van Haarlem*
(Noord-Hollands Archief, Haarlem)

some of them employed in moving water out of the surrounding fields. A number of canals ran from the moat around the city walls to the Spaarne, which further divided the main part of Haarlem into uneven sections.

By seventeenth-century standards, Haarlem was a city of considerable size. In the first decade of the century, it was the third largest in the United Provinces, with around 30,000 residents—much smaller than the population of Amsterdam, but only slightly less than that of Leiden (both of which were also in the province of Holland). It is thus not surprising that Haarlem played such an important role in the productivity that fueled the Dutch Golden Age.

Haarlem's economy, like Leiden's, was dominated by the textile industry, especially the finishing stages of production. The

broad fields extending southwest of the city were used for the bleaching of fabrics. They served not only local manufacturers, but also foreign firms. Bolts of linen—woven by the thousands of textile workers employed in Haarlem or on looms in London or Scotland and carried by boat across the English Channel— were first soaked in lye and then bathed for days in buttermilk supplied by surrounding dairies. They were then laid out in long stretches on the grasslands beyond the city's moat to dry and whiten in the sun from the late spring through the early fall.

The level and open landscape around Haarlem that was so conducive to bleaching linen also afforded a clear view of the city at great distances. The spires and rooftops seemed to rise right from the horizon and were easily seen by approaching travelers from far away. Towering over Haarlem and dominating its skyline was the massive Church of St. Bavo. This gothic structure, whose earliest parts were built in the tenth century, was named after Bavo of Ghent (Saint Baaf), who was also the patron saint of Haarlem.

St. Bavo was consecrated as a Catholic cathedral in 1559. But in 1578, when Haarlem rejoined the Dutch rebellion after the expulsion of occupying Spanish forces, the building was "cleansed" and converted to a Protestant church. Rising from the central square, St. Bavo dwarfed the five other Protestant churches scattered throughout the city, as well as the municipal hall on the other side of the square and the small Lutheran chapel on the far western edge of town. The spire was visible for miles across the perfectly flat countryside around Haarlem (color plate 2).

The Dutch Republic was a Calvinist republic. The Dutch Reformed Church dominated the religious, political, and social

lives of the nation's citizens, even though only a small minority of the population were actually formal members. And in this Calvinist republic there was little room for Catholics. The Union of Utrecht did promise freedom of conscience, and there were sizable Catholic minorities in some of the provinces. But for a long time after the beginning of the revolt from Spain, Catholicism was officially banned across the land. In Holland and other northern provinces, Catholic churches continued to be seized, stripped of their ornamentation, and converted into Reformed churches. Local authorities ousted priests from their posts and suppressed Catholic worship. There were even occasional outbreaks of popular violence against Catholics. In early 1579, Amersfoort, in the province of Utrecht, purged its town council of Catholics, a measure that was not sufficient to prevent anti-Catholic riots there in April and June.[1] With the United Provinces still in the early stages of war with Spain, the loyalty of Catholics was suspect; they were perceived to be an internal threat to the Republic, a potential fifth column of foreign agents working against political and confessional independence. Even in towns with substantial Catholic minorities—such as Utrecht and Haarlem—the local councils made it difficult for the Catholics to meet and celebrate the Roman mass.

As the war dragged on, however, and the military, political, and economic circumstances of the Republic grew more stable, the climate for Dutch Catholics improved. By the turn of the seventeenth century, their situation was, at least in some places, relatively tolerable. All the provinces of the Republic continued to protect the Reformed Church and to forbid Catholic worship, at least officially. A variety of edicts insured that public devotion was an exclusively Reformed affair. But any anti-Catholic legislation that may have existed at the national and provincial levels was not consistently enforced at the municipal level. Rather,

local history and tradition and long-standing social relations played a significant role in determining to what extent Catholic activities were allowed in a particular city or town.

In general, religious toleration in the Netherlands in the seventeenth century was—as to be expected in a polity where true power was exercised at the local, not the federal, level—a very patchwork, even messy affair. It evolved over the course of the century, as some provinces and municipalities became more accommodating toward Catholic worship (as well as toward Lutherans and, for different reasons, Jews), while others became more restrictive. At any given time, the provinces and, especially, the towns varied in the degree of toleration they granted their Catholic residents. What was allowed (if not formally permitted) in Holland or Utrecht might be impossible in Zeeland. If Catholics were able to worship with some liberty in Amsterdam and Haarlem, they faced serious repression in Edam and Enkhuizen.

Thus, it is inaccurate to speak in general terms of "Dutch tolerance" in the matter of religion, as if there were great freedoms across the land for all religious persuasions. Rather, there was what one scholar calls "an ambivalent semi-tolerance," although it sometimes and in some places was rather a situation "seething with tension."[2] In the Dutch Republic of the Golden Age, there was no active pursuit of religious diversity or even codification of religious toleration in law, and especially not toward Catholics.[3] No province or municipality in the seventeenth century ever explicitly proclaimed that henceforth Catholics would be allowed to worship openly and with impunity. What existed was a kind of acquiescence in the religious pluralism bequeathed to the Republic by the sixteenth century. The regents in some major cities faced the facts and recognized that substantial Catholic minorities were a reality of urban life, and that for the sake of political and social peace—as well as eco-

nomic expediency—they had to be given some latitude, even *de facto* (if not *de jure*) protection. Often, a town's leadership simply overlooked what was going on; many city councils found it easy to procrastinate in addressing complaints by intolerant Reformed ministers about the Catholics in their midst.

Passive toleration, of course, is not the same thing as equality. Discrimination against Catholics continued throughout the seventeenth century. In most places where organized Catholic activities were permitted, they were restricted to *schuilkerken*, or "hidden churches," usually in the attic or back room of a private home. But the Catholic rites that were performed in these domains were hardly a secret; the members of the town councils were well aware of what was going on behind closed doors. Throughout the Dutch Republic, and especially in major urban centers, Catholicism was, if not an officially authorized religion, at least, in many places, condoned by the local authorities. It was, in part, a concession to reality, as there were probably too many Catholics to make serious repression a live option. As long as they did not make too much of a public display, and especially if they avoided even the appearance of trying to convert Protestants—which would bring serious repercussions— Catholics, as well as members of other faiths, were generally left alone. Isaac Uziel, a rabbi of the Amsterdam Portuguese-Jewish community and writing in 1638 about that city, best sums up the confessional situation in the Republic at large in the early decades of the century: "Everyone here may live according to his faith, although he may not broadcast the fact that he is of a different faith from other citizens."[4]

———

Of all the towns in the Republic, Haarlem was among those with the highest percentage of Catholics. This was due, in part, to families from the Spanish southern Netherlands who had

migrated to the city in the late sixteenth century, moving as the United Provinces gained the upper hand in the war and the fortunes of the Flemish textile industry seemed to be on the decline. While most of the southern immigrants to Holland were Protestants, those who were Catholic tended to go to Haarlem. This may have been because the Reformation came relatively late to Haarlem. Only in 1577 was there any significant Reformed activity in this Catholic city, and it was confined mostly to services held in small wooden sheds. Consequently, Haarlem was spared much of the early iconoclastic rioting that, with the progress of Calvinism throughout the northern provinces in the 1560s, ravaged other Dutch Catholic communities (although one outbreak of anti-Catholic violence in Haarlem did lead to the destruction of the statues and ornamentation in St. Bavo). Even after the Reformed Church was declared the official church in Holland and Zeeland by the Pacification of Ghent in 1576, the situation in Haarlem continued to be a relatively liberal one. The so-called Religious Peace (*Religievrede*) proposed by the Prince of Orange to the States General in 1577 was intended to insure that both Catholics and Protestants were free to worship publicly throughout his provinces, Holland, Zeeland, and West Friesland. Haarlem in particular benefited from this experiment in religious toleration.[5]

The equilibrium in Haarlem did not last long, however. In early 1578 St. Bavo was plundered and then closed to Catholic services; several months later it was converted into a Reformed church. In 1581, as Calvinists gained the upper hand in the city's administration, a series of edicts stripped Catholics of numerous prerogatives: not only the right of public worship, but even the right to congregate publicly for *any* common purpose. In Haarlem there were to be no open Catholic masses celebrated, no Catholic weddings, and no students educated in Catholic schools. Anyone who violated these restrictions was

subject to fines, and priests caught administering Catholic rites were banished from the city. Private Catholic services were not, in principle, forbidden; and in practice the authorities, as elsewhere, often looked the other way even on public events. But Haarlem was now, like other Dutch cities, officially a Reformed domain. The town's Catholics were merely a tolerated rather than a protected group.[6]

By 1600, as things calmed down, the anti-Catholic edicts were observed mostly in the breach. There seemed to be little interest among the Haarlem authorities in enforcing them. While public worship was still officially banned, Catholics were able to acquire buildings in which to hold their services. The city's restrictive laws, in fact, seem to have had little effect on the size and activity of Haarlem's Catholic population. There was nowhere else for them to go—economic realities made emigration to the Spanish Netherlands out of the question, and other Dutch cities would have been less accommodating—and they certainly were not about to convert to Protestantism (nor were they required to do so). Thus, despite the legal obstacles on the books, Haarlem continued to be a religiously diverse—if not always religiously peaceful—city.

In the early 1620s, there were around twenty Catholic priests in Haarlem, "secretly" serving an estimated Catholic population of five thousand. Since Haarlem's total population at this time was near forty thousand, this means that close to thirteen percent of the city was Catholic (while only twenty percent of the citizens were full members of the Dutch Reformed Church). By comparison, Utrecht—whose total population was twenty-five thousand and which was by all accounts the most Catholic city in the Netherlands in the period, its bishop serving as the apostolic vicar for all Roman Catholics in the Republic—was almost twenty percent Catholic (although this did not keep the Utrecht city council from ruling in 1605 that "no Catholics will

be admitted to this town's citizenship, unless the council, for serious reasons, will unanimously decide to grant dispensation"[7]). Amsterdam, on the other hand, with a total population of over one hundred thousand, was less than ten percent Catholic.[8] And however cosmopolitan a city Amsterdam may have been, its Catholics were not as well off as those in Haarlem. According to an archbishop's report from 1617, "the Catholics of Amsterdam do not enjoy so much freedom [as those in Haarlem]."[9]

———

Among those twenty priests serving Haarlem's Catholics was Augustijn Alsten Bloemaert. Bloemaert was a native son, born in Haarlem in 1585, one of seven children raised by the merchant Thomas Bloemaert and his wife Christina van Geest. Thomas was a successful businessman, and the well-off family was prominent among the city's Catholic clans.[10] After an education in grammar and humanities in Utrecht and the Latin school in Haarlem and philosophical studies in Douai, a center of Counter-Reformation activity in the southern Low Countries, the young Bloemaert entered the Jesuit order in 1604. He was ordained a priest seven years later in Antwerp, and did some teaching in the Jesuit college in Kortrijk, a town in Flanders. By 1616 he was back in the northern Netherlands, serving as the director of a Jesuit mission in the border town of Nijmegen. This mission was housed on the Brouwerstraat, and on at least one occasion it was raided by the sheriff, who had decided that it was a good time to harass the local Catholic enclave.

Throughout his career, Bloemaert showed himself to be an energetic and conscientious clergyman, attentive to his pastoral duties and beloved by many of those in his care. He was an intellectually gifted young man, and had a taste especially for theology and philosophy. In the eyes of his ecclesiastic superiors, however, he was "of difficult character," an "obstinate and

rebellious" personality.[11] The course of his career as a priest appears to confirm this assessment.[12]

In 1618 there was a rupture within Nijmegen's Catholic community. Bloemaert's obstinacy and pride, as much as any substantive theological or practical problems, seem to have been major contributing factors in the rift. The apostolic vicar had decided that given Bloemaert's hard work, especially during a severe epidemic, and the increasing size of his flock, he needed someone to help him out. They therefore assigned another priest, Engebert d'Hollander, to the Nijmegen community. Bloemaert took offense at this, as did some of his parishioners. Moreover, he and d'Hollander reportedly had a serious difference of opinion on some matter, although what exactly was at issue remains a mystery.[13] Within a year, with the division unhealed and Bloemaert still at odds with his fellow priest and brooding over any slight he may have felt, he was transferred to Haarlem. He began holding services there in a *schuilkerk* near the Spaarne. Bloemaert continued to stay in touch with his former congregants in Nijmegen. They still had great affection for the priest, and the more devoted came regularly to Haarlem to receive the sacraments from him. He traveled often between Haarlem and Nijmegen, despite being explicitly forbidden to do so, and apparently encouraged his loyal followers in Nijmegen to stay away from d'Hollander's services.[14]

Unhappy in Haarlem, Bloemaert requested a return to his post in Nijmegen. When the local Jesuit authorities denied his request, he wrote to the Society's superior general in Rome asking to be excused from the Order. His request was granted, but only on the proviso that he enter a more austere religious order. Bloemaert did not accept this condition and, reluctantly, remained with the Jesuits. In 1621 he successfully sought a transfer to Maastricht, despite the fact that there were many Catholics in Haarlem who thought highly of his pastoral skills and

wanted him to stay. Bloemaert was reportedly a very talented preacher and his sermons were quite popular.[15] His fellow clergy in the Haarlem chapter had fine things to say about his character and abilities in a letter of recommendation they wrote on his behalf:

> We the undersigned declare, at the request of Father Augustinus Alstenius Bloemaert, in so far as we have been witness to his conduct, the following: the aforenamed Father has, in so far as we have been able to see and hear him, lived an exemplary life in Haarlem; he has labored hard, and worked peaceably with others. In all ways he has shown himself a servant of God, an indefatigable worker, and a preacher of God's pure word; and all of this in such a way that even those who do not agree with him must have nothing evil to say about him. He has labored to our, and everyone's, satisfaction, and his departure is mourned.[16]

A restless man of independent mind, and still in search of a satisfactory situation, it was not long before Bloemaert decided that Maastricht was not the place for him either. With a return to Nijmegen still out of the question, Bloemaert recused himself from his regular duties in Maastricht and sought asylum in a nearby cloister run by Dominicans. This, of course, did not make his Jesuit superiors very happy. They were even more upset when, in addition to refusing their demand that he resume his responsibilities, he began composing pamphlets attacking the Society of Jesus and its regulations.

Bloemaert, now under threat of excommunication, went to Rome to make a plea in person to be released officially from the Society of Jesuits. Much to his surprise, his wish was granted. He then made his way back to Haarlem, in 1631, where he was allowed to serve as a secular priest, unattached to any order, and to function as a canon in the local chapter. In 1636—the

year that Descartes gave up on urban life altogether and started looking for a place in the country—Bloemaert acquired a former brewery on the Koksteeg and established on its upper floor a *schuilkerk* dedicated to Saint Anne. He also founded a generous charitable fellowship, later called the *Broodkantoor* (or "Bread Office"), which distributed food, fuel, and money to poor Catholic women. Still a contentious soul, Bloemaert continued his anti-Jesuit activities while catering to the spiritual needs of Haarlem's Catholics and the material needs of its poor until his death in 1659. He was buried in the St. Bavo Church.

Though passionately devoted to his pastoral work—and he was no exception in this regard; Haarlem was generally well served by its Catholic clergy—Father Bloemaert was able throughout most of his life also to pursue his interests in more mundane intellectual and cultural matters. He had quite a few acquaintances outside the clerical world, some in very high places.

Among Bloemaert's close friends was the writer Joost van Vondel (1587–1679), perhaps the most prominent Dutch literary figure in the seventeenth century and—most surprisingly—someone who at the age of fifty-three converted to Catholicism. Vondel was one of the fiercest advocates for religious toleration in the Republic. During the Remonstrant–Counter-Remonstrant turmoil after the Synod of Dordrecht in 1618, he fought vigorously against the intolerant campaign of the orthodox Calvinists and condemned their "treasonous" persecution of Oldenbarneveldt. In several poems (one titled "Oldenbarneveldt's Stick") and his play *Palamedes, or Murdered Innocence* (in which he draws a comparison between the treatment of Holland's grand pensionary and the ancient Greek warrior at Troy who was falsely accused of being a traitor and executed), Vondel blames especially the stadholder Prince Maurits for leading what he sees as the true betrayal of the United Provinces.

This famous playwright, many of whose dramas had a biblical theme—and who not inappropriately might be called the Dutch Shakespeare; some of his plays continue to be performed in the Netherlands—composed a number of poems for his friend Bloemaert. One of these was an epitaph for the priest's gravestone, praising the man "who spread the fragrance of piety everywhere, through his garden on the Spaarn."[17]Another poem appears as the legend under an engraved portrait of Bloemaert by Jonas Suyderhoef, done after a painting by Johannes Cornelisz Verspronck:

> The Dutch Augustine regarded this wicked
> world with aversion and an unclouded eye,
> which he sowed with flowers of pious divinity
> along the Spaarne, where his footprints stand
> and show along which way one must approach God.
> This print depicts for you only the shadow of the man.
> Art could not touch the essence of elevated virtue.
> Bloemaert's soul now still shines forth with beautiful splendor.[18]

In Verspronck's portrait that inspired Vondel's tender sentiments over his recently deceased friend—a painting that at one point hung in the foyer of the Broodkantoor—Bloemaert, with his sharp facial features, appears at a writing desk among books and a small crucifix. He holds a quill pen in one hand and a piece of paper in the other, apparently ready to compose an uplifting sermon or take action against yet another Jesuit abomination (color plate 3).

Another literary friend of Bloemaert's was Pieter Coreliszoon Hooft (1581–1647), a scion of an Amsterdam regent family (his father was a *burgemeester*, or mayor, of Amsterdam in the 1580s). While Hooft was also a prominent poet and playwright, he devoted a good deal of his time to writing a history of the Netherlands, hoping to do for the Dutch Republic what

Tacitus had done for Rome. He was a founder of what would later come to be called the *Muiderkring* ("Muiden Circle"), an informal group of intellectuals that met from time to time in the castle of Muiden outside Amsterdam to discuss literature, philosophy, politics, science, and the arts. Vondel was one of its regular participants, as was Dirck Janszoon Sweelinck, son of the famous composer Jan Pieterszoon Sweelinck and his father's successor as organist in Amsterdam's Oude Kerk; Bloemaert himself was not so much a member of the Muiderkring as a fellow traveler, only occasionally attending its meetings.[19]

Closer to home, Bloemaert developed close working and personal relationships with a number of fellow priests who not only shared the duties in Haarlem and the surrounding area— the diocese had considerable independence from the apostolic vicar in Utrecht—but also had sympathetic intellectual interests.

Johan de Kater was born in Antwerp in 1590, although his family was originally from the north (Haarlem, according to records) and probably fled to the southern provinces during the "iconoclastic fury" of the 1560s.[20] He studied theology at Louvain throughout the 1620s and remained there—except for a brief spell in early 1629, when he was in Amsterdam registered as a secular priest—until he completed his degree in 1632. Soon thereafter, De Kater moved to Holland and became a member of the Haarlem chapter. In 1638 he was appointed the archpriest in Alkmaar, a town just north of Haarlem and within its diocese. Alkmaar's Catholics, the overwhelming majority of its seven thousand inhabitants, were served by at least five priests, although officially, public worship by Catholics was forbidden. De Kater's own responsibilities were centered on the "secret" church of St. Laurentius, a chapel in the back of a town house on the Diggerlaarssteeg.[21]

Little is known about De Kater's activities as priest, although there is a record of him being charged by the authorities with having administered the last rites to a Reformed citizen, a very

serious infraction that could potentially have endangered his whole community. While he and Bloemaert must have conferred occasionally about local church matters, in 1640 they also collaborated on a project of a philosophical nature, to which we shall return.

Like Bloemaert, Johan Albert Ban was a Catholic priest in Haarlem. He, too, was connected with the literary world of the Muiderkring—Vondel composed verses in his honor as well—although he made his impact on that company mostly through his talents as a composer, musician, and music theorist.

Ban was born in Haarlem in 1597 to one of the town's most prominent brewer families.[22] He quickly worked his way to the top of Haarlem's clerical hierarchy, from chaplain to apostolic notary to canon to apostolic vicar. In 1630, he was chosen to be the rector of Haarlem's *Begijnhof*, a society of religious laywomen. Soon afterward, in honor of his service to Haarlem's Catholic citizens, Ban was named the diocese's dean. In this capacity he represented Haarlem when, in 1635, the Catholics of Haarlem and Ghent set up a joint commission to reconcile any differences in their veneration of their common patron saint, Bavo.

Ban's most significant (if not lasting) accomplishments, however, were in the world of music. He was learned in the classics, and applied this to his study of musical theory and composition. He wrote a number of treatises, including the *Dissertation on the Nature, Origin, and Progress of Music*, published in 1637.[23] He was interested in providing scientific foundations for both music theory and performance, with the goal of examining how the playing of and listening to music—even profane pieces—might be a "spiritually moving" experience, with each emotion corresponding to a particular musical interval.[24] In his own compositions, Ban often set to music verses by others, including his Muiderkring colleagues Vondel and Hooft. While he was

said to have been a fine musician, especially on the virginal, many of his contemporaries were not impressed by his compositions; Descartes's Parisian friend Father Mersenne, for one, found them "very trivial."[25]

Bloemaert and Ban became quite good friends soon after Bloemaert settled in Haarlem. Professional colleagues and kindred spirits, they seem to have worked closely on pastoral matters, almost to the point of coordinating their career moves. In 1641, they together requested permission to cease their duties as canons, which was granted the following year. And in 1644, when Ban died, Bloemaert took over as the director of the Begijnhof.

The two men also had many acquaintances in common. These included De Kater, with whom Ban, as dean of the diocese, probably had to work closely on a regular basis. All three clerics were involved, in varying degrees, on that special philosophical project of 1640.

Of potentially greater consequence for Bloemaert and Ban was their acquaintance with Constantijn Huygens (1596–1687), the father of the scientist Christiaan Huygens and one of the great figures of the period in his own right. They would certainly have crossed paths with this well-born and well-placed gentleman from time to time in Muiderkring gatherings in the early 1640s. Ban, at least, was already corresponding with Huygens by 1636, mainly on musical topics, while Bloemaert may have first gained an introduction to him two years later, through a mutual friend, when he and Ban sought Huygens's intercession after the Haarlem municipal government published a decree "against the shamelessness of the Papists and their excesses."[26]

This would have been an extremely important political relationship for these Catholic priests. Like Vondel and Hooft, Huygens was a writer and poet (he translated John Donne's poems into Dutch). He was also a composer and musician, with some

skill at playing the lute. But the official duties imposed by his public career, from 1630 onward, probably left him little time for such leisurely pursuits. Huygens was the secretary and diplomat for two of the princes of Orange who successively served as stadholder in Holland, Frederik Hendrik (1584–1647), the half-brother of Maurits, and his son Willem II (1626–1650). He was thus one of the most influential men in the Dutch Republic.

Huygens was not himself a Catholic, but a very orthodox Calvinist. In fact, he was so distressed when a friend and fellow participant of the Muiderkring, the talented and inspiring Maria Tesselschade, converted to Catholicism that he wrote a poem bemoaning the event:

> My tongue was never hired, nor my pen e'er sold
> My hands were never snared by gold or jewels,
> My freedom ne'er enslaved, so that I handled
> The truth with velvet gloves, against belief.
> Yes, tongue, pen, hand and freedom all have served
> The princely order that our freedom sowed,
> 'Gainst Spanish force its counter force opposing,
> And Babel's filthy creatures (I'll speak plain).
> But worldly power strikes never to the root
> Of holy knowledge; 'tis no contentious use
> To fear eternal God, and a prudent Prince
> Who can and does suffer what truth my yield.
> So I ask justice of you, and no grace,
> Famous but, alas, Papist Tesselscha.[27]

Despite his feelings about Maria's change of faith, there is no reason to think that Huygens was hostile to Catholics per se. He may have deeply regretted seeing a Reformed person convert to Catholicism, especially a friend; and he was, like most of his Calvinist contemporaries, contemptuous of the Catholic

Church and endowed with a general prejudice against the superstitions and credulity of its followers. But Huygens was a highly educated, cultivated, and tolerant man who counted a number of Catholics among his close friends. As someone with access to the stadholder, and a good deal of authority of his own, he would have been seen as a useful intermediary for his Haarlem acquaintances Bloemaert and Ban, if they or the Catholic community they served needed his help.

———

Augustijn Bloemaert, then, was no isolated village priest with a provincial mindset. He belonged to a vibrant intellectual and artistic circle, one that stretched beyond the confines of Haarlem and gave him entrée to a cultural milieu that enriched a clerical career serving local Catholics. That he was welcomed into this milieu reveals that Bloemaert himself, while certainly not a man of great and lasting accomplishment outside of his work as a priest, was well regarded by some of his more illustrious contemporaries. Not just anyone managed to mingle with the likes of Huygens, Vondel, and Hooft.

Meanwhile, Bloemaert and Ban had their own little cultural circle in Haarlem, away from the luminaries in the Muiden castle whose literary and musical talents would have overshadowed their own. They met frequently, and often would sit around Bloemaert's quarters and discuss art as they looked upon his impressive collection of Dutch paintings.

Bloemaert owned fifty-eight paintings, many by well-known figures—including the Haarlem artists Hendrick Goltzius, Pieter Molijn, Salomon de Bray, Pieter Soutman, and Cornelis Cornelisz (also known as Cornelis van Haarlem). Hanging on his walls were landscapes, still lifes, religious paintings (including several images from the life of Christ and a picture of Jesus and the Virgin Mary), and a number of portraits and *tronyen* (genre

portraits; literally, "faces"), among which were two *tronyen* by Jan Lievens.²⁸

And then there were intimate musical evenings in Ban's rooms (because that is where the keyboard was), during which the two men would while away the hours of a long Dutch winter as Ban played for his friend a well-known piece (perhaps by Sweelinck) or a new composition of his own.

At some point, these *soirées à deux* expanded by one, as Bloemaert and Ban welcomed another person to their regular gatherings. Their new acquaintance, of growing philosophical renown but seeking a quiet venue in which to pursue his research, shared their interest in music. Just as important, he, too, was a Catholic.

CHAPTER 4

The Painter

Among the thousands of people employed in the textile industry in the city of Antwerp, in the province of Brabant in the Spanish Netherlands, was one Franchois Hals. He worked as a *droogscheerder*, or cloth cutter, and apparently made a fair living from it. Originally from the town of Mechelen, where his father was a wool dyer, Franchois and his brother Carel had moved to Antwerp in 1562. His first wife, Elisabeth Baten, died in 1581. Within the year, needing someone to care for his four children, he married his neighbor Adriaentgen van Geertenrijck, the widow of a tailor.[1] When the province's Spanish governors took a census of the civic guards in 1585 in order to root out Protestants (who, they feared, might be less than enthusiastic in helping them defend the city from the Dutch rebels), Franchois, who was serving in one of those military companies, was listed as a Catholic.[2]

Franchois and Adriaentgen had two sons in Antwerp. Their firstborn, Frans, was baptized in 1582 or 1583, and his younger brother Joost was baptized in 1584 or 1585;[3] both became painters. A third son, Dirck, was born in Haarlem, in 1591; he, too, went on to a career in art. Sometime between 1585 and 1591, then, the Hals family left Antwerp to settle in Holland. They really had no choice in the matter.

Antwerp was one of the early casualties of the Dutch war for independence. Over the long course of the conflict, this flourishing port lost not only its wealth and luster, but also a good part of its population. Once the crown jewel of northern Europe, Antwerp was brought down as much by its Dutch "friends" as by its Spanish "defenders."

Throughout the fifteenth and sixteenth centuries, this inland city on the Scheldt River was an economic engine for the dukes of Burgundy and, later, the Holy Roman emperor and the Spanish king. By the 1530s, Antwerp had eclipsed Venice as Europe's mercantile hub and the headquarters of major trading houses. Goods from the Continent and beyond—especially the so-called "rich trades"—came over its wharves. Portuguese and Spanish ships brought fruit, sugar, silver, and spices from colonies in the East Indies and the New World, while English merchants arrived with textiles and traders from the German lands trafficked in wine, grains, and metals. The city was home to a savvy native class of bankers and residence for an even larger number of foreign businessmen. This rapidly growing Brabant town was, by the mid-sixteenth century, "the center of the entire international economy,"[4] and possibly the richest city in Europe.

It was also, up to the middle of the sixteenth century, a relatively tolerant place, at least by early modern standards, although not all contemporaries regarded this as one of the city's virtues. The Duke of Alba, a particularly hostile commentator, described Antwerp as "a Babylon, confusion and receptacle of all sects indifferently and as the town most frequented by pernicious people."[5] Its population included a usually peaceful mix of Catholics and Protestants (especially Calvinists and Anabaptists, but also some Lutherans). Also within the city's fortified walls were Muslim traders and "conversos"—Jews who had

undergone forced conversions in Spain and Portugal but then emigrated northward and away from the epicenter of the Spanish and Portuguese Inquisitions, perhaps to continue practicing Judaism secretly in their homes (neither Muslims nor Jews were allowed to worship in the Spanish Netherlands). With their long-established trading networks reaching across several global empires, these resident groups not only created in Antwerp an extremely cosmopolitan environment, but also made an enormous contribution to the wealth of the city, the Low Countries, and, ultimately, the Spanish crown.

All of this peace and prosperity came to an end with the revolt of the Netherlands against Philip II. Antwerp, along with other towns in Brabant and Flanders, threw its lot in with the rebellion. At one point, the city was even headquarters to the southern branch of the Revolt, as William the Silent and other Dutch military leaders set up their command there. It was not long, however, before Spanish forces under the Duke of Parma overran rebel defenses in the southern provinces. During the winter of 1584–85, Parma laid siege to Antwerp, isolating its then eighty thousand inhabitants. When an attempt by the northern armies of Holland and Zeeland to free the city failed, its demoralized citizens capitulated.[6]

Once he had recaptured Antwerp, Parma instituted a confessional cleansing among Christians, albeit a comparatively gentle one. Protestants who wanted to stay were required to convert to Catholicism. Those who refused were forced to sell their possessions and leave the city, although they were given four years to do so. As a result of this measure, Antwerp's population was soon reduced by half. A good number of the refugees headed north, to Holland and other provinces belonging to the Union of Utrecht, while many fled to other European trade centers, such as Hamburg and Bremen.

This exodus was, in fact, the culmination of growing religious tensions in the city. The relationship between Antwerp's Protestants and Catholics had been seriously frayed since the violent iconoclasm of 1566, when Calvinists, emboldened by early local opposition to Philip's repressive religious policies, rampaged through Catholic churches and stripped them of images and other forms of "idolatry." This was followed, predictably, by a brutal anti-Protestant backlash led by Spanish forces under the Duke of Alba. The upshot, foreshadowing the later emigration, was the departure of large numbers of Calvinists to the northern provinces (as well as to England and Germany). Further population losses over the next twenty years, of both Protestants and Catholics, and especially under Parma's governorship and the city's diminishing trade, had dire long-term consequences for Antwerp's social and economic life.

The final stage in Antwerp's decline—and its own rapid eclipse by Amsterdam—was brought about by the northern Dutch armies themselves. Early in the Revolt, William and his "Sea Beggars," as the rebels were popularly known, secured the towns of Brill and Flushing at the mouth of the Scheldt. This gave them control over an important part of the coast, as well as over traffic on the river between the sea and Antwerp. As the war progressed, this was a crucial advantage for the Dutch, who were able to sever one of the military and economic lifelines of the Spanish forces. The Spanish may have recaptured Antwerp, but the Dutch navy still owned the waters off Brabant and Flanders. When Antwerp fell to Parma, the Dutch blockaded the Scheldt, thereby cutting access to international trade and effectively strangling the city. As one historian describes what the situation was like over the next several years, "the town which Parma, thanks to his indomitable spirit, his military genius, and his knowledge of human nature, had succeeded in conquering, now withered, as it were, beneath his hand."[7]

The Golden Age of Antwerp was over. The city was overrun by the Spanish army (aided by brutal German mercenaries), its main commercial artery was choked off, its trade was crippled, and its population seriously reduced by religious and economic emigration. As merchants saw that it was best to take their business elsewhere, Antwerp faced a bleak future.

——————

If the Hals family was Catholic, then Haarlem—because it was more accommodating to Catholics than most other Dutch cities—was a natural destination for them, as it was for other non-Protestant Flemish emigrés. Prompted primarily by economic realities, they were seeking a congenial place to relocate their families and to reestablish themselves in their professions. With Antwerp's decline, its all-important textile industry moved north, to the bleaching fields of Haarlem. Franchois Hals— like others who earned their living in the trade—decided to go where the work was.

On the other hand, perhaps Franchois and his clan were Protestant. It may be that Franchois, to keep his position in the civic guard (and his livelihood in Antwerp) for the time being and to avoid the demands of Parma's confessional edict until he could get his affairs in order, lied about being a Catholic— after all, his son Dirck was baptized just a few years later as a Protestant.[8] In this case, their departure would also have been motivated by religious considerations; in all likelihood they left, as so many Protestants did, soon after the city fell to the Spanish army.

Haarlem absorbed the influx from the south particularly well. Despite the expected tensions between natives and newcomers— including disputes among artists in the competition for commissions—the city's economy benefited greatly from the displacements caused by the war. It was hard to escape completely one's

origins, however, and Franchois's son was, as an adult, still referred to (and on occasion referred to himself) as "Frans Hals van Antwerpen."[9]

———

The Haarlem in which Franchois's eldest son Frans grew up and lived as a young man, at the turn of the seventeenth century and during the following few decades, was still experiencing the rapid growth that had begun with the early years of the Revolt. Its population increased from fourteen thousand in 1570 to almost forty thousand by 1620. The ranks of its denizens were swelled not only by newcomers who were fleeing to Holland from Spanish dominion in the southern Low Countries—according to one estimate, by 1622 fifty-one percent of Haarlem's population were either first- or second-generation Flemish immigrants[10]— but also by Catholics from other northern provinces whose towns were less willing than those in Holland to let them go about their business.

Catering to the thirst of these Haarlemers were nearly one hundred breweries. That amounts to one brewery for every four hundred people. There was the "Vergulde Hart" ("The Gilded Heart"), run by Cornelis Guldewagen; the "Drie Starren" ("Three Stars"), which belonged to Abraham Loreyn; Dirc Dicx's "Scheepgen" ("The Small Ship"); Jacob Pietersz Olycan's "Hoeffeyser" ("The Horseshoe"); and the "Gecroonde Ruyte" ("The Crowned Diamond"), owned by Johan Herculesz Schatter. Beer had long been Haarlem's main industry and a source of great wealth and influence for many of its leading citizens; it was also an important beverage for those who lived in Dutch cities, where the water was virtually poisonous. The brewers, along with prosperous professionals and some merchant families, had constituted the city's elite class for decades. The older, more established brewery clans tended to be Catholic, however, and so

were barred from holding public office. Their social leadership and political influence in the late sixteenth and early seventeenth centuries were thus a matter of respect and tradition rather than formal authority. It was only after the Remonstrant turmoil of 1618 that a younger cohort of brewers of Calvinist background was able slowly to gain control of the city council, at one point occupying twenty-one of the council's twenty-four seats.[11]

Many of Haarlem's Flemish textile magnates had to settle for more subtle ways of participating in municipal politics. The initial wave of immigrants, because they were foreigners, were, like the Catholics, excluded from public service. And although subsequent generations assimilated by marriage into Haarlem's regent clans, many of them were Mennonites and so were barred from government office as well.[12] As Haarlem's flourishing came to depend more and more on the expanding market for cloth, linen, and silk, however, the growing wealth of these manufacturers and merchants allowed them to exercise significant influence over the city's affairs. It also gave them, like the brewers, the means to commission great works of art.

———

Frans Hals is said to have begun his artistic career in the studio of Karel van Mander, another Flemish immigrant to the Dutch Republic.[13] Van Mander, who was living in Haarlem by 1583, was a painter in the mannerist tradition, but also a Dutch Vasari. He is best known not for any great works of art but for his *Schilderboek* (*Painter Book*), a survey of the lives and careers of hundreds of historical and contemporary painters supplemented by a treatise on the art of painting. Van Mander, along with the painter Cornelis Cornelisz and the great graphic artist Hendrick Goltzius, ran a kind of art academy in Haarlem. While this school did not have the organization or status of more formal art academies established elsewhere in Europe (such as the

Accademia di Belle Arti in Florence, founded by the Medicis in the mid-sixteenth century, or, later, Paris's Académie de Peinture et Sculpture), it attracted a number of talented students, "some of whom," according to Van Mander's early biographer, "became good masters."[14] The young Hals would have worked under Van Mander sometime before 1603, the year in which the older artist left Haarlem (Van Mander died in Amsterdam in 1606). Hals entered the professional stage of his own career in 1610, when he joined Haarlem's Guild of St. Luke.

The Haarlem painter's guild, chartered in 1514, was one of the oldest in the Netherlands. Like Guilds of St. Luke generally—named for the evangelist, who, according to legend, painted the portrait of the Virgin Mary—the Haarlem guild governed artists and artisans working in decorative occupations in a variety of media. Among those classified as "artists" in the guild were both painters and craftsmen. The painters were primarily fine art painters, while the craftsmen included etchers, glass cutters (but not glass makers), sculptors, and metalworkers. Other artisans usually governed by a city's Guild of St. Luke were printers, potters, engravers, bookbinders, goldsmiths, silversmiths, embroiderers, and weavers.

The guild was charged with managing both production and sales in the industries under its aegis. In the case of painting, these included the materials and methods of artists and the dealing of their works (whether by commission, private sale, or auction). The guild was also responsible for regulating professional relationships. It oversaw the hierarchy of the local artistic community—masters (who alone were authorized to train other painters), journeymen (trained artists who, while no longer apprentices, had not yet set up a master shop of their own), and apprentices (young artists learning the trade in masters' workshops)—and set the rules for the training of apprentices. It also adjudicated any disputes between its members. No artist in Haarlem was

allowed to take on an apprentice or even to sell his paintings unless he was a member of the city's Guild of St. Luke.

The Haarlem guild, which served as a model for painters' guilds in other Dutch cities, had a fine history. Among its early masters was Martin van Heemskerck, an important painter of portraits and religious works in the early sixteenth century. In the first half of the seventeenth century, its ranks—increased dramatically by the influx of Flemish painters at the end of the sixteenth century—were particularly well endowed artistically. The membership roll included the great landscape artists Hercules Seghers, Jan van Goyen, Esais van de Velde, and Salomon van Ruisdael; the architect Jacob van Campen; Pieter Saenredam, a master of architectural interior paintings (also called "perspectives"); the brothers Adriaen and Isaak van Ostade, famous for their raucous interiors and tavern scenes; and the genre painters Judith Leyster and Willem Buytewech.[15]

In his *Schilderboek*, Van Mander makes sure to highlight Haarlem's rich artistic tradition and reserves special praise for the artists of his hometown, "where there had always been great painters." He notes, in his entry on Jan Mostaert, that "in Holland the ancient and important city of Haarlem has brought forth many good spirits in our art."[16] He is even more effusive in his entry on Dirck van Haerlem:

> It has long been rumored that of old, even in very early days, very good or even the best painters of the entire Netherlands lived in Haarlem, in Holland, which cannot be denied or shown to be a lie but can rather and more easily be proved true.[17]

The city is renowned, he says, "for the best and earliest manner of landscape painting,"[18] and especially for the skill with which its artists worked in oils. Among the living Dutch painters he profiles, Van Mander names three who were his students.

However, he does not include Frans Hals, no doubt because at this point Hals was not yet someone worth mentioning among the "illustrious" and "renowned" artists in whom Van Mander is interested.

While Van Mander's local favoritism is evident, his praise of Haarlem would have been seconded by many of his contemporaries. The city's reputation as a center of fine painting and graphic works on paper went back to the late fifteenth century and the luminous religious paintings of Geertgen tot Sint Jans.[19] From the sixteenth-century prints of Goltzius and Jan van de Velde, with their mannerist depictions of improbable musculature and elongated features, to the luscious seventeenth-century landscapes of Van Goyen, Haarlem outshone practically all northern Netherlands cities in the quality of its artistic output in the final period of Spanish rule and the early decades of the Dutch Revolt.

In the years during which Hals was supposedly training under Van Mander and Goltzius and then beginning his own career as a master, and until the early 1620s—when the end of the truce with Spain brought substantial changes not only to the Dutch economy but to aesthetic tastes as well, thereby allowing Amsterdam, Leiden, and (to a lesser degree) Delft to play a more significant role in Holland's art world[20]—Haarlem was unsurpassed in its level of artistic innovation. The originality of its solo and group portraits, including portraits of local regent boards and militia guards and so-called "merry company" pieces; the realistic depiction of landscape, still life, and domestic interiors; and the dramatic representation of mythological scenes (or "history" painting)—in short, a high degree of excellence in so many of the subjects and techniques that strike modern viewers as the hallmarks of Golden Age Dutch art— all contributed to Haarlem's dominance in the art market. Its

only real competition at this stage was Utrecht, with its cohort of Italianate painters who worked in the *chiaroscuro* style of Caravaggio. And what a market it was. The Dutch were voracious buyers of paintings. Large and small pictures were acquired by citizens at all levels of society—from the wealthiest *burghers* to peasant families—and hung in homes, meeting halls, public buildings, even taverns and brothels. With the average price of a portrait at six guilders (the cheapest kind of picture for most of the century), it was well within the financial reach of most families.[21] They purchased their commemorative or decorative works through commission, private sale, auction, even lottery and barter. The contribution from Haarlem to the sea of images circulating in Holland was impressive. From 1600 to 1640, over 1.5 million new paintings came on the market in that province;[22] of these, over 200,000 originated in Haarlem. Buyers in Amsterdam, in particular, seem to have had a taste for paintings from Haarlem.[23]

Hals's earliest works as a master, from around 1610, already show his proclivity for portraiture and his prodigious skills and creativity in this genre. Soon after joining the guild, Hals painted a pair of anonymous portraits. In one, an older man in dark clothes and white ruff collar is shown in three-quarter length and holding a skull, a classic allusion to human mortality. In its companion piece, a woman (presumably his wife) in fashionable attire holds the end of a gold chain that hangs around her waist as a belt. Her light grasp of this valuable accoutrement likewise suggests the transience of the goods of this world. These well-dressed subjects are from the upper strata of Haarlem society, and the paintings, hung in their home, would

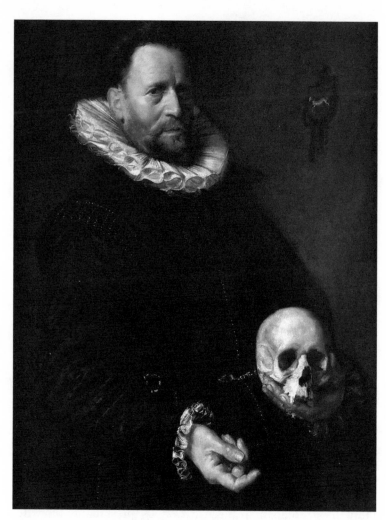

FIGURE 5. Frans Hals, *Portrait of a Man Holding a Skull*, ca. 1610–14 (The Barber Institute of Fine Arts, University of Birmingham)

have served to remind them (and others) of the ephemeral nature of their accomplishments and acquisitions.

At around the same time, Hals painted a bust-size portrait of the Catholic clergyman Jacobus Zaffius. An archdeacon in

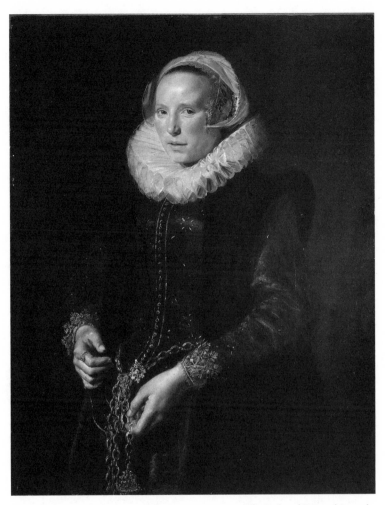

FIGURE 6. Frans Hals, *Portrait of a Woman*, ca. 1611 (The Duke of Devonshire and the Chatsworth House Trust)

the Haarlem diocese when he sat for Hals, Zaffius had been serving as the provost of St. Bavo when, in 1578, the cathedral was overrun by iconoclasts and transformed into a Reformed church. This is the earliest known dated painting by Hals. A

1630 print, by Jan van de Velde II, of another (but now lost) Hals portrait of Zaffius, this one three-quarter length, shows the provost posing with a skull.²⁴ The *vanitas* theme—represented in paintings by bones, urns, broken ceramics, timepieces, delicate flora, and scattered precious items—is a recurring element in Hals's art. It appears in his solo portraits, family and group studies, and genre pieces over the next several decades.

More striking than the *memento mori* message in these portraits, however, is Hals's ability to capture, in an apparently fleeting moment but with some intimacy, the individuality of the person being portrayed. These are not stiff, formal portraits. His subjects are rather relaxed in posture, and often in a state of transition. The sitter or some part of his body—a head, a hand, a foot—is moving or about to move. Moreover, these bodily actions, subtly conveyed through gesture or expression, point to more than just a change of physical position; they offer a glimpse of something beyond outward form. Whether it is the look on the anonymous man's face, with his furrowed brow, tightly pursed mouth, and half-opened hand, or the barely separated lips of his wife in the pendant, there seems to be something on the minds of these people. Rather than the self-satisfied, even pompous subjects found in so many Dutch portraits over the centuries, this well-off couple is slightly but noticeably troubled. Perhaps they have been taken by the pious urge—one encouraged by so much of the art and literature of their time—to ponder their mortality.²⁵

Over the next four and a half decades, Hals produced a remarkable output of portraiture, making him, without question, one of history's greatest practitioners of this art. No other major painter of the time devoted him- or herself so thoroughly and single-mindedly to this genre. Rembrandt and Rubens were—in very different ways—extraordinary portraitists, but they were extraordinary in a great variety of genres. Even Antony van

Dyck, Hals's Flemish contemporary who became England's greatest portrait painter, also produced (relative to his overall output) a significant percentage of "history" paintings on biblical and mythological subjects. By contrast, of the authenticated paintings by Hals, estimated to number around two hundred and twenty (not all of them extant), four-fifths are portraits.[26]

Just as remarkable is Hals's originality. His contributions to the art of portraiture—including portraits depicting particular individuals (many of whose identities are now lost) and groups as well as those that are mainly genre paintings (*tronyen*)—encompass significant innovations in both form and content. In one overcrowded early piece, the *Shrovetide Revellers* (ca. 1615; color plate 4), practically every space in the upper part of the canvas is occupied by an expressive face or gesture, and all the action takes place above an artfully rendered still life of food, drink, vessels, and musical instruments.

The magisterial *Banquet of the Officers of the St. George Civic Guard Company* (color plate 5), done one year later and the first of Hals's major group commissions, is similarly full of incident. Rather than posing rigidly for their collective portrait, the officers of the company interact around a richly laden table. Some of the guards are engaged in amusing banter; others are talking about more serious matters; and a few are turned, as if suddenly interrupted, to face the artist.

In a more serene vein, the members of the family portrayed in a landscape in a painting from around 1620 are tenderly enjoying each other's company. There is little concern for decorum as they gather for their portrait. Only the father and the youngest child, on the ground at the left, are looking out at the viewer; everyone else is too busy talking or playing—or, in the case of the woman, admiring her husband—to pay the painter much mind.

From the sweet portrait of Catharina Hooft with her nurse of 1619–20 and the magnificent *Laughing Cavalier* of 1624, with

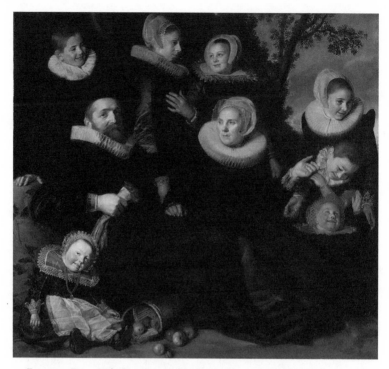

FIGURE 7. Frans Hals, *Van Campen Family Portrait in a Landscape*, early 1620s
(Toledo Museum of Art)

his sly, knowing look and beautifully rendered brocade jacket,
to the warmth of the trader Pieter van den Broecke's smile and
casual air (1633); from the full-length, nearly life-size portrait
of a swaggering Willem van Heythuyzen (1625; color plate 6),
whose confidence and aristocratic demeanor are bolstered by
the long sword he proudly displays, to the more solemn (and
more loosely painted) rendering of the same man nine years
later, with the merchant now seated at his desk and tipped back
on his chair, holding (in another bit of aristocratic pretention) a
riding crop rather than a sword[27]—in these and so many other
works, Hals went well beyond his predecessors in the portrayal

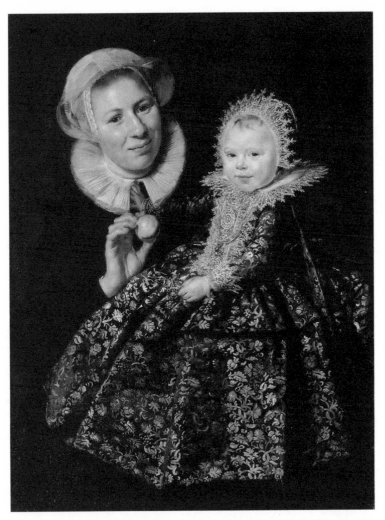

FIGURE 8. Frans Hals, *Catharina Hooft with Her Nurse*, ca. 1619–20 (Gemäldegalerie, Staatliche Museen, Berlin, Germany)

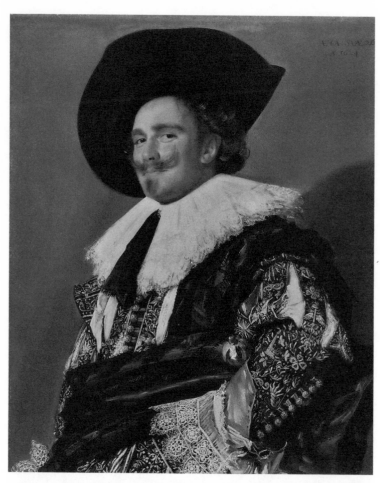

FIGURE 9. Frans Hals, *Laughing Cavalier*, 1624 (The Wallace Collection, London)

not just of faces and bodies, but of life and character. As Hals expert Seymour Slive explains, what gives the artist's portraits, whether of real individuals or genre characters, their singularity, what makes them so memorable, is the "sense of heightened vitality and spontaneity" they convey.[28] These are people who

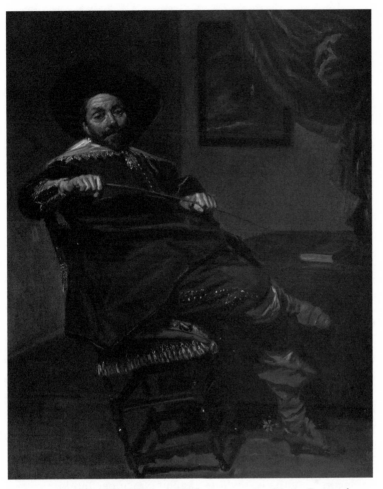

FIGURE 10. Frans Hals, *Willem van Heythuyzen*, ca. 1637 (Musées Royaux des
Beaux-Arts, Brussels)

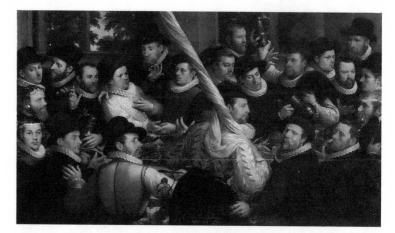

FIGURE 11. Cornelis Cornelisz (Cornelis van Haarlem), *Banquet of the St. George Civic Guard Company*, 1583 (Frans Hals Museum, Haarlem)

enjoy life but who are occasionally reminded (and remind us) that its pleasures are transitory.

Hals was an especially innovative master of the group portrait. Cornelis Cornelisz may have broken new ground with his crowded and bustling 1583 rendering of a local militia company, in which he shows the guard's members eating, drinking, talking, and gesturing to one another. But the scene he produced is rather flat, visually and emotionally. The represented space does not have the depth, nor the faces the liveliness and personality, found in Hals's analogous portrayal of the officers of the St. George company—whose changing membership he painted three times over the course of twenty-three years—or in his painting of the city's St. Hadrian Civic Guard, captured once in raucous revelry around a banquet table (1627; color plate 7) and once reviewing matters in the yard behind its headquarters (1633).[29]

These are distinctly rendered and animated gatherings of military men who draw the viewer's attention this way and that

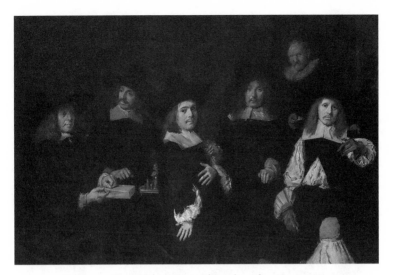

FIGURE 12. Frans Hals, *Regents of Haarlem Alms House*, 1664
(Frans Hals Museum, Haarlem)

by the variety of their expressions and gesticulations. The pictures are highlighted by small, bold areas of color—the light blue and gold sashes the men wear across their black clothes, the reds in the emblems they carry on their shoulders—and are sharpened by the generally clear and light atmosphere. In these regards, they stand in contrast with some of Hals's later group portraits, especially the two dark and somber paintings that he did of the regents and regentesses of Haarlem's Old Men's Alms House in 1664.

Hals also excelled at the genre portrait. The lute players, flutists, smokers, drinkers, fish mongerers, fruit vendors, young boys and girls, standing men, seated women, soldiers, game players, and artists that anonymously populate Hals's painted world suggest a democratic interest in the great variety of life around him. Some of these characters appear teasingly to challenge the viewer to join them for a drink or sample their rustic

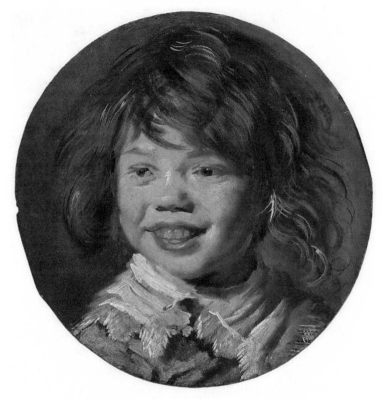

FIGURE 13. Frans Hals, *Laughing Boy*, ca. 1625 (Mauritshuis, The Hague)

wares. Others lean forward conspiratorially, as if about to impart a pearl of wisdom from their drunken haze. And some—especially his more youthful subjects—seem to be doing nothing more than finding joy in simple pleasures. Hals is clearly taken by the laughing boy captured, as if in a snapshot, while he is entertained by something beyond our view, which he painted on a circular panel in the early 1620s; it may be the same child who appears in other works from this period, amused in one painting by his flute and in another by a bubble. At the other end of life is one of Hals's most famous (and most reproduced)

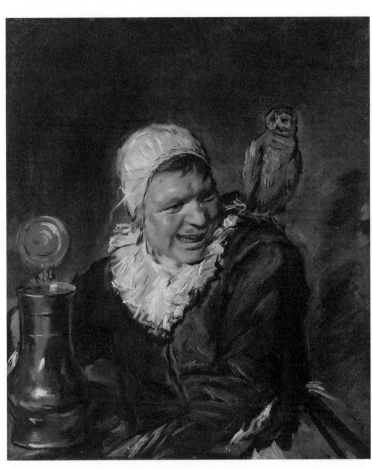

FIGURE 14. Frans Hals, *Malle Babbe*, ca. 1633–35 (Gemäldegalerie Staatliche
Museen, Berlin, Germany)

genre works, the dissipated old woman known as Malle Babbe,
shown enjoying a good laugh over her beer.

———

While Hals apparently did not enjoy an international reputation,
he was held in high esteem by the Haarlemers of his time. The

singular virtues of his art were recognized by local luminaries, especially those whom he portrayed. Theodorus Schrevelius, who was born in Haarlem in 1572, was painted by Hals in 1617. When he sat for his portrait, he was the director of city's Latin school, a post he held until he was removed in the anti-Remonstrant upheavals after 1618. As the author of the *Harlemias* (1647), a scholarly history of Haarlem in which he sings the praises of the city and its inhabitants, Schrevelius takes note of Hals, who

> excels almost everyone with the superb and uncommon manner of painting which is uniquely his. His paintings are imbued with such force and vitality that he seems to defy nature herself with his brush. This is seen in all his portraits, so numerous as to pass belief, which are colored in such a way that they seem to live and breathe.[30]

Similarly, Samuel Ampzing, also a Haarlem native who sat for Hals—his portrait was done in 1627—made sure to single out Hals (as well as Hals's brother, Dirck) in his 1621 book *Beschrijvinge ende Lof der Stad Haerlem in Holland* (*Description and Praise of the City of Haarlem in Holland*). In overwrought verse, he summons the Hals brothers to "come forth" and take the honors that are rightly theirs. "How dashingly Frans paints people from life!"[31]

Even Hals's signature "rough" style—named according to Van Mander's contrast between *net oft rouw*, "neat or rough," methods of painting—so much of a departure from the seemingly more careful methods and smooth canvases of most painters of the period (with one obvious exception being Rembrandt), had its admirers.[32] This loose technique, dominated by exposed, independent, and brusque strokes applying touches of unblended colors, generally becomes more pronounced as his career progresses.[33] What Schrevelius refers to as the "uncommon man-

ner of painting that is uniquely his"—where a hand might be rendered not by the carefully drawn lines and shaded hues feathered by invisible brushstrokes, but almost abstractly, by a few bold, abbreviated, apparently spontaneous but strategically placed stripes and dabs of color—was also described, centuries later by Ernst Gombrich, as Hals's "quick and deft handling of the brush through which he conjures up the image of tousled hair or of a crumpled sleeve with a few touches of light and dark paint."[34] While off-putting to some—one early critic complained that Hals's canvases were not "properly finished"[35]—his broad and highly visible brushstroke style impressed at least the seventeenth-century Flemish art biographer Cornelis de Bie, one of several successors to Van Mander. Writing in his *Het Gulden Cabinet van de Edel Vry Schilderconst* (*The Golden Cabinet of the Noble Liberal Art of Painting*, 1661), De Bie, in his biosketch of the painter Philips Wouwerman, notes that he "studied with Frans Hals, who is still alive and living in Haarlem, a marvel at painting portraits or counterfeits that appear very rough and bold, nimbly touched and well composed, pleasing and ingenious, and when seen from a distance seem to lack nothing but life itself."[36]

A telling testimony to Hals's reputation in his lifetime is a commission he received in 1633—not from Haarlem, but from Amsterdam. When that city's Crossbow Civic Guard, led by Captain Reynier Reael, wanted a group portrait to hang in its headquarters, they did not give the project to Thomas de Keyser, Amsterdam's premier portrait painter at the time. Nor did they ask a young local artist of increasing prominence named Rembrandt Harmensz van Rijn, who had just completed one group portrait (*The Anatomy Lesson of Dr. Tulp*) and five years later would produce a large painting of an Amsterdam civic guard that is one of history's most famous works of art (*The Shooting Company of Captain Frans Banning Cocq*, more familiarly

known as *The Nightwatch*). Rather, they summoned an older artist from Haarlem now at the height of his powers.

In the end, it was not a happy arrangement.[37] Hals traveled several times to Amsterdam to work on the painting, but he made meager progress. Apparently, the trip was too much for him and the task of assembling the members of the company too difficult,[38] and he eventually stopped turning up at all. In early 1636, three years after the initial commission, with Hals's promise from the previous year to finish the painting still unfulfilled, the frustrated members of the guard took legal action to force him to come to Amsterdam and get the job done. He replied that he was perfectly willing to complete the painting, but that their agreement had stipulated that he could "begin the heads in Amsterdam but complete the rest in Haarlem."[39] He thus blamed the officers for violating the terms of their contract, and told *them* to come to Haarlem so he could continue working on their features. They, in turn, annoyed by Hals's "frivolous and untruthful response,"[40] complained that this was most definitely *not* what they had agreed to. They tried to entice Hals to come to Amsterdam by offering him more money, but to no avail. By the end of the year, the militia had had enough. They eventually commissioned Pieter Codde, an artist in Amsterdam, to finish the work.

In addition to indicating something about Hals's fame in Holland and his working methods,[41] this episode—as detailed in several legal documents—provides a rare glimpse into his personality. The Hals who appears here is a stubborn, exasperating person. He did not like to be inconvenienced. It is not very far from Haarlem to Amsterdam, but Hals evidently could not be bothered to make the trip.

A difficult and argumentative Hals appears in another dispute from this period of his life. In September of 1635, the artist Judith Leyster, whose painting style is very much like Hals's—she was probably his student at one point, and her works have

sometimes been attributed to him—lodged a complaint against him before the Guild of St. Luke. She accused Hals of stealing one of her pupils (*leerjonghen*), one Willem Woutersz; Woutersz worked under Leyster for only a few days before decamping to Hals's studio.[42] Hals was ordered by the guild to stop teaching the young man or face a fine of three guilders. He apparently ignored the order, for one month later the guild summoned him again to defend himself, as well as to register his new student (still referred to as *de jonghen van joffrou Laystaer*) with the guild and to pay the required apprenticeship fee. Leyster seems to have been on very good terms with Hals before this; she possibly served as one of the witnesses at his daughter's baptism. She and her husband, the talented genre painter Jan Miense Molenaar, also owned a number of paintings by Hals, including two portraits of Leyster herself. But this affair over Woutersz surely put an end to their relationship.

A more amusing but apocryphal anecdote about Hals appears in *De Groote Schouburgh der Nederlantsche Konstschilders en Shilderessen* (*The Great Theater of Netherlandish Painters and Paintresses*), yet another compendium of Dutch artistic biographies, this one written in the early eighteenth century by Arnold Houbraken. According to Houbraken's entry on Hals, Antony van Dyck, before his departure for England in 1632, traveled to Haarlem to seek out his fellow painter. Upon arriving at Hals's house and learning that he was off drinking in a tavern, Van Dyck decided to play a trick on him. Hals knew Van Dyck by reputation, but was personally unacquainted with him. Aware of this, Van Dyck told Hals "only that he was a foreigner" and pretended to be a potential client interested in commissioning his portrait.

> He [Hals] took a canvas, whatever he happened to have at hand at the time, and went right to work. Van Dyck made little small talk with him while sitting, in order not to be known or discovered. It was

done in a short time, and Frans asked him to stand, to see whether it was to his liking. Van Dyck praised it, and made some conversation so that he might suspect nothing. Among other things he said: Is that all there is to painting, what you do? Could I also not do it? He then grabbed an empty canvas which he saw standing there, put it on the easel, and asked [Hals] to sit. Frans immediately saw, by the way he handled the palette and brushes, that this was not his first time.

Hals suspected only that this was some painter or another playing a joke on him, but still had no idea that it was the famous Van Dyck. However,

> it was not long before Van Dyck now asked him to stand up in order to see the work. As soon as [Hals] saw it, he said: "You are Van Dyck, because no other man can do such [work]." He then fell on his neck and kissed him.

As Houbraken tells the story, Van Dyck took his portrait, still wet, with him, thanked Hals, and gave him some coins for his children. The children never saw the money, however, because, Houbraken says, Hals quickly spent it on drink.[43]

This late biographer is one of the sources for the well-worn notion that Hals, like the subjects of many of his paintings, was a drunkard, "generally filled to the gills with liquor every evening."[44] Houbraken claims that Hals was "devoted to an evil manner of living" and suggests that he could have been even more successful had he been more temperate.

> However, his students had great esteem for him, and the eldest understood that they had to take turns taking care of him, and especially in the evening, when it was dark or late and he came out of the tavern, so that he would not walk into the water or in any other way meet some misfortune. They safely brought him home, removed his socks and shoes, and helped him into bed.[45]

Houbraken recommends that ambitious young painters take their cue from Hals's artistry and not from his lifestyle.

There is no documentary evidence to support tales of Hals's dissolute lifestyle, and scholars are hesitant to give them much credibility.[46] He certainly did, however, have a number of students who, while they may not have had to put their master to bed after a night of drinking, showed great fealty to his style of painting. Many of them went on to become successful and well-known artists. Among those who studied under Hals are Adriaen van Ostade, Philips Wouwermann, Dirck van Delen, and Adriaen Brouwer, as well as Hals's younger brother Dirck.[47]

There were five other painters in the seventeenth century whom Hals directly influenced: his sons.

In the year he joined the St. Luke Guild, Hals married into the Haarlem regent class when he wed Annetje Harmensdr. Her uncle, of whom she was a ward, was a member of the city council, at least until the 1618 purge of Remonstrants. He was also an officer in the St. George militia guard and was in this company when Hals first painted its group portrait. Frans and Annetje had two children, one of whom, Harman, who was born in 1611, would go on to become a painter.

Domestic happiness did not last long; Annetje died in 1615. Two years later, Hals married again, a Haarlem woman named Lysbeth Reyniers. Their relationship evidently had grown intimate well before they became husband and wife, as their daughter Sara was baptized nine days after the wedding. Hals and Lysbeth had eleven children altogether, including four sons who also became painters: Frans Hals the Younger, Reynier Hals, Nicolaas (or Claes) Hals, and Johannes Hals. (Meanwhile, their daughter Adriaentgen married one of Hals's pupils; as was the case with many trades, the art world in Haarlem was a tight-knit, even inbred society.)

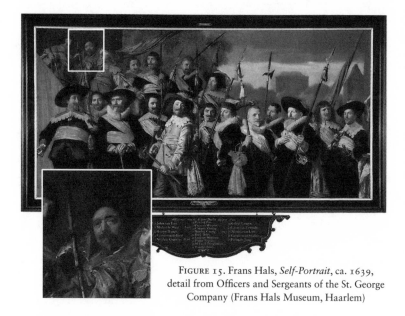

FIGURE 15. Frans Hals, *Self-Portrait*, ca. 1639, detail from Officers and Sergeants of the St. George Company (Frans Hals Museum, Haarlem)

In addition to his prolific artistic career, Hals was an active participant in Haarlem's civic life. He joined the St. George militia in 1616, albeit as an ordinary guardsman—his painting of the company that year thus portrays his own officers. (He inserted a self-portrait into the third painting of the militia that he made in 1639; his rotund face, with long dark hair, bushy moustache, and small patch of beard under his lower lip, appears in the upper left hand corner.)

In 1644, Hals was elected to a term on the board of the St. Luke Guild, a sign of respect from his painter colleagues.[48] He also belonged to the city's chamber of rhetoricians, one of the popular literary and dramatic societies that flourished in many cities in Holland. The amateur members of these clubs, who usually came from the upper classes, put on plays, recited poetry, and held fundraising events—such as lotteries—for public works.

By the 1630s, because he was in growing demand as a portraitist, Hals might have been hard-pressed to make time for these extracurricular activities. This was a period of great economic growth for Haarlem—the boom lasted until the 1650s, when even Haarlemers began to invest their money in businesses based in Amsterdam—and the city's wealthiest patrons sought him out for robust likenesses with which to decorate their homes and impress their associates.

Still, despite the healthy load of commissions, Hals experienced financial problems throughout most of his life. Portraiture was not among the most lucrative genres of Dutch painting. It certainly did not have the cachet of "history" painting (mythologies, biblical subjects), and mean prices for portraits lagged well behind works with classical, allegorical, and New Testament themes. While a portrait painter working on commission could still do better than painters of landscapes, genre scenes, and still lifes—which were usually less expensive and sold on the open market—an artist who specialized in portraiture and had a family to feed would want to aim high for clients.[49]

Hals must have taken on a great number of commissions to make up in quantity for what was lacking in value. If he worked as fast as the Van Dyck episode suggests, he could have painted quite a few portraits in a short amount of time. As portrait painters go, though, Hals was generally well paid for his work. What he received for a solo portrait was above the market average; and a large-scale group commission (such as he might have earned from the Amsterdam Crossbow officers) could bring him over one thousand guilders.[50]

More likely, many of his problems stemmed from poor economic management and irresponsible spending—for example, by buying paintings he could not afford; in 1634, he was not able to come up with the money to pay for a painting for which he was the highest bidder at an auction.[51] Moreover, Hals seems

to have suffered from what was either a careless inattention to financial urgencies or a willful refusal to meet his obligations.[52] He was subject to numerous legal claims for failing to pay his bills. These include debts for art supplies and for household expenses for his large family. He was taken to court by his landlord, by a local baker, and by art dealers. In 1616, after his first wife had died but before he remarried, he owed thirty-seven guilders to Neeltgen Leenders for taking care of his son Harman.[53] In 1634, Bouwen Fransz tried several times to collect the twenty-three guilders that Hals owed him for bread.[54] Hals failed to answer many of the complaints lodged against him. He tried to make ends meet by finding work as an art appraiser and restorer, but this did little to improve his fortunes. Even in 1661, when Hals should have been enjoying the twilight of an illustrious career, he was still in arrears to various creditors, including an auction house in Heemstede for some pictures he had purchased.

During the final years of his life, Hals lived on a municipal annuity, which he had requested from the city of Haarlem in 1662. The council also occasionally provided him with peat for heating fuel and a housing subsidy to pay his rent.[55] This financial support continued until his death, in August 1666. He was buried in the St. Bavo Church. Nine years later, his widow Lysbeth was still petitioning the city for relief funds, "since she has now come to such an advanced age and has fallen into poverty."[56] One wonders whether she ever turned to the *Broodkantoor*, Father Bloemaert's charitable foundation, for assistance.

CHAPTER 5

"Once in a Lifetime"

In a letter to his friend Claude Picot in 1649, Descartes describes the life he has been leading in Egmond de Abdij. The small village, just north of Haarlem, offers him "a solitude . . . as peaceful and with as much sweetness as he has ever had."[1] While he occasionally experienced a longing for France, he knew that the political turmoil now raging in his homeland—he was writing at the time of the Fronde, a nobility-led uprising against the regency of Anne of Austria, the young king's mother, and her first minister Cardinal Mazarin—made it impossible to settle there again. Descartes now expected to spend the rest of his life in this quiet corner of North Holland. While the country has, he admits to Picot, lost some of the charm that originally brought him there, still, there is no place that is better.[2]

The house in Egmond de Abdij (Egmond-Binnen) was, in fact, only the most recent of several rural residences that Descartes tried in the province after giving up on the cities. From 1637, when he left Leiden, to the winter of 1638, he lived "near Alkmaar," most likely with Helena Jansdr van der Strom, a servant whom he met in the home of his host in Amsterdam; she and Descartes now had a daughter, Francine, and he may have thought the countryside near Alkmaar was a suitable place for the family to live without scandal (the girl was in Descartes's life

for only a short time; she died of scarlet fever in 1641, at the age of six). He then moved to Santpoort, a village close by Haarlem. Sixteen months later he tried Leiden again, this time for a year, but apparently he rediscovered that city life did not agree with him and so he decamped to a chateau in the nearby hamlet of Endegeest. Finally, in the spring of 1643 Descartes moved to the coast, where he settled in a house among the dunes that surrounded the three villages of Egmond. This rustic area would be his home for the next six years, the remainder of his time in the Netherlands. (We do not know whether, after the death of Francine, Helena accompanied Descartes in these wanderings. Their relationship was certainly over by 1644, when she married another man. She and Descartes remained in touch, however, for he served as a witness to her marriage contract—in which she is identified as being a resident of Egmond—and even gave her a substantial financial sum at her wedding.[3])

Baillet says that Descartes was looking for "a place of retreat [*lieu de retraite*], where he might set himself up without being too far from the conveniences of life. He believed himself to have found just what he wanted near the town of Alkmaar, in the County of Egmond." (Descartes's earlier residence "near Alkmaar" mentioned by Baillet may in fact also have been Egmond; apparently, he liked the area enough to want to move back there.) At first he lived in Egmond aan den Hoef. But of the three Egmond villages, Baillet says, it was Egmond de Abdij that "has always passed as the most beautiful village of North Holland." In addition to its aesthetic charms, Egmond de Abdij reportedly had the additional advantage for Descartes of being amenable to the practice of his religion.

> He was brought to prefer this place over any other in the country primarily by considerations of religion, for the practice of which he would not have to content himself with mere inner worship [*culte intérieur*]. For there was in Egmond a church for Catholics, which

this village was full of, and so the exercise of our religion was entirely free and completely public there.

There was certainly no public Catholic church in Egmond de Abdij, although there might have been a *schuilkerk* that was a poorly kept secret. Still, as Baillet notes, Egmond is not very far from Alkmaar and Haarlem, "where there was equally a great number of Catholics." In any case, having settled on this village as the place best suited to his various needs and desires, Descartes soon set up house there, "to enjoy the pleasures of solitude that he had so desperately sought up until then, and that he had not yet found so complete anywhere else."[4] While he continued to visit Amsterdam and other cities in the Netherlands over the following years, and even returned to Paris several times, Egmond de Abdij was now home.

Life in the country was good for Descartes's research, and not only because of the anonymity it afforded him. Descartes was a devoted experimentalist, and he now had the leisure, space, and means to pursue controlled observations. He enjoyed working in the garden of his small house, where he could monitor the growth of plants. And living in a rural community had the advantage of providing ready access to animals so that he might continue his anatomical inquiries. Descartes worked with live chickens and studied the formation of embryos in their eggs, and he arranged for local butchers to kill pregnant cows so he could study the development of their fetuses. "I arranged for them to bring me more than a dozen wombs in which there were small calves, some as big as mice, others like rats, and yet others like small dogs, in which I was able to observe many more things than in the case of chickens because their organs were larger and more visible."[5]

Egmond was, Descartes decided, an ideal setting for a natural philosopher who was more intent on serious scientific work than on seeking a reputation and the honors conferred by polite

society. At times it could be a lonely existence, and Descartes occasionally longed for more intellectual companionship. During one of his brief trips to Paris, he enjoyed being received by the learned community there and finding interest among scholars for his various projects. But it was not long before he was eagerly planning his return to his country retreat. Immediately after his arrival in the French capital, he wrote to his friend Pierre Chanut, the French ambassador to Sweden, to say that the air of Paris "disposes me to conceive of chimeras instead of philosophical thoughts. . . . The innocence of the desert from which I came pleases me much more, and I do not believe that I can keep myself from returning there soon."[6]

Descartes made rapid progress in his philosophical work during his second decade in the Netherlands. In 1637, he published the results of his scientific investigations—not *The World*, which did not appear in print until after his death, but a quasi-autobiographical and methodological essay in which he reviewed his overall philosophical and scientific project, supplemented with three extended and detailed essays about his discoveries in optics, meteorology, and geometry. While the *Discourse on Method* is a step back from the earlier, more ambitious treatise "which certain considerations prevent me from publishing," it nonetheless presents in summary form many of the ideas that Descartes had already broached in *The World*, as well as in the *Rules for the Direction of the Mind*.

In the *Discourse*, Descartes describes his growing frustration with both the traditional and antiquated learning of the Schools and the skepticism about the possibility for real knowledge put forward by many of his contemporaries. He describes his ongoing quest for certainty in the sciences and sketches the details of the method with which he has had success and that, he believes,

will lead any properly motivated and sufficiently careful investigator to truth.

The key to Descartes's method as now laid out in the *Discourse* is to "raise the mind above things which can be perceived by the senses" and conceived by the imagination. Sensory appearances are misleading as to the true nature of things. They have led ordinary people and, more seriously, Aristotelian-Scholastic philosophers to conclude quite naïvely that the properties that objects in the world *seem* to have really do belong to them—that the colors they see and the heat and cold they feel are real qualities in physical objects, rather than being merely sensory effects in the mind of the perceiver caused by the motions among the finer parts of material things. Knowledge about the world can, Descartes insists, come only by moving beyond the confused testimony of the senses, by ignoring what is obscure and confused in the raw visual, tactile, auditory, and olfactory evidence with which we are presented to get to a scientific core that is conceptually pure and composed only of "clear and distinct" elements. This is achieved through the intellect and the proper and critical use of our reasoning faculties. Such is the epistemological project undertaken in the *Discourse* and, more rigorously, in the analytical *Meditations on First Philosophy* published four years later.

The *Meditations* have long been regarded as an attempt on Descartes's part to refute skepticism, or the view that absolutely certain knowledge is not possible given the limitations of our faculties in a constantly changing world, and that the best we can hope for in science and even ordinary life are probabilities.[7] Skepticism, which first flourished as a philosophical school in antiquity, enjoyed a revival in the sixteenth century with the rediscovery of ancient texts that presented the various arguments used by skeptics to undermine confidence in knowledge claims; Michel de Montaigne, for one, in his longest essay, the *Apology for*

Raymond Sebond, rehearses the various tropes of ancient skepticism for the purpose of dulling the allure of dogmatism and encouraging self-examination and humility in human affairs.[8]

By the early seventeenth century, the "Pyrrhonian revival"—so-called after the ancient skeptic Pyrrho of Ellis—is reported to have made inroads in certain European intellectual circles, including one frequented by Descartes. Baillet tells a story of Descartes attending, in 1627 or 1628, a gathering in Paris of "learned and inquisitive persons" at the home of the Papal Nuncio to hear a lecture by a certain Sieur de Chandoux, a scientist with a particular interest in chemistry. Chandoux, Baillet reports, no less than other modern thinkers, "sought to escape from the yoke of Scholasticism" and argued on behalf of a "new philosophy . . . established on unassailable foundations." His presentation was roundly applauded by the assembled company, who, "*presque universels*," approved his refutation of "the philosophy ordinarily taught in the Schools." The one holdout was Descartes. When one of Descartes's friends noticed his reticence and asked him why he did not join the others in praising the lecturer, he replied that while he appreciated Chandoux's attack on Scholastic philosophy, he was not pleased by his willingness to settle for mere probability in the quest for knowledge.

> He added that when it was a matter of people easygoing enough to be satisfied with probabilities, as was the case with the illustrious company before which he had the honor to speak, it was not difficult to pass off the false for the true, and in turn to make the true pass for the false in favor of appearances. To prove this on the spot, he asked for someone in the assembled group to take the trouble to propose whatever truth he wanted, one among those that appear to be the most incontestable. Someone did so, and then, with a dozen arguments each more probable than the other, he [Descartes] finally

came to prove to the company that the proposition was false. He then proposed a falsehood of the sort that is ordinarily taken to be most evidently false, and by means of another dozen probable arguments, he brought his hearers to the point of taking this falsehood for a plausible truth. The assembly was surprised by the force and extent of the genius that M. Descartes exhibited in his reasoning, but was even more astonished to be so clearly convinced of how easily their minds could be duped by probability [*la vray-semblance*].[9]

When asked whether he knew of some other, better means for avoiding error, Descartes replied that he knew none more infallible than the one he had himself been using, and that there did not seem to be any truth that he could not clearly demonstrate with certainty using the principles of his own method.

Much of this account may be Baillet's own creation, although it is based on an undated letter that Descartes wrote to his friend Étienne Villebressieu.[10] The story is often taken to show that, for Descartes, to settle for mere probability and thus give up the search for absolute certainty is to concede too much to the philosophical skeptic.

But in the *Meditations* Descartes clearly has a grander, more important goal in mind than simply refuting skepticism as an epistemological exercise. Aside from demonstrating the possibility of certain knowledge in the face of the skeptical challenge, Descartes was concerned actually to provide for science—for *his* science—solid and indubitable foundations.[11] This means a new epistemology altogether, to replace the old methodology and theory of knowledge that guided Scholastic science, as well as absolutely certain metaphysical principles. These foundations, once established, would in turn ground a general theory of nature (physics in the broadest sense) and particular scientific explanations of natural phenomena that constitute the individual sciences.

The *Meditations* is, above all, a book about mind, body, and God.[12] This is the real content of "first philosophy." Descartes wants to show what he, using reason and his own method of inquiry, can discover about the soul, material things, and their Creator, and how the most basic understanding of these general things can lead to other, even more useful knowledge. Writing a few years after the publication of the *Meditations*, Descartes employs the metaphor of a tree to explain how he sees the entire structure of human knowledge:

> The whole of philosophy is like a tree. The roots are metaphysics, the trunk is physics, and the branches emerging from the trunk are all the other sciences, which may be reduced to three principal ones, namely medicine, mechanics, and morals.[13]

In the *Meditations*, Descartes tends primarily to the roots of the tree of knowledge, "which contains the principles of knowledge, including the explanation of the principal attributes of God, the immaterial nature of our souls and all the clear and distinct notions which are in us."[14]

None of these truths will become evident to Descartes as he narrates his cognitive itinerary in the work until after he accomplishes a kind of intellectual cleansing and reorientation. Descartes tells the reader in the "Synopsis" that serves as a preface for the *Meditations* that one of his goals is to "free us from all our preconceived opinions and provide the easiest route by which the mind may be led away from the senses."[15] He wants to empty the mind of prejudices, some acquired in childhood, that may hinder proper inquiry into nature and to redirect our attention from the confusing testimony of sense experience toward the clear and distinct ideas of the intellect.

The starting point of this process is the so-called "method of doubt." Progressing in a systematic manner, Descartes will con-

sider all of his mind's contents, all of his beliefs and judgments, in order to see if there is something, anything, that is not merely a haphazardly acquired opinion (whether it be true or false) or ungrounded prejudice but real knowledge, an absolute certainty. In effect, what Descartes does through the Method of Doubt is play the skeptic to as radical a degree as possible—not for the sake of undermining human knowledge but in order to beat the skeptic at his own game. If Descartes can show that there are certain unassailable beliefs even for someone who is in the midst of an extreme skeptical crisis, where everything is subjected to the possibility of doubt, then the reconstruction of the edifice of knowledge, especially scientific knowledge, can begin on a secure basis. Descartes was fond of comparing this procedure to more familiar sorts of activities, such as tearing down a house and re-building it from the ground up because its foundations were un-stable; or going through a barrel of apples to see if there are any that have gone bad and whose rot might spread to the good fruit.

> Suppose [a person] had a basket full of apples and, being worried that some of the apples were rotten, wanted to take out the rotten ones to prevent the rot from spreading. How would he proceed? Would he not begin by tipping the whole lot out of the basket? And would not the next step be to cast his eye over each apple in turn, and pick up and put back in the basket only those he saw to be sound, leaving the others?

In the first stage of his project, Descartes will tip over the contents of his mind, "to separate the false beliefs from the oth-ers." This is required of all who want philosophize correctly,

> so as to prevent the [various opinions they have stored up from child-hood] from contaminating the rest and making the whole lot uncer-tain. Now the best way they can accomplish this is to reject all their

beliefs together in one go, as if they were all uncertain and false. They can then go over each belief in turn and re-adopt only those which they recognize to be true and indubitable.[16]

He knows that this is not an easy thing to do, and that it requires an uncomfortable degree of critical self-examination. It is, however, something that must be undertaken at least once, if only to see what one does know and, more important, *can* know. "I realized that it was necessary, once in a lifetime [*semel in vita*], to demolish everything completely and start again right from the foundations if I wanted to establish anything at all in the sciences that was stable and likely to last."[17]

Descartes proceeds to lead the reader through the exercise by noting that many things that people ordinarily and uncritically take to be certain can, in fact, be subject to doubt. There are, at first, the simple (and easily resolvable) doubts about objects that arise when one apprehends them under less than ideal circumstances. For instance, it is easy to mistake the size or shape of something when it is perceived at a distance or through a fog. The lesson here is that the senses are not *always* to be trusted, that not everything they report about the external world is true. "From time to time, I have found that the senses deceive, and it is prudent never to trust completely those who have deceived us even once." These kinds of errors, however, are not very serious, and one can guard against them through careful examination of what the senses are reporting and under what conditions.

On the other hand, there are many other beliefs about the world that even the most careful and critical observer ordinarily accepts as certain. These constitute some of the core beliefs of common sense, such as that one has a body, that there is an external world, and that things in that world are basically (if not, according to science, exactly) as they appear to be under the best of observational conditions. "Although the senses occasionally deceive us with respect to objects which are very small

or in the distance, there are many other beliefs about which doubt is quite impossible, even though they are derived from the senses—for example, that I am here, sitting by the fire, wearing a winter dressing-gown, holding this piece of paper in my hands, and so on." What could be more certain than that there is a world out there made up of familiar objects?

And yet, Descartes continues, even these apparently indubitable beliefs can be put into doubt. After all, one is often deceived by dreams, in which fantasies are mistaken for reality. "How often, asleep at night, am I convinced of just such familiar events—that I am here in my dressing-gown, sitting by the fire— when in fact I am lying undressed in bed!" Perhaps, the skeptical Descartes suggests, he is only *dreaming* that he is sitting by the fire, holding a piece of paper, or even has a body, in which case it would all be an illusion and these most evident beliefs would in fact be false. The experiences of dream life are so realistic, so much like what is ordinarily considered to be waking life, that one cannot tell whether one is awake or dreaming; thus, on any given occasion, what one takes to be an experience of independent reality may not be such. Or, to put the doubt another way, let it be granted that one knows when one is awake and when one is asleep; but because of the qualitative similarity—the experiential vividness, the composition of things, their shapes and colors, and so on—between dreams (which are known to be illusory) and waking life, how can one be certain that the appearances of waking life are not also illusory?[18] Dream experiences are not to be trusted, so why should any more credence be given to waking experiences, since the two seem to be so much alike? Thus the level of doubt deepens—and his confidence in the senses as a source of knowledge about the world diminishes—as Descartes continues his quest for something certain.

And yet, even if one's experiences are all dreams, or no more veridical than dreams, must there not at least be a world out there, an external realm of things that, if not exactly resembling

the items presented in sensory experience, are nonetheless suf-
ficiently like them to serve as the basic materials out of which
one's dreamlike perceptions are constituted? Where would the
stuff of dreams come from if there were not at least *something*
that is their ultimate source?

> It surely must be admitted that the visions which come in sleep are
> like paintings, which must have been fashioned in the likeness of
> things that are real, and hence that at least these general kinds of
> things—eyes, head, hands, and the body as a whole—are things
> which are not imaginary but are real and exist. For even when paint-
> ers try to create sirens and satyrs with the most extraordinary bodies,
> they cannot give them natures which are new in all respects; they
> simply jumble up the limbs of different animals.[19]

Or maybe, Descartes continues, there are not even such "gen-
eral kinds of things" in an external world, and maybe no exter-
nal world at all. Even so, surely there can be no doubting the re-
ality of "even simpler and more general things," such as bodily
nature in general, or extension, shape, size, and number. These
are perhaps the most basic items imaginable. Moreover, they
do not require the existence "in nature" of anything, since they
seem to be only simple and objective concepts discovered by
the understanding. So, Descartes says, let it be granted that all
those sciences that depend on the actual existence of things in
nature are now uncertain—"that physics, astronomy, medicine,
and all other disciplines which depend on the study of compos-
ite things are doubtful." Still, he suggests, mathematics, at least,
as well as other abstract, purely rational disciplines that require
only such simple concepts as number and extension, "which
deal only with the simplest and most general things, regardless
of whether they really exist in nature or not," would appear to
remain true and certain. "For whether I am awake or asleep,"
Descartes says, "two and three added together are five."

However, if the project of the First Meditation is to be consistently pursued to the end, even these apparently most certain truths have to be put to the test in order to see if there can be any conceivable reason for doubting them. Are the principles of mathematics in fact real and objective truths, as they seem to be, or simply compelling fictions concocted by the mind? This is where Descartes takes the epistemological exercise to what he calls a "hyperbolic" level. For he now entertains the radical possibility that, while he may have been created by an omnipotent God—and this is not yet certain either, but appears to be only "a long-standing opinion"—because he lacks any firm knowledge about this God, he presently has no compelling reason to believe that his creator is not a deceiver who allows him regularly to go astray even in those cases where he thinks he has "the most perfect knowledge." How, Descartes asks, can he be sure that he does not go wrong "every time I add two and three or count the sides of a square, or in some even simpler matter, if that is imaginable?" For all Descartes knows at this point, God, or whoever his creator may be, is deceptive and thus has intentionally given him a faulty and deceptive mind, a rational faculty that, even when used properly and carefully, produces only false beliefs. Descartes may feel compelled to believe that two plus two equals four, because his intellect tells him it is so; but maybe, just because his intellect has its origin in an all-powerful and deceptive deity and therefore is systematically unreliable, that proposition is not in fact true.

Descartes suggests that this kind of doubt is even more compelling if "the author of my being" is not God but simply the random forces of nature. Let us assume, then,

> that I have arrived at my present state by fate or chance or a continuous chain of events, or by some other means; yet since deception and error seem to be imperfections, the less powerful they make my original cause, the more likely it is that I am so imperfect as to be deceived all the time.[20]

It is immaterial whether Descartes was created by a God of unknown, and possibly vicious, character, or his being is the result of happenstance. Either scenario raises serious doubts about the reliability of his faculties, including reason itself. For all Descartes knows, he is deceived even with respect to those things that seem to him to be the most certain (such as his belief that there is an external world, or the truths of mathematics). Maybe because of his inherently defective nature nothing at all that Descartes thinks is true, no matter how subjectively certain he may feel about it, really *is* true. "I am finally compelled to admit that there is not one of my former beliefs about which a doubt may not properly be raised."

Descartes's descent into skeptical doubt is, by the end of the First Meditation, complete. Some of the doubts are generated by highly improbable and fantastic considerations. At one point, in order to reinforce the uncertainty engendered by the case of dreams—the force of habit is strong, he says, and it is hard "not to slide back into my old opinions"—he even considers the possibility (reminiscent of Don Quixote's "Evil Enchanter"[21]) that all of his sensory experiences are merely "phantasms" and illusions generated by an all-powerful evil deceiver, a "malicious demon" intent on deceiving him. Nonetheless, as fabulous and unlikely as these considerations may be, Descartes insists that they are to be taken seriously in this philosophical moment if he is to discover something that is absolutely certain and immune to any doubt whatsoever, for the purpose of reestablishing the edifice of knowledge on secure foundations. While there may certainly be, among the things that Descartes had believed, many that really *are* true, he needs to come up with some reliable way to distinguish these from what is false or doubtful.

———

With the Second Meditation, the rebuilding begins. Even in the midst of radical skeptical doubt, Descartes immediately comes

upon a first irrefutable truth. There is one thing that he can know with absolute certainty: "I am, I exist" (or, as he puts it more famously in the *Discourse on Method*: "I think, therefore I am"; *je pense, donc je suis,* or *cogito ergo sum* in the work's Latin translation). The belief in one's own existence is indubitable, completely immune to any skeptical suspicion whatsoever. One cannot possibly doubt one's own existence, no matter how hard one tries. In fact, the harder one tries, the more convinced one will be that one exists. The mere fact that I am thinking is sufficient to establish that I am, regardless of *what* I happen to be thinking—even if I am thinking that I do not exist, and even if I am contemplating the possibility that I am being tricked by an evil demon.

> But there is a deceiver of supreme power and cunning who is deliberately and constantly deceiving me. In that case I too undoubtedly exist, if he is deceiving me; and let him deceive me as much as he can, he will never bring it about that I am nothing so long as I think that I am something. So after considering everything very thoroughly, I must finally conclude that this proposition, *I am, I exist,* is necessarily true whenever it is put forward by me or conceived in my mind.[22]

"I am being deceived, therefore I am" is just as valid an argument—and serves Descartes's purposes just as well—as "I think, therefore I am."

At the same time, these reflections establish something essential about the "I" who is thinking and who concludes that he therefore exists. Through the *cogito* argument, Descartes realizes, also with absolute certainty, that he is a thinking thing, an individual who has a great variety of thoughts, beliefs, feelings, desires, and so on. This, too, cannot be doubted. "What then am I? A thing that thinks. What is that? A thing that doubts, understands, affirms, denies, is willing, is unwilling, and also imagines and has sensory perceptions."[23] All of these are activities

of his thinking, conscious states whose presence and whose status as *his own* cannot possibly be doubted. At this point, Descartes has no solid reason for believing that he is anything *but* a thinking thing; he does not yet know whether he also has a body (or whether it is in fact a body that is doing all this thinking), because the existence of material and external things has not yet been reestablished with any certainty. But for now, he can be indubitably sure—even if his faculty of thought was created by an evil deceiver—that he is at least a thinking thing, or mind.

Descartes can also be absolutely certain that there is a God. Or so he argues. This is *the* crucial step in the argumentative progress of the *Meditations*. Once Descartes knows that he (along with his rational faculties) was in fact created not by an evil demon but by the true God—once he knows that the author of his being is an omnipotent and perfectly good and benevolent deity who would never want to see him be systematically led astray—he has established something of great epistemological and metaphysical importance.

Descartes offers several arguments for God's existence, all of which take their start—as they must, given Descartes's current situation—from an item that he discovers indubitably to be in his mind, namely, the *idea* of God. Among the many thoughts that Descartes is certain that he, as a thinking thing, has is the idea of an infinite, all-perfect being. And the fact that a thinker has an idea of such a being—which is nothing other than an idea of God—is, like any fact, something that needs an explanation, a *causal* explanation that must be sufficient to account for every feature of the effect.

Descartes insists that a finite, created being such as himself cannot possibly be the cause of the idea of an infinite, eternal being. This is because a being that is merely finite could not, through its own resources, be the origin of the notion of a being

that is infinite. The proposed cause of an effect must, Descartes insists, "contain as much reality" as the effect, since "something cannot arise from nothing, and what is more perfect—contains in itself more reality—cannot arise from what is less perfect." This is as true for the content of an idea as it is for an actually existing thing, since "the mode of being by which a thing exists . . . in the intellect by way of an idea, imperfect though it may be, is certainly not nothing, and so it cannot come from nothing."[24] Not only does a finite being not have enough reality in itself to bring an infinite being into existence, it does not have enough reality in itself to generate even the *idea* of a being that is truly infinite. Descartes concludes that the only possible explanation for the idea of God in his mind must be that there really *is* such an infinite being who has all the attributes represented in the idea and who, when He created Descartes, endowed his mind with that idea, like "the mark of the craftsman stamped on his work."

Descartes also argues that it is impossible to clearly and distinctly conceive of God as *not* existing. The idea of God—which is "the most clear and distinct" of all of the ideas that Descartes discovers in his mind—is the idea of a supremely perfect being. But a supremely perfect being must necessarily have all perfections (otherwise it would not be the *supremely* perfect being). Existence, Descartes insists, is "a supreme perfection." Therefore, the idea of God necessarily implies the thought that God exists.

> It is quite evident that existence can no more be separated from the essence of God than the fact that its three angles equal two right angles can be separated from the essence of a triangle, or than the idea of a mountain can be separated from the idea of valley. Hence it is just as much of a contradiction to think of God (that is, a supremely perfect being) lacking existence (that is, lacking a perfection), as it is to think of a mountain without a valley.[25]

In other words, to insist that "God does not exist" is to put forward a proposition that is as logically contradictory and inconceivable as the proposition that "a triangle does not have three angles."

Through these arguments, Descartes comes to realize that the careful use of his rational thinking, working on the ideas he indubitably finds within himself, leads him inexorably to the conclusion that "I cannot think of God except as existing," and that his, Descartes's, being as a thinking thing has its origin not in some malicious demon or in the random forces of nature but in an infinitely perfect being. Even in the midst of the most radical skeptical doubts, Descartes cannot but conclude that God exists and that it is God who created him.

Moreover, he continues, God cannot be a deceiver. This is because God is necessarily wise and good. An infinitely perfect being must have *all* perfections, and wisdom and goodness are perfections. Thus, an infinitely perfect being would never produce a creature whose rational faculties are so inherently faulty that he is systematically deceived whenever he uses them properly; nor would such a being interfere with the operation of those faculties so as to lead their owner astray. Such malicious intentions are "impossible" for God, "for in every case of trickery or deception some imperfection is to be found."[26]

Descartes's intellect now has a divine guarantee. Once he is certain that he is a thinking thing who was created by an omnipotent and benevolent deity, the overwrought skeptical doubts that had been engendered about his faculties and the beliefs they generate can be dismissed. Knowledge *is* possible. At the end of the Fifth Meditation, he says that

> I see plainly that the certainty and truth of all knowledge depends uniquely on my knowledge of the true God, to such an extent that I was incapable of perfect knowledge about anything else until I knew

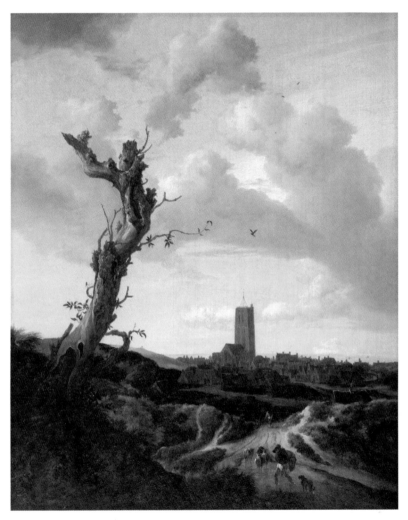

PLATE I. Jacob Isaacksz van Ruisdael, *View of Egmond*, 1648
(Currier Museum of Art, Manchester, New Hampshire)

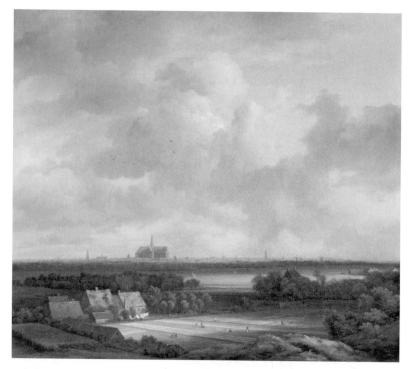

PLATE 2. Jacob Isaacksz van Ruisdael, *View of Haarlem with Bleaching Grounds*, ca. 1670–75 (Mauritshuis, The Hague)

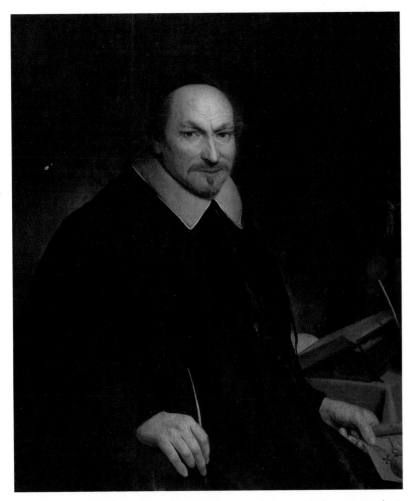

PLATE 3. Johannes Verspronck, *Augustijn Bloemaert*, 1658 (Frans Hals Museum, Haarlem)

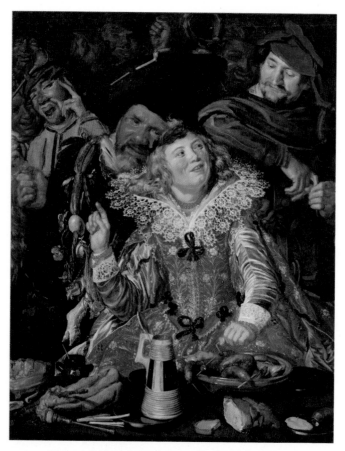

PLATE 4. Frans Hals, *Merrymakers at Shrovetide*, ca. 1615
(Metropolitan Museum of Art, NY)

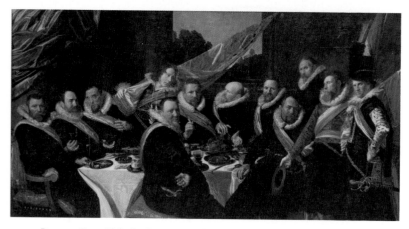

PLATE 5. Frans Hals, *St. George Guard*, 1616 (Frans Hals Museum, Haarlem)

PLATE 6. Frans Hals, *Willem van Heythuyzen*, ca. 1625 (Alte Pinakothek, Bayerische Staatsgemäldesammlungen, Munich, Germany)

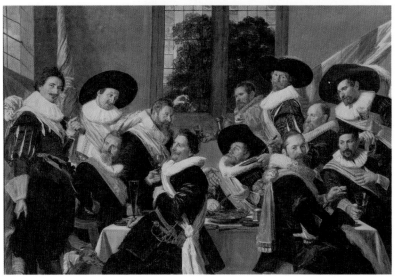

PLATE 7. Frans Hals, *St. Hadrian Guard*, 1627 (Frans Hals Museum, Haarlem)

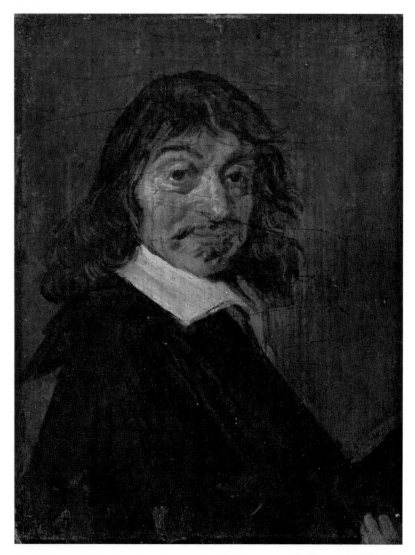

PLATE 8. Frans Hals, *René Descartes*, ca. 1649 (Statens Museum for Kunst, Copenhagen)

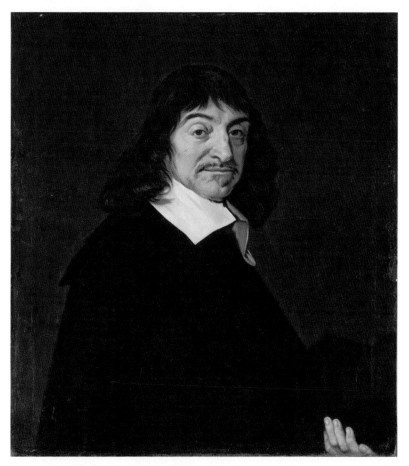

PLATE 9. Unknown artist (after Hals), *René Descartes* (Musée du Louvre, Paris)

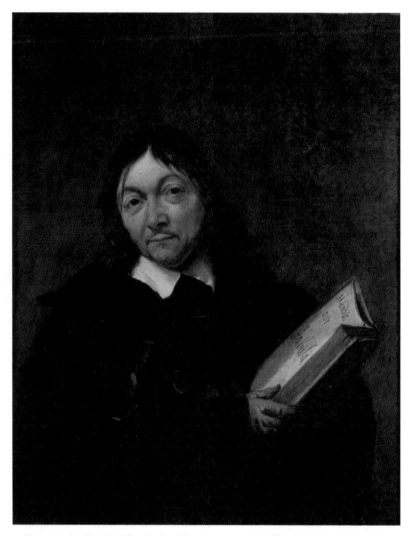

PLATE 10. Jan Baptiste Weenix, *René Descartes*, 1647–48 (Centraal Museum, Utrecht)

him. And now it is possible for me to achieve full and certain knowl-
edge of countless matters, both concerning God himself and other
things whose nature is intellectual, and also concerning the whole of
that corporeal nature [extension or spatial dimension] which is the
subject matter of pure mathematics.[27]

Descartes can now be certain that whenever he employs his in-
tellect properly, he will not go wrong. As long as he proceeds
with sufficient care and attentiveness and affirms only what he
clearly and distinctly perceives to be true—only what he ap-
prehends with such compelling evidence that his will cannot
withhold its assent—he will reach truth. Descartes concludes
the Fourth Meditation by saying that

> every clear and distinct perception is undoubtedly something, and
> hence cannot come from nothing but must necessarily have God as
> its author. . . . So today I have learned not only what precautions to
> take to avoid ever going wrong, but also what to do to arrive at the
> truth. For I shall unquestionably reach the truth, if only I give suf-
> ficient attention to all the things which I perfectly understand, and
> separate these from all the other cases where my apprehension is
> more confused and obscure.[28]

What Descartes learns from his foray into rational think-
ing validated by divine benevolence is that the proper use of
his faculties can give him not just beliefs, but true knowledge.
He no longer has any reason, however fantastic or unlikely,
to doubt that one plus one really does equal two. The most
important rule is to avoid precipitate judgment and give cre-
dence only to what one has irresistible justificatory reasons to
believe. Only then can one be sure that what one believes is not
only subjectively or psychologically compelling but also objec-
tively true. Descartes offers this principle as an essential guide

to any philosopher or scientist sincerely looking to make progress in his inquiries. (He warns, however, that atheists can never achieve the absolute certainty that is available to believers; this is because atheists cannot have the confidence in their rational faculties that comes from knowing that those faculties were created by an omnipotent, non-deceiving God.[29] The atheist will, like anyone, certainly believe many things that happen to be true—along with many things that happen to be false—but he can never be *justified* in knowing that they are true.)

Having done his epistemological groundwork, Descartes can now proceed immediately to discover a number of additional truths. Among the first things he can be certain of after the existence and veracity of God is a basic metaphysical fact: there is a "real" and radical distinction between mind and body. Mind or thinking substance has nothing in common with body or material substance, and the one can exist independently of the other.

> Simply by knowing that I exist and seeing at the same time that absolutely nothing else belongs to my nature or essence except that I am a thinking thing, I can infer correctly that my essence consists solely in the fact that I am a thinking thing. . . . I have a clear and distinct idea of myself, in so far as I am simply a thinking, non-extended thing; and on the other hand I have a distinct idea of body, in so far as this is simply an extended, non-thinking thing.

Because "everything which I clearly and distinctly understand is capable of being created by God so as to correspond exactly with my understanding of it," Descartes knows that if he can clearly and distinctly conceive of one thing without the other, he can confidently conclude that "the two things are distinct, since they are capable of being separated, at least by God." Now thought or mind *can* be clearly and distinctly conceived without

conceiving of body (as the *cogito ergo sum* argument showed), and body or matter *can* be clearly and distinctly conceived without thought. Accordingly, he concludes, "it is certain that I am really distinct from my body and can exist without it."[30] From "I exist," to "I am a thinking thing," to "I am a thinking thing that can exist without a body": Descartes has made considerable metaphysical progress since the Second Meditation.

Not only are mind and body independent of each other, but the nature and properties or "modes" of these two kinds of substance are mutually exclusive. Minds or thinking things are simple substances that have thoughts—ideas and volitions, purely mental activities; minds do not have shape, size, spatial location, or motion. Bodies or material things, on the other hand, because they are not minds or souls, cannot have thoughts; they lack all mental life. They are non-thinking, extended or spatial, and complex substances capable of motion and divisible indefinitely into parts.

Descartes is now, by the Sixth Meditation, also certain that there *are* bodies, that there is in fact an external world. God has clearly given him a strong natural propensity to believe in such a world on the basis of the data of his senses. For example, he cannot help but judge that his visual experiences "are produced by corporeal things," and that if he is awake and sees a tree, it is because there is a tree causing that perception. If there were no world of corporeal things actually and ordinarily producing these experiences, then a demonstrably benevolent God would, in giving him such a propensity, have led him astray. "I do not see how God could be understood to be anything but a deceiver if the ideas [of sense] were transmitted from a source other than corporeal things. It follows that corporeal things exist."[31]

However, the external world whose existence has been reinstated with absolute certainty is not, qualitatively, the same

external world that Descartes, in the guise of a philosophically naïve meditator, believed in at the beginning of this long exercise. One of the things that Descartes has learned over the course of the *Meditations* is that the reports of the senses are not to be trusted regarding the nature of things. The bodies that exist outside the mind do not really have the colors, sounds, tastes and other sensory qualities that they are ordinarily perceived to have. Descartes insists that all that he perceives clearly and distinctly to belong to bodies, and to corporeal nature in general, are purely mathematical properties: shape, size, divisibility, and mobility. This is because the clear and distinct idea of body or matter consists only in extension, or three-dimensional space. Since he is now to judge things only according to the clear and distinct ideas of the intellect and affirm only what he perceives with supreme, unimpeachable, and irresistible evidence, he must look beyond the confused, obscure, and misleading testimony of the senses and believe that external bodies consist in extension alone. All the other properties that *seem* to belong to bodies and that make up the richness of our sensory experience are—just like the pains and pleasures that bodies often cause in us—only perceptions in the mind brought about by the motions of matter.

Among those bodies in the external world, Descartes recognizes, is one in particular to which he as a thinking thing is closely related. With the uncertainty of the Second Meditation now dispelled, he may now conclude that he does have "a body that is very closely joined to me." Mind may be different from and independent of matter, but that does not preclude their being united in a human being. "There is nothing that my own nature teaches me more vividly than that I have a body, and that when I feel pain there is something wrong with the body, and that when I am hungry or thirsty the body needs food and drink, and so on." More than a simple and indifferent juxtaposition of two things, the mind's union with the body is

an intimate one, or so "nature"—Descartes's God-guaranteed propensities—leads him to believe.

> Nature also teaches me, by these sensations of pain, hunger, thirst, and so on, that I am not merely present in my body as a sailor is present in a ship, but that I am very closely joined and, as it were, intermingled with it, so that I and the body form a unit.[32]

Somehow, despite their radical disparity, the mind and the body whose union constitutes a human being engage in an immediate and mutual causal relationship: some mental events cause motions in the body (such as voluntary movements of a limb), and some motions in the body bring about events in the mind (for example, a sensation of pain). Descartes's best explanation of this fact is that the correspondence between the two substances is the result of a divine institution—God has so providentially created the nature of mind and body that certain motions do give rise to certain thoughts, and vice versa—and thus testimony to "the power and goodness of God."

The first edition of the *Meditations* has the subtitle "in which the existence of God and the immortality of the soul is demonstrated."[33] The mind-body distinction can certainly contribute to establishing the soul's immortality. An immaterial mind is not subject to the decay and decomposition that inevitably affects the material body, and so it will naturally survive the latter's demise. But Descartes's main concern in the *Meditations*, as in the *Discourse* and its accompanying essays, is not Christian apologetics. The metaphysical dualism that empties the bodily realm of all spiritual or mind-like elements (such as the immaterial forms and qualities of the Aristotelians) is really working on behalf of Descartes's scientific project. The exhaustive and

exclusive division of mind and body—*everything* is *either* mental *or* physical—provides a metaphysical foundation for his new mechanistic picture of the world. Whatever takes place in the physical world is to be explained by material principles alone.

That unorthodox (by early seventeenth-century standards) scientific vision of things, which he planned soon to present in a major "textbook," would ultimately be a source of great trouble for Descartes. Much as Descartes feared ten years earlier when he decided not to publish *The World*, the controversies surrounding his metaphysical principles and his philosophy of nature, and especially its perceived implications for religion, would end up disturbing the peace he so ardently sought in the Dutch countryside.

CHAPTER 6

A New Philosophy

In the fall of 1640, Descartes wrote to Mersenne in Paris to seek his advice. The *Meditations* were now ready to go to press, and he was unsure about the best way to proceed. He originally wanted to have a small number of copies printed, a kind of preview run, to send to several dozen theologians "for their opinion of it." The idea was to seek their approval, or at least get a sense of what they might find objectionable. "I have no fear that it contains anything that could displease the theologians," he tells Mersenne, "but I would have liked to have the approbation of a number of people so as to prevent the cavils of ignorant contradiction-mongers." He was concerned, however, that even with a limited printing, copies would end up in the hands of "almost everyone who has any curiosity to see it; either they will borrow it from one of those to whom I send it, or they will get it from the publisher, who will certainly print more copies than I want."[1]

In the end, Descartes decided just to send a manuscript copy to Mersenne, so that the friar might circulate it with little fanfare among "learned critics," especially theologians and philosophers with whom he was personally acquainted. Descartes charged Mersenne with collecting their objections to the work, especially—and despite Descartes's confidence that it contained

nothing of which theologians might disapprove—regarding items that might appear theologically problematic. "I will be very glad if people put to me many objections, the strongest they can find, for I hope the truth will stand out all the better from them."[2] By August of 1641, after Descartes studied the criticisms that Mersenne had received and forwarded to him and carefully composed responses to each, the book that he often referred to as "my *Metaphysics*" was in print. This first edition included six sets of objections and Descartes's replies, and was prefaced by a flattering dedicatory letter to the theologians of the Sorbonne, whom Descartes calls "the greatest tower of strength to the Catholic Church."

The *Discourse on Method* and its three accompanying essays (the *Dioptrics*, *Meteorology*, and *Geometry*), although published anonymously, had gone far toward establishing Descartes's reputation among his contemporaries as a major thinker of his time. The *Meditations* only increased his fame. Cartesian metaphysical and physical principles were now on their way, at least among progressive and independent minds, to becoming the century's scientific paradigm. Later natural philosophers, such as Leibniz and Newton, could offer their theories only against the background of, and in explicit opposition to, Cartesian science.

Descartes even went so far as to believe that his philosophy might be adopted by the faculties in the schools and universities to replace that of Aristotle. Soon after finishing the *Meditations*, he started work on a broad presentation of his entire system in the form of a textbook, complete with detailed explanatory theories of specific phenomena and "in an order which makes it easy to teach." The *Principles of Philosophy* (*Principia Philosophiae*), which Descartes finished after moving "near Alkmaar op de hoef, where I have rented a house"[3] (that is, to Egmond aan den Hoef), includes much of the material that he had hoped to publish a decade earlier, before the condemnation of Galileo;

in fact, he describes his work on the *Principles* as a matter of his "teaching [*The World*] to speak Latin."[4] His highly unrealistic hope was that this new book, which appeared in 1644, would supplant the Scholastic textbooks then widely in use in the teaching of philosophy, especially metaphysics and natural philosophy.

Descartes knew the Scholastic textbook tradition well. He had studied from these *summae philosophiae* as a young student at La Flèche. And in the winter of 1640–41, in order to prepare himself for the objections to his *Meditations* that he expected to receive from theologians, he reacquainted himself with a number of "the most commonly used" works, especially by Jesuit authors.[5] The typical Aristotelian textbook, used for teaching in the liberal arts curriculum in "colleges" (essentially, preparatory schools) and in the higher faculties of universities, was divided by broad philosophical discipline. Thus, the four parts of the *Summa Philosophiae Quadripartita* of Eustachio à Sancto Paulo (a member of the Feuillants, a Cistercian order)— which Descartes was busy reading that winter and even referred to as "the best book of its kind ever made"—were Logic, Ethics, Physics, and Metaphysics. Descartes's own four-part *summa philosophiae* follows this model, albeit not in the same order. Moreover, he replaced "logic" with an opening discussion of method and theory of knowledge—essentially, a detailed review of what he had accomplished epistemologically in the *Meditations,* but presented more in the style of a systematic treatise than as a series of meditative reflections.[6]

Because Descartes's primary aim in the *Principles* is to present his metaphysical principles and the physics they ground, he is careful in part 1 ("The Principles of Human Knowledge") and the opening articles of part 2 ("The Principles of Material Things") to elaborate on his conceptions of mind and body. These are, he insists once again, two distinct kinds of "substance," which

Descartes defines as "nothing other than a thing which exists in such a way as to depend on no other thing for its existence."[7] A substance is an independent individual thing, something that exists by itself and can be conceived by itself. Each substance has its own "principal attribute" or essential nature, which makes it the kind of stuff it is. For mind, that principal attribute is thought, which Descartes now identifies in terms of consciousness: "By 'thought' I understand everything which we are aware of as happening within us, in so far as we have awareness of it."[8] Body, on the other hand, is, following the lessons of the *Meditations*, nothing but extension; to be a body is simply to be spatially dimensional.[9] It follows, as Descartes discovered in the Sixth Meditation, that the properties that belong to thought and the properties that belong to extension are radically dissimilar and mutually exclusive:

> There are various modes of thought such as understanding, imagination, memory, volition, and so on; and there are various modes of extension, or modes which belong to extension, such as all shapes, the positions of parts, and the motions of the parts.[10]

Sensations (such as color, warmth, and pain), emotions, and appetites belong to the mind; they are not "real things existing outside the mind."[11] Sensory perception, Descartes warns once again, "does not show us what really exists in things, but merely shows us what is beneficial or harmful to man's composite nature."[12] The only properties really existing in bodies are shape, size, position, and motion or rest. Bodies, in other words, are merely geometrical entities.[13]

If body is nothing but extension, Descartes continues, then there is no distinction between "corporeal substance" and space, since any given space is or has a measurable extension. But this means that there can be no space that is not itself a body. In

other words, a vacuum, or an area absolutely devoid of body, is impossible. In the Cartesian cosmos, there is and can be no truly empty space; matter—extension—is everywhere and the universe is a plenum.[14] Nor can there be "atoms," or "pieces of matter that are by their very nature indivisible." This is because any corpuscle of matter, no matter how small, just because it is extended in three dimensions, can be further divided.[15]

What does in fact divide the material plenum up into parts, and thereby introduce physical diversity into the universe, is motion. This is where the great number and variety of individual bodies comes from. "All the variety in matter, all the diversity of its forms, depends on motion."[16] Different bodies are simply different ways in which matter is in motion and rest. And any particular body is the body it is because it is a collection of material parts that are at rest relative to each other but in motion relative to surrounding bodies. By "motion," Descartes means only the transference of a body from the vicinity of one set of bodies that are in immediate contact with it to the immediate vicinity of other bodies—essentially, nothing other than change of position of a parcel of matter relative to other parcels of matter.

In part 1 of the *Principles*, Descartes also lays out some of the basic parameters that are to guide scientific inquiry. Perhaps the most important of these is the elimination of teleology, or "final causes," from explanations in natural philosophy. Appeals to God's purposes or any kind of goal-oriented behavior within nature—like Aristotelian bodies "seeking" their natural resting place, or things behaving or having the properties they do for the sake of achieving some end—have no place in physics. Explanations are to be framed solely in terms of what was traditionally called "efficient causation," whereby an effect follows simply and necessarily from the nature and activity of a causal agent. "It is not the final but efficient causes of created things that we must inquire into. When dealing with

natural things we will never derive any explanations from the purposes which God or nature may have had in view when creating them . . . For we should not be so arrogant as to suppose that we can share in God's plans."[17]

This is an important methodological principle of the new mechanistic philosophy. With the reduction of matter to extension and the identification of motion as the sole agent of change in nature, Descartes has now marked the only legitimate elements of scientific explanation. When inquiring into why certain natural phenomena come about, it will not do to appeal to divine providence or purposiveness within nature; nor is it acceptable to introduce any kind of spiritual or vital elements in bodies. Rather, the explanation should be framed solely in terms of the way in which material particles, moving according to the laws of nature, have been ordered by impact and adhesion to produce an organism of a certain complex structure and function.

With these metaphysical elements in place—the "roots" of the tree of knowledge—Descartes is prepared to turn to the most general physical principles of the cosmos (the "trunk"), including the mechanics of hard and fluid bodies. His first move is to inquire into the laws of nature of a world created by a God whose essence is simple, whose activity is immutable, and who is the first and sustaining cause of motions among bodies. This transition from metaphysics to physics represents not only the highlight of part 2 of the *Principles*, but also one of the work's more stunning and audacious maneuvers. For Descartes declares that he can deduce, with absolute and logical certainty, what the laws of nature are from his understanding of the divine attributes alone; in fact, he claims he can deduce what the laws of nature would be for *any* world that God might create.

Descartes's confidence in his ability to determine *a priori*, solely from premises about God, what the laws governing bod-

ies in motion *must* be appears early in his career, in the 1630 treatise *The World*. Looking back on that project several years later in the *Discourse on Method*, he says that

> I showed [in *The World*] what the laws of nature were, and without basing my arguments on any principle other than the infinite perfections of God, I tried to demonstrate all those laws about which we could have any doubt, and to show that they are such that, even if God created many worlds, there could not be any in which they failed to be observed.[18]

Descartes is proclaiming that he does not need to engage in any kind of controlled experimentation or even basic observation of the world in order to discover the most general laws of nature. He does not need to witness apples falling from trees, examine the motions of the planets, or do any mathematical calculations. He does offer some empirical examples to illustrate the laws—such as the centrifugal force exerted by a stone being swung around in a sling—and make their content familiar to his readers. But all he really needs to know is that the world was created by a God having certain attributes. This theological information, supplemented by already demonstrated metaphysical principles about matter and motion, is sufficient to ground a logical deduction of the laws. (To be fair, unlike Newton, Descartes is not in fact interested in formulating the precise mathematical laws governing forces and motion, but only in specifying in broad mathematical terms very general kinematic principles that cover the basic movement and interaction of ideally geometric bodies.)

Descartes begins his deduction of the laws of nature with the claim that "God is the primary cause of motion" in the universe who "in His omnipotence created matter along with its motion and rest." When God created the world out of nothing,

He introduced a certain amount of motion into the matter composing it. With this premise in hand, Descartes believes he can immediately demonstrate the most universal law of nature: the law of the conservation of motion. This law states that the total quantity of motion in the universe (measured in any body by the product of its mass and its speed) is constant and will never change. Any gain or loss of motion in one part of the cosmos must be compensated for by an equivalent loss or gain of motion in some other part. This law follows from the immutability of God:

> God's perfection involves not only his being immutable in Himself, but also his operating in a manner that is always utterly constant and immutable. Now there are some changes whose occurrence is guaranteed either by our own plain experience or by divine revelation, and either our perception or our faith shows us that these take place without any change in the creator; but apart from these we should not suppose that any other changes occur in God's works, in case this suggests some inconstancy in God.

There are continual changes in the motions of individual bodies everywhere; some bodies speed up, other bodies slow down and even come to rest. But there can be no change in the overall quantity of motion in creation, for this would imply a change in the immutable Creator who first implanted and now conserves a certain quantity of motion in it.[19] God does not change His mind or His activity.

> God imparted various motions to the parts of matter when He first created them, and He now preserves all this matter in the same way, and by the same process by which he originally created it; and it follows from what we have said that this fact alone makes it most rea-

sonable to think that God likewise always preserves the same quantity of motion in matter.[20]

This same divine immutability, along with the universal conservation law, provides Descartes with justification for his first subordinate law of nature, tantamount to a law of inertia: "Each and every thing, in so far as it can, always continues in the same state; and thus what is once in motion always continues to move." No body changes its state of motion or state of rest unless such change is brought about by external causes.

Descartes's argumentation for this first law, in both the *Principles* and *The World*, is sketchy, and amounts only to the claim that because God is immutable, "always acting in the same way, He always produces the same effect."[21] But Descartes's underlying reasoning seems to be that if there were a spontaneous gain or loss of motion in a body—one not brought about by some causal interaction with another body—there would be no compensating loss or gain of motion elsewhere. This self-generated change in motion would therefore be something that appears out of nowhere, and thus would amount to an increase or decrease in the total quantity of motion in the universe, which would be a violation of the conservation law.[22]

The second subsidiary law of nature is that "all motion is in itself rectilinear." All bodies in motion have a natural tendency to move in a straight line, and they will do so unless their path is impeded by some other body. Any body that is moving in a circle (such as a stone in a sling) still has a centrifugal tendency to move in a straight line away from the center of the circle that it is describing. (These first two laws of nature formulated by Descartes appear in Newton's physics as a single law of inertia.) Descartes says that "the reason for this second rule is the same as the reason for the first rule, namely the immutability and

simplicity of the operation by which God preserves motion in matter."²³

Descartes, like almost all philosophers and theologians of his time, believed that God, after initially creating the world, continuously conserves it from moment to moment to keep it in existence. Were God to cease the creative action by which He brought the world into being, the world would cease to be, much as the light and heat of the sun would disappear were the sun to stop actively causing it (as opposed to a house that, once built, no longer requires the activity of the housebuilder). This is true not only of the world at large, but also of each and every thing within it. God's activity is required to conserve the souls He created, as well as all material things. Now when God conserves an individual body, He takes into account only the motion that is occurring in that body at a single instant, "at the very moment when He preserves it, without taking any account of the motion which was occurring a little while earlier." Therefore, Descartes argues, the tendency or determination of motion of a body at any given moment can be only along a straight line, since curvilinear motion requires reference to at least two moments of motion and the relation between them.

The third law of nature states that "if a body collides with another body that is stronger than itself, it loses none of its motion; but if it collides with a weaker body, it loses a quantity of motion equal to that which it imparts to the other body."²⁴ Both parts of this law are simply the application of the conservation principle to collisions between perfectly hard bodies; the law insures that in these interactions no overall gain or loss of motion occurs in the physical world. In order for the collisions and resulting transfers of motions among bodies to preserve the total quantity of motion in the universe, any loss or gain of motion in one part must be compensated for by a reciprocal gain or loss

of motion in another part. If a body collides with another body that is so much stronger than itself that it cannot move that second body, then while there is a reason why the first body's *direction* of moving should change, there is no reason why it should lose any of its motion. And if a body impacts upon a body that it *can* move, then its own loss of motion will be equivalent to the gain of motion by the body being moved.

Still operating in a purely deductive manner, Descartes proceeds to derive from these general laws of nature a number of particular "rules" governing the impact of solid bodies and the transference of motions that result from their collisions. For example, the first rule says that if two perfectly hard bodies of equal size and equal speed are moving toward each other in a straight line and collide, each will rebound in the direction from which it came without having lost any of its speed. The second rule states that if one body is even slightly larger than the other (both still moving at the same speed) and thus has a greater overall quantity of motion (the product of its mass and speed), then only the second body will bounce back, and both bodies will move together in the first body's line of direction at that body's original speed.[25]

All of these laws state only abstract tendencies under ideal conditions, in an environment without friction or elasticity. But because in reality, according to Descartes, there are no truly empty spaces, all bodies move in, with, and through a plenum of matter. The material cosmos, in other words, functions essentially like a fluid. Motion occurs throughout the universe in an infinite series of vortices, with all matter moving only relative to, and displacing, other matter. This means that there is no body that does not face some resistance to its motion, and so no actual observations can possibly confirm the laws. But for Descartes this is irrelevant. He has demonstrated the laws with

deductive rigor from first principles about God, the creator of nature. That, he insists, is all he needs to give his natural science an absolutely certain metaphysical foundation.

———

The three essays published with the *Discourse* in 1637, all intended to be illustrations of the fecundity of Descartes's new method, cover a lot of scientific and mathematical material. The *Dioptrics* offers a detailed investigation into the nature of light (which Descartes says is nothing other than an instantaneous impulse from a luminous body passing rectilinearly through the particles of the air) and its refraction by various media, the physiology of the human eye, the operation of lenses, and other matters pertaining to human vision. In the *Meteorology* (*Les Météores*), he deals with the nature of terrestrial bodies, winds, clouds, the various forms of precipitation (rain, snow, and hail, including the different shapes that snowflakes can take), storms ("lightning and all the other fires that blaze in the air"), rainbows, and the phenomenon of "the apparition of many suns" in the sky. And in the three books of his *Geometry*, Descartes lays out the principles of his analytic geometry, and especially the use of algebraic equations to solve geometric problems.

At the same time, Descartes recognized that there was something incomplete about what he had accomplished in physics so far. He did not doubt that he was right about the general constitution and behavior of bodies; and he, at least, was convinced that the particular explanations he was able to provide for a wide range of phenomena were true. But he also conceded that at best his conclusions were still only hypotheses—consistent with the experimental evidence, but hypotheses nonetheless. This is because while the explanations he offered in the essays certainly did "save" the phenomena and provide plausible accounts of the unseen causal mechanisms behind the observable

facts, the whole explanatory framework as presented was not grounded in higher principles.

> Should anyone be shocked at first by some of the statements I make at the beginning of the *Optics* and the *Meteorology* [about the general nature of light and of bodies] because I call them "suppositions" and do not seem to care about proving them, let him have the patience to read the whole book attentively, and I trust that he will be satisfied.

In these earlier works, Descartes makes general "suppositions" about the natures of things to serve as his starting points; for example, in the *Dioptrics*, he begins with certain claims about the makeup and action of light. While these assumptions themselves remain undemonstrated, he insists that they, as well as the causal mechanisms he subsequently derives from them, do such a good job of accounting for the phenomena that their explanatory success all but renders them certain. Still, Descartes continues,

> I have called them "suppositions" simply to make it known that I think I can deduce them from the primary truths I have expounded above [in the epistemological and metaphysical parts of the *Discourse*]; but I have deliberately avoided carrying out these deductions in order to prevent certain ingenious persons from taking the opportunity to construct, on what they believe to be my principles, some extravagant philosophy for which I shall be blamed.[26]

Writing to Antoine Vatier, a Jesuit priest, in 1638, Descartes says that "I cannot prove *a priori* the assumptions I made at the beginning of the *Meteorology* without expounding the whole of my physics," noting that he could, if he wanted, "deduce them in due order from the first principles of my metaphysics."[27] Only when this "deduction" of his physics from metaphysics

is completed, with the steps filled in that justify his account of matter and the laws governing the motions of bodies, can Descartes safely say that his explanations in physics and in the more particular sciences are absolutely certain.

Several years later, with the *Principles*, Descartes is at last prepared to bring this project to completion and present his entire system, foundations and all. On the background of the metaphysics of mind, matter, and God and the most general principles of nature (what he called, to Vatier, "the whole of my physics") that are laid out in parts 1 and 2, he is now able to "consider the observable effects and parts of natural bodies and track down the imperceptible causes and particles which produce them."[28] Descartes can thereby offer not just "hypotheses" about the mechanisms behind nature's phenomena, but confirmed explanations that, with the help of experiments, are ultimately "deduced" from those higher principles.

To this end, Descartes turns, in part 3, to "the visible universe." He explains the formation of the cosmos and major celestial phenomena involving the sun, the moon, the stars, comets, and planets (both the "higher planets"—Mercury, Venus, Mars, Jupiter, and Saturn—and the "lesser planets," that is, the moons orbiting the higher planets). Among the topics covered are the placement of the different planets relative to the sun, the spinning of the earth on its axis (which is caused by the rotational motion of the material vortex in which it is embedded), the motion of comets through the celestial vortices, and "why the moons of Jupiter move so fast while those around Saturn move so slowly or not at all." There is a discussion of why stars seem to appear and disappear, why comets have tails but planets do not, and an extended account of sunspots, which he says are nothing other than the conglomeration of tiny particles of matter on the surface of the sun into large masses.

Feeling somewhat bolder than ten years earlier, Descartes now argues explicitly that "Ptolemy's hypothesis does not account for the appearances." While still cloaking his version of the Copernican theory of the cosmos as an "hypothesis ‹or supposition that may be false› and not as the real truth,"[29] he nonetheless insists that it "seems to be the simplest of all both for understanding the appearances and for investigating their natural causes." He remains cautious, however, and pins his hopes on a technicality. Strictly speaking, Descartes says, the earth does *not* move. This is because it is always in the same position relative to the parts of the material vortex (or "heaven") that surround it and that, through their own motion, cause its rotation. Given Descartes's definition of motion, the earth is immobile with respect to the bodies with which it is in immediate contact, and thus it is stationary.

> In the strict sense, there is no motion occurring in the case of the earth or even the other planets, since they are not transferred from the vicinity of those parts of the heaven with which they are in immediate contact, in so far as these parts are considered as being at rest.[30]

Nonetheless, the rotational motion of the vortex within which the earth's own rotating vortex is embedded carries the earth in revolutions around the sun (with a similar mechanism working for the other planets). There is no mistaking Descartes's preferred cosmology: "All the planets are carried around the sun by the heaven."[31]

Finally, in part 4, "The Earth," Descartes considers such terrestrial phenomena as gravity,[32] magnetism, the nature of water and the ebb and flow of the tides, fire and lightning, the formation of mountains, plains, and seas, and the process of sensation in animals and human beings. Everything takes place according

to the principles of the mechanical philosophy. Thus, heat does not consist in the presence of some mysterious form or quality called *calor* in a body, but is simply the agitation of fine particles of matter; the heating, burning, rarefication, and condensation of bodies are all explained by the communication of such agitation from fire or some other source to the particles composing those bodies. And magnetism is not an occult power acting on bodies at a distance and drawing them together. Rather, it is explained by the grooves found on minute particles of matter floating throughout nature and the way these grooves determine the direction of passage of those particles through the poles of the planet and through the tiny pores found in iron but not other bodies.

Matter, motion, and impact—all the world's phenomena can be explained in these simple terms. "I have described this earth and indeed the whole visible universe as if it were a machine: I have considered only the various shapes and motions of its parts."[33] By contrast, the immaterial human mind is a distinct domain within nature and does not operate according the mechanistic laws that govern the behavior of material things. Still, it remains intimately connected with the human body, especially in the way in which some mental events—such as pain—are caused in a lawlike way by bodily events.

> A sword strikes our body and cuts it; but the ensuing pain is completely different from the local motion of the sword or of the body that is cut—as different as color or sound or smell or taste. We clearly see, then, that the sensation of pain is excited in [the mind] merely by the local motion of some parts of our body in contact with another body.[34]

Motions are communicated from the body's extremities to the brain via the nerves, "which stretch like threads from the

brain to all the limbs" and whose channels are inflated with "animal spirits." When these fluid-like spirits carry the motions to the center of the brain, they cause a movement there of the pineal gland, which Descartes calls "the seat of the soul." The different ways in which this gland is moved is coordinated by nature—that is, by divine institution—with various sensations, emotions, and appetites in the mind. When the gland is moved one way, there occurs in the mind a feeling of pain referred to some body part; when it is moved another way, a feeling of warmth, and so on.

The discussion of sensation—what Descartes calls "a few observations"—appears toward the end of part 4. He tells the reader that his original plan for the *Principles* was to include two additional parts, one devoted to biological phenomena (animals and plants), and one devoted to the human being. The latter would presumably have been a reworking of material from the unpublished essay on the human body, the *Treatise on Man*, that was the second part of *The World*. This earlier work, which did not appear in print until 1662,[35] treats the body "hypothetically" as if it were a "machine made of earth," operating on its own and without the benefit of a soul, just as do "clocks, artificial fountains, mills, and other such machines." The quasi-medical treatise thereby provides a mechanistic account of the functioning of the human nervous, circulatory, sensory, digestive, and respiratory systems. Descartes explains, for example, how when the fibers running through the nerve canals are "disturbed" and tugged by various external forces acting on a part of the body, they cause the pores of the brain to which they are attached on the other end to open in different ways, "just as, pulling on one end of a cord, one makes the bell on the other end ring."[36] This new arrangement of the brain's pores affects the flow of the animal spirits from the pineal gland back outward through the nerves to the muscles. This is what gives rise

to the body's natural motions, such as when a foot that is too near a fire quickly and instinctively withdraws because of the intense heat. Such purely mechanical operations, without any mental intervention (such as the will), can in fact explain all of the body's operations, including "the digestion of food, the beating of the heart and arteries, the nourishment and growth of the limbs, respiration, waking and sleeping, the reception by the external sense organs of light, sounds, smells, tastes, heat, and other such qualities," as well as the appetites and passions, memory, imagination, dreams, and movements of the limbs.[37]

None of this material on human physiology ever made it into the *Principles*, however. Descartes confesses, toward the end of the work, that, even at this later point, "I am not yet completely clear about all the matters which I would like to deal with there, and I do not know whether I shall ever have enough free time to complete these sections."[38]

The *Principles* is just as ambitious a treatise as Descartes envisioned *The World* to be, perhaps even more so. With extraordinary confidence—what his critics considered impertinent boldness—Descartes intended his "textbook" to provide the metaphysical and physical tools for a thorough understanding of the terrestrial and celestial realms. In the letter to the Abbé Picot that serves as the preface to the French translation of the work, he insists that "in order to arrive at the highest knowledge of which the human mind is capable there is no need to look for any principles other than those I have provided."[39] Nothing lies outside the scope of Descartes's project. Having established the principles of "immaterial or metaphysical things," and then "deducing"[40] from these an account of the most general features of the cosmos and concrete theories to explain a wide range of particular topics, he boasts that "there is no phenomenon

of nature which has been overlooked in this treatise."⁴¹ All of
those phenomena—except for those within the human mind
itself—are explained solely according to the clear and distinct
notions that inform the mechanical philosophy. "This is much
better than explaining matters by inventing all sorts of strange
objects which have no resemblance to what is perceived by the
senses ‹such as 'prime matter', 'substantial forms', and the whole
range of qualities that people habitually introduce, all of which
are harder to understand than the things they are supposed to
explain.›"⁴²

Descartes believed that his philosophical principles would open
up the world and make its operations transparent to human
reason. His explanations cover some of the most puzzling and
opaque processes of nature, and even show why the laws of na-
ture themselves are what they are. His boldness goes well beyond
that of Galileo at the beginning of the century. The Florentine
played an important role in the mathematization of the study
of nature. He, too, was committed to a corpuscularian account
of phenomena and the distinction between the real, quantifi-
able properties of bodies and their more qualitative properties
that are only sensory effects in the mind. However, Galileo was
not interested in an investigation into the metaphysical foun-
dations of physics, least of all by inquiring into God's causal
role in nature. And while he was occupied with the explanation
of certain phenomena—including, like Descartes, sunspots, the
earth's tides, and the solidity of bodies—he did not aspire to
provide an exhaustive and systematic account of the variety of
natural phenomena.

As for the great scientist at the other end of the century, Des-
cartes's philosophical ambitions went too far even for him. A
more reserved Isaac Newton, focused in his own *Principia*—the
Philosophiae Naturalis Principia Mathematica, or *Mathematical
Principles of Natural Philosophy*—primarily on the mathematical

laws of bodily forces, remonstrated against engaging in specula-
tion about the ultimate and hidden causes of these forces. He
was no less committed than Galileo and Descartes to the cor-
puscular philosophy of nature, and was on occasion willing to
consider various mechanisms behind gravitational attraction—
suggesting that it was the result of either a material "aether" op-
erating on bodies, or God—but he generally resisted such con-
jectures that go so far beyond what is empirically verifiable and
mathematically demonstrable. *"Hypotheses non fingo"*—"I do
not feign hypotheses"—he famously says in the General Scho-
lium that appears in the second edition (1713) of his *Principia*
when discussing the ultimate causes of nature's forces.

> I have not as yet been able to discover the reason for these properties
> of gravity from phenomena, and I do not feign hypotheses. For what-
> ever is not deduced from the phenomena must be called a hypothesis;
> and hypotheses, whether metaphysical or physical, or based on occult
> qualities, or mechanical, have no place in experimental philosophy.[43]

It is clear that with this remark Newton had Descartes's meta-
physical physics in mind.

———

The *Principles of Philosophy* was published in Amsterdam by
the family firm founded in the sixteenth century by Lodewijk El-
zevier, a Protestant emigré from Leuven (in Flanders) who settled
in Leiden during the Dutch Revolt. The business was carried on
through the seventeenth century by his sons and grandsons, and
quickly became one of the most renowned publishers in Europe.
The Elzeviers—there were branches operating independently in
Amsterdam and Leiden—published works in a variety of genres
and languages, from Hebrew and Christian scriptures, Greek
drama, and Latin verse to more recent writings—political and
legal treatises, poetry, scientific essays—in French and Dutch.

Many of the most important works of seventeenth-century science and letters bore the motto *Apud Ludovicum Elzevirium*, not all of them inoffensive editions of classical literature. Elzevier did not shy away from controversial publications. In 1638, the firm brought out Galileo's *Discorsi e dimostrazioni matematiche, intorno a due nuove scienze* (*Discourses and Mathematical Demonstrations, Relating to Two New Sciences*), despite the fact that the Inquisition in Rome had forbidden the publication and dissemination of any writings by the Italian scientist now condemned to house arrest.

Fortunately, the Inquisition's reach did not extend into the Dutch Republic. The province of Holland, in particular, was the best place to publish something that would never have seen the light of day elsewhere on the continent. Even Paris, which also lay outside the authority of the Inquisition, did not offer the degree of freedom of the press that publishers enjoyed in Amsterdam. The king, Church, and *parlements* in France all paid a good deal of attention to the books and pamphlets being produced within their domain. By law, nothing was to be printed unless it carried the indication *Avec permission et privilège du roi*, a royal *imprimatur* that was granted only after the work had been approved by the relevant censors. These anointed protectors of public welfare, often theologians, were quick to prevent the appearance of anything they deemed offensive to state, religion, or morality. It would take a brave publisher—perhaps a foolhardy one—to issue something in France without an *imprimatur*.

Things were not so rigidly controlled in the decentralized Dutch Republic. In fact, by the early seventeenth century Amsterdam was infamous for flooding Europe with subversive literature in many languages.[44] Radical political treatises, dissenting religious pamphlets, atheistic writings, even erotic novels and poems—in Dutch, Latin, French, Spanish, English, and other languages—had their first readers in Amsterdam. This was a source of dismay to Dutch authorities (or so they pretended,

particularly when these clandestine writings, often critical of monarchical regimes and ecclesiastic power, caused trouble for foreign allies by stirring up democratic sentiments or spreading freethinking ideas). But there was little they could do about it, even if they wanted to. The regents of Holland, urged on by conservative Reformed ministers and the concerned governors of other provinces, made various (but often halfhearted) efforts to control what came off the city's many presses, but over time these measures were of decreasing efficacy.

In the late sixteenth century, no book or pamphlet could be published in Holland without permission of the States of Holland; this "privilege," granted after the contents of the work had been examined and approved, had to be printed in the book itself.[45] In the first decades of the seventeenth century, the States General (a representative body across the provinces that had broader responsibilities than the provincial states but often less effective authority) became increasingly interested in books that were likely to cause problems "in both ecclesiastical and political affairs." This culminated in a 1615 edict intended to encourage provincial and municipal bodies to engage in the preventive censorship of offensive works.

By the 1640s, however, with a marked increase in the number of books and pamphlets being prepared for publication—and, in many cases, simply being published without being submitted for official approval—neither the province of Holland nor the States General was able to keep up, and so they no longer required publishers to submit manuscripts for approval prior to publication. Printers henceforth had only to register their businesses with the local magistrates, as well as swear an oath that they would hand over any suspicious writings that had been submitted to them and that in their opinion might be a danger to the state or to piety. The control of the presses in the Dutch Republic by this point, then, was a generally decentralized af-

fair, with the States General (which really had no authority in these matters) leaving it to the individual provinces to manage things, and the provincial states in turn leaving it up to the cities and towns to keep an eye on their local publishers. Consequently, there was a great deal of inconsistency throughout the land in the enforcement of censorship, whether before or after publication. A book that might be severely repressed in Groningen could well find easy distribution in Amsterdam or Leiden.

When Descartes was bringing the manuscript of his *Principles* to Amsterdam to hand it over to Lodewijk Elzevier in late 1643—the same publisher he had used for the second edition of the *Meditations* the year before—the Dutch Republic, and especially Holland, was enjoying a period of particularly generous press freedom. It was certainly not, however, an absolute liberty to publish anything at all. From 1640 to 1649, seventeen books or pamphlets were proscribed by the secular authorities, most of them works of a political nature. But this was one of the lowest tallies since the early years of the Revolt, and significantly less than the forty-one publications that were prohibited in the following ten-year period. Still, it was not a trivial number, and ten more than had been proscribed in the previous decade.[46] Even the Amsterdam regents had their limits. They bowed sometimes to political pressure from above, sometimes to local ecclesiastic influence. The strictness of their oversight waxed and waned over the course of the century, and was usually dependent upon the ever-changing Dutch political-religious context.

Descartes had used a Parisian publisher for the first edition of the *Meditations*, but he was not happy with the results. Some of the problems were due to the difficulty of living in the Netherlands while overseeing a book's production in France; he had to rely on Mersenne a good deal, and gave his friend permission "to correct or change everything that you think is appropriate."[47] Moreover, as Descartes tells Mersenne, there were few

legal barriers to pirated editions in the Dutch Republic. The exclusive royal privilege given to Michel Soli, the publisher of the first edition of the *Meditations* in Paris, would not be valid outside of France. Descartes thus decided now to work under contract with a Dutch publisher in the hope that this would discourage other Dutch presses from bringing out unauthorized editions.[48]

His choice of an Amsterdam press for the *Principles*, then, as well as for a Latin translation of the *Discourse* and its essays that same year, was dictated by a combination of legal strategy, the city's relative liberalism, and, not least, geographical convenience. The trip from Egmond to Amsterdam was not especially long, so Descartes could easily confer with Elzevier and manage the transition from manuscript to print with little disruption of his cherished routine in a rural retreat.

In a letter to Mersenne of 27 May 1638, when he was still living "near Alkmaar," Descartes told his friend how much he enjoyed his peaceful life in the Dutch countryside. He greatly appreciated the isolation and anonymity it afforded him.

> As long as I am allowed to live in my own way, I shall always remain in the country, in some region where I cannot be bothered by visits from my neighbors, as I currently do here in a corner of North Holland. For this is the only reason which makes me prefer this area to my native land, and I am now so accustomed to it that I have no desire to change.[49]

When Descartes had left France ten years earlier, however, interruptions from family, friends, and even total strangers were not the only things he was fleeing. There were potential disturbances that would have been much less benign.

In the Dutch Republic, Descartes was able to put some dis-
tance between himself and the less tolerant intellectual milieu
under Louis XIII and his prime minister, Cardinal Richelieu.
He knew the power wielded by the ecclesiastic establishment in
his Catholic homeland. Theologians who were troubled by his
researches and who would regard his ideas as inconsistent with
traditional religious dogma could easily—and with royal might be-
hind them—make life difficult for him were he to remain in France.

By contrast, the stadholder of Holland, Prince Frederik Hen-
drik of Orange, was the most tolerant and enlightened person
to hold that position in the century. While the prince was oc-
casionally at odds with the liberal regents who governed the
towns of this most liberal of the provinces, and while he was not
above colluding with the more conservative Calvinists when it
suited his political purposes, he refused to be beholden to reli-
gious authorities. The Netherlands prospered economically and
militarily during Frederik Hendrik's stadholdership; moreover,
the twenty-two years during which he occupied the post was a
time of great scientific and cultural flourishing. The persecution
of Remonstrants and their sympathizers that so poisoned the
religious and political atmosphere after the Synod of Dordrecht
had quieted down somewhat by the late 1620s, and the Repub-
lic enjoyed a corresponding relaxation in intellectual affairs as
well. In the late spring of 1637, Descartes told Constantijn Huy-
gens, with perhaps not a little obsequiousness, that "I would
never have decided to retire to these provinces and to prefer
them to many other places . . . had I not been persuaded by
my great respect for his Highness [Frederik Hendrik, Huygens's
employer] to entrust myself entirely to his protection and gov-
ernment."[50]

Descartes knew early on in his research that he would be
straying from Aristotelian orthodoxy and (despite his disin-
genuous protestations to the contrary) promoting "novelties"

in philosophy. He believed in 1628, justifiably, that he was less likely to be persecuted for these innovations if he moved to Holland. Many years later, he was certain that, on the whole, he had made the right choice. Near the end of his time in the Netherlands, Descartes expressed his overall satisfaction with the life he had been allowed to lead there. The newly independent nation could be a peaceful place, especially for a resident foreigner who was smart enough not to get involved in Dutch political and religious affairs. In a letter to his friend Henri Brasset, the French resident (or permanent representative) to the Netherlands, in April 1649, Descartes says that

> It was not considered strange if Ulysses left the enchanted islands of Calypso and Circe, where he could enjoy all imaginable pleasures, and that he so scorned the song of the Sirens, in order to go live in a rocky and infertile country, insofar as this was the place of his birth. But I [speak as] a man who was born in the gardens of Touraine, and who is now in a land where, if there is not as much honey as there was in the land that was promised by God to the Israelites, there is undoubtedly more milk.[51]

The Dutch Republic was certainly no paradise. But the freedoms it offered and the laissez-faire attitude in intellectual matters—especially in Holland—suited Descartes's purposes well.

Still, even in this tolerant land, where neither Rome nor the bishops of Paris had any influence, one had to be careful in navigating a complicated and often treacherous theological-political landscape. Descartes, unfortunately, was not always so careful, and much of his time during his final decade in the Netherlands was taken up by some very nasty disputes.

Soon after the publication of the *Discourse* in 1637, Descartes acquired several admirers in Dutch universities. Among these was Henricus Regius (Henri de Roy), a professor in the faculty of medicine at the University of Utrecht. Regius had ob-

tained permission to teach physics as well, and he used this opportunity to introduce his students to Cartesian scientific principles. Elements of Descartes's philosophy had already appeared in some of the university's lectures and disputations, but Regius was bolder than most. He also went beyond anything that Descartes himself would have sanctioned.

Descartes's dualism of mind and body had to be handled carefully, lest one either anchor the soul too much in the body and thus undermine its independence and immortality or, at the other extreme, overstress its distinction from the body to the detriment of what theologians considered the unity of human nature. At one point, Descartes cautioned Regius that what he was saying about the mutual independence of mind and body made the union of these two substances in a human being too much of a merely accidental conjunction rather than a true union. True, Descartes told Regius, the soul can exist without the body (and does, after death); but in this lifetime, the soul can properly be described as being—and here Descartes diplomatically recommends Aristotelian-Scholastic terminology— the "substantial form" of the body, intimately united with it and dependent on it for many of its mental states. In late 1641, while examining a draft of a university disputation sponsored by Regius, Descartes pointed out those things that are likely "to give offense to theologians." Most important, he warns Regius, is that "[i]n your theses you say that a human being is an *ens per accidens* [an entity by accident, rather than an *ens per se*, or an entity by itself]. You could scarcely have said anything more objectionable and provocative."[52] If the body is not truly an *essential* element of a human being, then the doctrine of the resurrection of the body, an important part of orthodox Reformed dogma, is undermined.

Among those provoked by Regius's theses—which were taken to be Descartes's theses as well—was Gisbertus Voetius (Gijsbert Voet), an influential conservative Reformed minister and the

firebrand rector of the university. Voetius was deeply troubled by Regius's abandonment of Aristotelian natural philosophy and soundly attacked his colleague for introducing the "new philosophy" into the studies that he supervised. Suggesting that "there is so much that we do not know" and that therefore one should be content with the learning handed down by the Schools, Voetius angrily accused the Cartesian philosophers in his university of arrogance and even delusions of divine grandeur in making bold claims to knowledge about the cosmos.[53]

Descartes, in turn, advised Regius on how to deal with his superior. He suggested that Regius take a respectful, even obsequious approach—"Remind yourself that there is nothing more praiseworthy in a philosopher than a candid acknowledgement of his errors"—and directed him to make some harmless concessions in matters of language: "Why did you need to reject openly substantial forms and real qualities?"[54]

Despite recommending that Regius swallow his pride and opt for a conciliatory posture, Descartes was himself growing annoyed with Voetius. In a subsequent letter to Regius, he offers a harsh assessment of the rector's character and the unreasonable degree of control he exercised in Utrecht. "I did not know that he reigned over your city, and I believed it to be more free . . . and I pity that city that it is so willing to serve so vile a pedagogue and so miserable a tyrant."[55] It was now Descartes's battle as much as Regius's, since it was ultimately his own philosophy (albeit poorly represented by Regius) that was being maligned. Descartes was not one to back down, but then neither was Voetius.

Much to Descartes's chagrin, Regius continued to make things worse. He refused to take the cautionary advice of Descartes and of his more moderate colleagues at Utrecht, and in February 1642 he made a very public reply to Voetius in the form of a pamphlet aggressively defending his philosophical principles. In

this *Responsio*, Regius went on the counterattack and accused the Aristotelians of atheism and of implying that the human soul, as the form of the body, is itself material.[56]

Voetius exploded. This had gone too far. He convened the university senate and directed it to ask the city council to order the seizure of all copies of Regius's pamphlet and to censure the theories it defended. The Utrecht councilors followed suit, and on 4 April 1642 they issued a condemnation of the "new philosophy."[57] Meanwhile, the university stripped Regius of his right to give lectures on physics and forbade the further teaching of Descartes's ideas, which it proclaimed to be incompatible with the "ancient philosophy" and prejudicial to theology.[58]

Descartes complained about all this in a letter to a French Jesuit— Father Jacques Dinet, a supervisor at La Flèche when Descartes was a student there and now the order's provincial in Paris. He recounts his treatment by the university, describes Voetius in highly unflattering terms, and expresses his hope for better consideration from the Jesuits in France. The Latin letter was published in 1642 in Amsterdam with the second edition of the *Meditations*. It was easily accessible to Dutch readers, especially after the more provocative parts were translated that same year. This very public indictment of Voetius (whom Descartes calls "stupid," "foolish," "malicious," and "a quarrelsome and incompetent rector") and of the University of Utrecht (which he accuses of preferring a slavish devotion to tradition over the pursuit of truth) was not a wise step for someone who desired only peace to continue his work and who wished to avoid distracting quarrels. If Descartes thought his letter to Dinet would put an end to the matter, he was sorely mistaken.

This affair in Utrecht led to years of trouble for Descartes. Voetius sued him for libel, and the Utrecht city council summoned him to respond to the charge. Descartes was sufficiently worried by this that he asked Brasset, the French resident, to

intervene on his behalf and have the summons canceled. Meanwhile, other scholars at the university and in Groningen (apparently at the instigation of Voetius) joined the battle. They accused Descartes of fostering skepticism and atheism, in part on the grounds that the proofs for the existence of God that he offers in his writings are so obviously bad that they must in fact be intended to dissuade people from believing in God. By 1645, the Utrecht city councilors were so tired of the fighting that they issued a decree forbidding the printing or dissemination of books for or against Descartes. Still, the wrangling continued, and the fallout from the affair occupied Descartes well into 1648.

To make matters worse, a similar battle over Cartesian philosophy was brewing in Leiden. This could potentially be more problematic legally for Descartes. Unlike Utrecht, Leiden was in the province of Holland, and so any formal measures taken by that city against Descartes personally (such as a summons to answer a charge of libel, should one be issued) would be enforceable.

The trouble in Leiden began, as in Utrecht, when a number of teachers at the university started promoting Cartesian ideas. Adriaan Heereboord, a professor of logic, argued in a 1644 disputation that only Descartes's philosophy offered the possibility of true knowledge of nature. He said that the Aristotelians were interested in nothing more than slavishly following their ancient master and in conflating his philosophy with theology. "A monstrous and monastic kind of philosophy was born which, with its boring and futile sophistries, corrupted everything."[59] Heereboord and others defended Cartesian method in philosophical inquiry—beginning with doubt and proceeding only by assenting to what is known clearly and distinctly—and the tenets of Cartesian metaphysics and physics.

The attack on Aristotle in Leiden was received just as it had been in Utrecht. Descartes's philosophy was described by conservatives as "dangerous" to faith and morals, and his par-

tisans were accused of encouraging skepticism and freethinking. In 1646, the university senate proclaimed that only Aristotelian philosophy could be taught and discussed. Descartes's philosophy was now officially banned—at least in the public lessons—at two Dutch universities.

Descartes subsequently wrote to the university curators at Leiden to protest some of the personal attacks that had been made against him by individual professors (who had called him, among other things, a blasphemer) as they battled their Cartesian colleagues. In an attempt to calm things down, the curators in May 1647 ordered professors in the faculties of theology and philosophy to cease any and all discussion of Descartes's philosophy, whether for or against. Furthermore, they wrote to Descartes himself and requested that he stop causing trouble with his new and controversial opinions.[60] In a letter to his friend Princess Elizabeth of Bohemia, who was living in exile in the Netherlands after her father was deposed as king, Descartes complained that the Leiden authorities "are turning a minor disagreement into a major dispute" and that the theologians "want to subject me to an inquisition more severe than the Spanish one, and turn me into an opponent of their religion."[61]

Things did not calm down, and by the end of the decade rancorous debates over Cartesianism erupted in other universities throughout the Netherlands. The tranquil life of the mind that Descartes had sought in his rural Dutch retreat was becoming harder to sustain. It was enough to make him consider leaving "this peaceful land" and to return to France, as he tells Elizabeth in May 1647:

> As for the peace that I came here seeking, I expect that I will not henceforth be able to enjoy it as much as I would have wanted, because not only have I not yet received all the satisfaction that I should have for the injuries I received from Utrecht, I see that they now bring

others in their wake, and that there is a band of theologians, school-men [at Leiden], who seem to have conspired together in order to oppress me with calumnies.[62]

In fact, within the month Descartes was off to Paris and Brittany. He went primarily to take care of some financial affairs and to see old friends. He also paid a visit to the mathematician and religious thinker Blaise Pascal and worked on the French translation of the *Principles*. He undoubtedly enjoyed the respite from the recent unpleasant tangles with Dutch theologians.

Still, despite all the troubles in Utrecht and Leiden—just the kind of attacks on his philosophy from theologians that he had hoped to avoid when he embarked for the Netherlands—Descartes very soon missed Holland. It was now his home, and he had long come to appreciate, even to depend upon its advantages. He kept the trip to France short, and by early autumn he was back in "the happiness of a tranquil and retired life" in Egmond-Binnen.

CHAPTER 7

God in Haarlem

Dutch winters can be long and cold. In the mid-seventeenth century, they were especially so, as Europe was then going through a particularly severe stretch of the so-called "Little Ice Age." For someone living by himself in the countryside, the winter months could also be lonely.

Descartes appreciated the solitude of his home in Egmond. The peace and quiet were conducive to the undisturbed reflection needed in order to make progress in his philosophy. He took advantage of the isolation to pursue further experiments in physics and animal physiology, although he often lamented the absence of the funding and manual assistance necessary to carry them out.[1] But it is clear that, with each passing year, the extended wintry weather was wearing him down. Already in March 1641, while still living in Leiden, he had written to Father Mersenne in Paris that "I have plenty of time and paper, but I do not have any material, if only because winter has begun once again in this country, and it snowed so much last night that one can now travel in the street by sled."[2] Now that Descartes was set up in the country, it was only worse. He was often frustrated by the many occasions on which he had to put off plans for a journey because of a particularly cold stretch.[3] In March 1646, he wrote from Egmond to Chanut, in Sweden, that

the extraordinary rigor of this winter has obliged me to make frequent wishes for your good health and that of your family; for it is said around here that there has not been so severe [a winter] since 1608. If it is the same in Sweden, you will have seen there all the glaciers that Septentrion [the northern regions] can produce.[4]

When March comes, one wants signs of spring, not more snow and ice. It was not only the quarrels in Utrecht and Leiden that led Descartes, despite his affection for his adopted homeland, to consider returning to France. Still, he had learned a few things from the Dutch about how to survive their winters. "What consoles me is that I know that there are more preventatives against the cold in these parts than there are in France."[5]

Descartes found relief from the tedium of the cold months, and breaks from his solitary philosophical pursuits in Egmond, among some recent acquaintances in nearby Haarlem. By 1638, when he was living "near Alkmaar" (possibly a first residence in Egmond[6]), he had come to know and enjoy the company of two Catholic priests in the city: Augustijn Bloemaert and his friend Johan Albert Ban. They came to be among Descartes's closest friends throughout the 1640s.

It appears that the introduction to Ban came first, by way of their mutual friend Constantijn Huygens. Huygens owned a copy of an unpublished manuscript on music written by Descartes in the mid-1630s, the *Compendium Musicae*, and shared it with Ban in their discussions concerning musical harmony. Ban was suitably impressed. It was probably he who made the first move by seeking out the philosopher in his rural retreat. Descartes wrote Huygens that "if you had never said anything good about me, I would perhaps never have become familiar with any priest in these parts; for I have gotten to know only two, one of whom is Monsieur Ban, whose acquaintance I have acquired through the esteem that he heard you express over the

little treatise on music that at an earlier time escaped from my hands."[7]

In January 1638, Descartes paid a visit to Ban in Haarlem. Ban wrote to William Boswell, secretary to the English ambassador, that "I had an excellent opportunity to confer with Descartes, a man, as you know, of great skill and second to none in natural and mathematical subjects. I received him in my home with a ten part piece of music, with voices and instruments . . . He admired it and praised it."[8] The two men talked about musical intervals and the division of octaves, and they compared notes over Mersenne's new system of tuning, as expounded in his *Traité de l'harmonie universelle*.

In fact, Ban was so taken by Mersenne's harmonic innovations that, at Descartes's suggestion, he designed a harpsichord adapted especially to them.[9] At a later meeting, Descartes—like so many other visitors to Ban's rooms—listened patiently as the excited musician first described what he had done and then played on his new keyboard. While Descartes was no doubt polite and encouraging to his new friend, he was unsure what to make of the instrument. He does seem to have been impressed by its unusual qualities: "I have seen the new spinet of Monsieur Ban with the perfect system [of tuning] that makes him so extremely happy, and although I am almost deaf [i.e., tone deaf], it seems to me to be something above the common run."[10] But, as a letter Descartes wrote to Huygens several months later shows, he was interested in learning what a more discerning listener thought: "I heard that you were recently in Haarlem, where I would have flown if I had been able to find the time, in order to learn from you whether Monsieur Ban flatters himself or if there is indeed something extraordinary about his spinet."[11]

Whatever Descartes's true evaluation of Ban's modified harpsichord may have been, he definitely did not think very highly of his talents as a composer. Like Mersenne, he found Ban's work

lacking in interest and inventiveness. In fact, it was an undertaking by Mersenne that gave Descartes the opportunity explicitly to pass judgment on Ban's music.

Ban had been pestering Mersenne with letters extolling the virtues of his theories and samples of his compositions.[12] When Mersenne's response was not the laudatory one Ban had been expecting, he was highly offended and suggested that anyone who did not agree with him was "raving mad . . . a deaf musician."[13] In the spring of 1640, after several more exchanges, the annoyed Minim friar decided to put this matter to rest and initiated a little competition between Ban and a French composer, Antoine Boësset. Each was to set a short verse to music, and the resulting pieces would be sent to various experts for their judgment.[14] The poem, by Germain Habert, was forwarded to Ban by Huygens:

> Me veux tu voir mourir, insensible Climaine?
> Viens donner à tes yeux ce funèste plaisir!
> L'excez de mon amour, et celuy de ta haine,
> S'en vont en un moment contenter ton désir.
> Mais au moins souviens toi, cruèlle,
> Si je meurs malheureux, que j'ay vescu fidelle.

> [Do you want to see me die, callous Climaine?
> Come, feast your eyes on this funereal pleasure!
> The excess of my love, and that of your disdain,
> Will soon satisfy your desire.
> But at least remember, you who are so cruel,
> That if unhappy I die, I lived faithful.][15]

Boësset was a highly accomplished composer, the director of music for Louis XIII, so there was little doubt in Mersenne's mind as to who would win the competition. But perhaps this

Frenchman wanted only to convey a certain message to the up-start Dutchman. He tells a correspondent that "the little har-monic combat we have begun . . . consists in making him [Ban] see that our songs and compositions are better and more elegant than his."[16]

The deck was stacked. As expected, the judges pronounced Boësset's composition to be far the superior one. Ban was in-dignant, of course, and he let Mersenne and others know how wrongheaded their criticisms of his work were. "First of all, he [Boësset] did not do well to choose the key of D minor. It would have been better to have used F major, which is appropriate for expressing the motions and passions of indignation."[17] Ban then tried to enlist Descartes on his behalf. He gave Descartes a copy of his extended and highly technical critique of Boësset's piece, expecting the philosopher to come to his defense. Descartes was amused by being put in such a situation; as he tells Huygens, whom he charged with conveying his response to Ban, he is himself "someone who never learned to sing 're, mi, fa, sol, la' nor how to judge if someone else was singing it well" but who is now being asked to render judgment "on a subject that depends only on the ear's discernment."[18]

Ban was no doubt disappointed by the reply he received from Descartes. In his mind, even someone with little confidence in his musical ability should be able tell which was the better com-position. Descartes's judgment, however, was tactful but clear. "You ought not to be surprised if, perhaps because of the exces-sive honor you have shown me in this matter, I am insolent and dare to side with my own people against you." What follows is a precise explanation of why he thought Boësset's piece to be superior to Ban's.[19] Writing to Mersenne, he was even more can-did. "As for the music of Monsieur Bau [Ban], I believe it differs from the air by Bosset [Boësset] just as the cry of a schoolboy who is practicing all the rules of rhetoric differs from an oration

by Cicero . . . I have said as much to him." But, Descartes continues, "this does not keep him [Ban] from being a very good musician, and a very good man, as well as my good friend."[20]

Descartes appreciated not only Ban's virtues as a person and skill on the harpsichord, but also his willingness to entertain him on that instrument from time to time. What may have made the long winters in Egmond during the 1640s passably tolerable were the evenings spent in Haarlem listening to music with his friends. Descartes, Ban, and Bloemaert—Ban's "*intime amy*" with whom Descartes was now acquainted—formed a regular little party, meeting in Ban's rooms to listen to the harpsichord and discuss various subjects, perhaps while enjoying some warming beverage (but apparently nothing too strong). As Baillet describes it, "Descartes left the solitude of Egmond from time to time to go see [Ban and Bloemaert]; and because they were hardly greater drinkers or gamblers than he was, the debauchery which they ordinarily engaged in together was some musical concert with which Monsieur Ban was accustomed to regale them."[21] Naturally, during these soirées Ban played some of his own compositions, in which, Descartes explains to Huygens, with some disingenuousness, "there is much art and beauty."[22] Ban and Bloemaert, in turn, often visited Descartes in Egmond, sometimes bringing him his mail, since Descartes had instructed correspondents such as Mersenne and Huygens to address their letters to him by way of Bloemaert.[23]

Descartes was very fond of these two Dutch coreligionists. He tells Huygens that "I find them to be such fine gentlemen [*si braves gens*], so virtuous, and so exempt from those qualities which have led me ordinarily to avoid the society of those of their robe in this country, that I count their acquaintance among the debts that I owe you."

This praise of Ban and Bloemaert occurs in a letter in which Descartes asks Huygens to intercede with the Prince of Orange on their behalf. "They desire a favor from His Highness, and

hope to be able to obtain his clemency through your intercession." Descartes does not know what the issue is, and neither do we, but he assures Huygens that Bloemaert can explain the particulars to him. (The request was most likely related to the anti-Catholic measure passed by the Haarlem town council in 1639, following which the two priests may have suffered harassment.[24]) It is a delicate enough matter that Ban, who knows Huygens well, is hesitant to approach the stadholder's secretary directly and would rather have an aristocratic equal (and someone who knows Huygens even better) like Descartes do it. In his letter, Descartes says that

> I believe that I have been with them often enough to know that they are not like those simple folk who are persuaded that one cannot be a good Catholic except by favoring the party of the king who is called "Catholic," nor among the seditious types who try to convince such simple folk of this. Rather, they are men of good sense and good morals.

They should not be despised, he tells Huygens, simply for being Catholic priests doing mission work on behalf of the pope. "If anyone should be excused [for this crime], I am certain that there is no one who deserves it more than these two." Descartes finds that their company is pleasant, even useful to him. Moreover, with regard to those critics, especially in France, who find fault with Descartes for spending his life peacefully in a Protestant nation that officially forbids Catholic worship, Descartes replies that his time with these two priests eases his religious conscience.[25]

―――――

During the musical evenings with Ban and Bloemaert, the conversation must have turned on occasion to matters related to religion. After all, these were three Catholics in a Calvinist land,

two of whom were priests and the third a philosopher. Descartes was at this time preparing to present to the Latin-reading public his *Meditations*, the second work published in his lifetime and one in which he hoped to demonstrate a number of important points of philosophical theology: the existence and nature of God and the immortality of the soul.

When Mersenne circulated the manuscript of the *Meditations* among various philosophers and theologians to gather "objections," he included the English thinker Thomas Hobbes and the French materialist Pierre Gassendi, an early modern reviver of the philosophy of Epicurus. During one of their meetings, Descartes apparently took it upon himself to ask Ban and Bloemaert if they had any theological colleagues to whom they might pass along the work for comments. They thought immediately of Johan de Kater, their friend and fellow priest in Alkmaar who had studied theology and philosophy at Louvain.

De Kater (or Caterus, as his name appears in the Latin first edition of the *Meditations*) felt "obliged in this matter to go along with the wishes of such very good friends" and responded in a letter to Ban and Bloemaert, offering a number of objections to a philosopher "of the highest intellect and the utmost modesty." He focused primarily on issues raised by Descartes's proofs for the existence of God. In the Third Meditation, Descartes argues for the existence of God on the premise that only an actually existing infinite being could be the cause of his idea of an infinite being. But De Kater wondered why an idea, which is merely a psychological item in the mind and not an actual thing in the external world, is something that needs a cause in the first place. He was also puzzled by what Descartes could mean by claiming that God is a *self-caused* being, given that ordinarily a cause is something distinct from and prior to its effect. And De Kater, like so many others before and after him, questioned the validity of the *a priori* or conceptual demonstration of God's existence that Descartes employs in the Fifth

Meditation—the so-called "ontological proof" in which he tries to show that it is impossible to conceive an infinitely perfect being such as God as *not* existing.[26]

Descartes, who addressed his response to De Kater's objections to Ban and Bloemaert, answers with an excessive politeness that, at the same time and in a condescending, backhanded way, quickly deflates De Kater's objections:

> You have indeed called up a mighty opponent to challenge me, and his intelligence and learning could well have caused me serious difficulty had he not been a good and kind theologian who preferred to befriend the cause of God, and its humble champion, rather than to mount a serious attack. But though it was extremely kind of him to pull his punches, it would not be so acceptable for me to keep up the pretence.[27]

He then disposes of De Kater's points one by one. The exchange is useful in so far as De Kater has forced Descartes, if not to retract or even revise anything he has said—humility was not one of Descartes's virtues—at least to clarify some of his arguments. He explains, for example, the way in which God's existence is "self-caused . . . in a positive sense," and not merely in the negative sense that God's eternal being is without any cause. God stands to himself as a true efficient cause in so far as God's "immense and incomprehensible power is so exceedingly great that it is plainly the cause of his continuing existence."[28]

De Kater must have talked these things over with Ban and Bloemaert before committing them to paper. Descartes was not present during these discussions, since he does not in his published reply seem to be familiar personally with De Kater. But there can be no doubt that the philosopher's views on God, and especially the central role that God plays in Descartes's epistemology and metaphysics, were topics that occupied Descartes's own time with Ban and Bloemaert between musical interludes.

Descartes's use of God is among the most problematic and controversial elements in his philosophy. It was a source of trouble from his theological critics, and it has given rise to numerous philosophical objections ever since the work's publication. While some of his clerical opponents suggested that his proofs for God's existence are so obviously bad that they must have been designed by a devious atheist to in fact undermine the belief in God's existence, more secular-minded critics protested against Descartes's resorting to God as a *deus ex machina* to solve an epistemological quandary, and they questioned the propriety of relying on matters of faith in what should be a project of rational inquiry.

Descartes appeals in the *Meditations* to God's goodness and veracity in order to justify the reliance on his own reasoning powers to achieve knowledge. Because he, Descartes, was created by an infinitely wise, powerful, and benevolent being, he can be sure that his rational faculties, when used properly, lead him toward truth. Moreover, God, as the first and sustaining cause of matter and motion, also clearly plays an extraordinarily important role in Descartes's metaphysics and in his science.

Does Descartes really need God? In epistemology, there are other ways of responding to skeptical doubts about the possibility of knowledge. It may be that hyperbolic suspicions that one is merely dreaming there is a world out there or that one is being systematically deceived by an evil God, while certainly *logical* possibilities, are not to be taken seriously, and that one should be satisfied with a very high and sufficiently practical degree of probability that one's beliefs are true.

As for what really matters to Descartes—finding perspicuous and powerful explanations of natural phenomena within the new paradigm of the mechanistic science—he himself believed that there is no need to resort to God in the daily activity of scientific inquiry. The world of Cartesian bodies is intelligible on

its own terms. Even in the seventeenth century, physics, chemistry, and biology can proceed quite well without importing theological premises.

However, Descartes was not interested in probabilities. He wanted absolute certainty. He had to be sure that indubitable knowledge, immune from skeptical attack, was possible. And he wanted the explanations provided by his science to be established with "more than moral certainty," as he says in one of the final articles of his *Principles of Philosophy* when summarizing the results of his investigations:

> There are some matters, even in relation to the things in nature, which we regard as absolutely, and more than just morally, certain. ‹Absolute certainty arises when we believe that it is wholly impossible that something should be otherwise than we judge it to be.›[29]

One can pursue physics, chemistry and the other natural sciences without God, as Galileo, Boyle, Newton, and others did.[30] Understanding the underlying corpuscular causes of natural phenomena or the mathematical laws governing them need not involve appeals to the divine nature or providential will. If, however, one is a scientist in the 1640s seeking for his work *metaphysical* foundations that are solid bedrock and that can impart absolute certainty to his conclusions, if one wants to know *why* those laws of nature are what they are—and this is precisely what Descartes wanted—then there may be no alternative to engaging in speculation on "first principles," and especially on God's relationship to human knowledge and to nature.

Descartes was always hesitant to trespass on purely theological questions and matters of revealed truth.[31] He knew what dangerous terrain that could be in the volatile religious environment of his time. But he also believed that much could be known about God—His existence, His attributes, and His

activity—and that it is imperative for the sake of achieving absolute certainty to use this knowledge to render the demonstrations of his science complete and to ground his physics in higher metaphysical principles.

———

Aside from the role that God plays in the *Meditations* justifying the human cognitive faculties and in the *Principles* serving as the ground of the laws of nature, there is yet another doctrine in Descartes's philosophy involving God that is especially revelatory of the character of his thought. It is a bold, even audacious doctrine, and it ultimately brought much trouble to its author. But Descartes regarded it not only as indispensable to his overall project, but as the only view of God's relationship to truth that fully respects God's omnipotence and freedom.

In a series of letters to Mersenne in the spring of 1630, Descartes reveals an opinion that he fears will be disturbing to many.

> The mathematical truths that you call eternal have been laid down by God and depend on Him entirely no less than the rest of His creatures. Indeed, to say that these truths are independent of God is to talk of Him as if He were Jupiter or Saturn and to subject him to the Styx and the Fates.[32]

God created the visible universe and the souls over which he stands in judgment; on this, Descartes and his philosophical and theological predecessors and contemporaries were in perfect agreement. As for the so-called "eternal verities"— mathematical and logical truths, moral truths, and metaphysical truths (for example, principles about space and time and the essences of human beings and other creatures)—earlier philosophers for the most part regarded them as independent of God's will and, thus, as uncreated.[33] God might be the cause of the

existence of this or that just action, of an actual triangular object, or of a particular human being. He is not, however, causally responsible for what the essence of justice or of triangularity is or for what human nature essentially is. What is true about triangles is determined by the eternal essence of the triangle, whether or not God actually brings any triangles into existence. What is true about justice is true even if no just actions are ever performed. Such truths are not created or determined by God; they are eternal, necessary, and absolute. What is good is objectively good, and what is essentially true is objectively true, for God as for human beings.

Descartes, however, rejects such a distinction between created world and uncreated truths. He insists that the eternal truths, too, are created things. For Descartes, even necessary and unchanging truths are ultimately, like truths about the world, contingent upon an act of the divine will. God made the world, but he also made it true that one plus one equals two. And just as he might have not made a world, so he might just as well have *not* made it true that one plus one equals two, or even have made it true instead that one plus one equals three. Similarly, "[God] was free to make it not true that all the radii of the circle are equal— just as free as He was not to create the world."[34]

Descartes does not deny that these are a special class of truths, different from empirical truths about bodies and minds that actually exist in the world. He says that mathematical truths, although established by God—and even *because* established by God— nonetheless remain eternal and necessary through the eternity and immutability of the divine will that creates and sustains them.

It will be said that if God had established these truths He could change them as a king changes his laws. To this the answer is: Yes He can, if His will can change. "But I understand them to be eternal and unchangeable."—I make the same judgment about God.[35]

Descartes apparently wants to maintain something from the distinction between necessary truths (which cannot conceivably be false) and contingent truths (which are about things that conceivably could have been otherwise). But, contrary to the traditional view, the eternity and necessity of the eternal truths is not something that belongs to them intrinsically, independently of what God (eternally) does.

What Descartes says to Mersenne about mathematical truths applies to all the eternal truths, including metaphysical and moral principles, and to all values whatsoever. It applies even to the laws of logic.

> Our mind is finite and so created as to be able to conceive as possible the things that God has wished in fact to be possible, but not be able to conceive as possible things which God could have made possible, but that He has nevertheless wished to make impossible. . . . [This] shows us that God cannot have been determined to make it true that contradictories cannot be true together, and therefore that He could have done the opposite. . . . I agree that there are contradictions that are so evident that we cannot put them before our minds without judging them entirely impossible. . . . But if we would know the immensity of His power we should not put these thoughts before our minds.[36]

God could have made mountains without valleys. And God could have made it the case that a triangle has interior angles whose sum is more or less than 180 degrees, and that a vacuum or extended space without body (a metaphysical impossibility for Descartes, for whom extension is the essence of matter) is possible. God could even have made it possible for two logically inconsistent propositions (such as 'Augustijn Bloemaert is a Catholic priest' and 'Augustijn Bloemaert is not a Catholic

priest') to be true at the same time; or for one and the same proposition to be both true and false at the same time. As Descartes puts it, "[God] could have made it false that . . . contradictories could not be true together."

The upshot is that *whatever* is true is true only because God has made it so, and that nothing is good except by God's having made it good.

> God did not will the creation of the world in time because He saw it would be better this way than if He had created it from eternity; nor did He will that the three angles of a triangle should be equal to two right angles because He recognized that it could not be otherwise, and so on. On the contrary, it is because He willed to create the world in time that it is better this way than if He had created it from eternity; and it is because He willed that the three angles of a triangle should necessarily equal two right angles that this is true. . . . If some reason for something's being good had existed prior to His preordination, this would have determined God to prefer those things that it was best to do. But on the contrary, just because He resolved to prefer those things that are now to be done, for this very reason, in the words of Genesis, "they are very good"; in other words, the reason for their goodness depends on the fact that He exercised His will to make them so.[37]

Descartes sees this doctrine as the natural consequence of a proper understanding of the divine nature. God's simplicity means that God is not a composite being, made up of parts, and thus there is no real distinction among His attributes. In particular, God's understanding is not a separate faculty from His will. "In God willing and knowing are a single thing in such a way that by the very fact of willing something He knows it and it is only for this reason that such a thing is true."[38] God's will cannot

be directed by His wisdom, by what He knows, because this would imply a distinction between two faculties and a priority of one over the other. For God to know that one plus one equals two is therefore identical with God willing that one plus one equal two. Descartes says to Mersenne that "you ask what God did in order to produce [these truths]. I reply that from all eternity He willed and understood them to be, and by that very fact He created them. Or, if you would reserve the word 'created' for the existence of things, then He established them and made them. In God, willing, understanding and creating are all the same thing without one being prior to the other even conceptually."[39]

Descartes also regards the creation of the eternal truths as the only position that is consistent with God's omnipotence. "The power of God," he insists, "cannot have any limits": not moral limits by objective and independent values, and—what his medieval predecessor were not willing to concede—not even logical limits. "I do not think that we should ever say of anything that it cannot be brought about by God. For since every basis of truth and goodness depends on his omnipotence, I would not dare say that God cannot make a mountain without a valley, or bring it about that 1 and 2 are not 3. I merely say that He has given me such a mind that I cannot conceive a mountain without a valley, or a sum of 1 and 2 that is not 3; such things involve a contradiction in my conception."[40]

For Descartes, then, divine omnipotence requires not only that God enjoy complete independence of being and power, but also the total dependence of everything else upon Him. This means that God is the cause not only of the existence of things but also of their essences. This, in fact, is precisely how Descartes's God creates the eternal truths. By establishing the essential nature of the triangle to be what it is—and He could have made it different from how it in fact is, although *we* cannot

possibly conceive a triangle otherwise than having the proper-
ties it does—God thereby causes there to be certain truths about
triangles. "You [Mersenne] ask me by what kind of causality
God established the eternal truths. I reply: by the same kind of
causality as He created all things, that is to say, as their efficient
and total cause. For it is certain that He is the author of the es-
sence of created things no less than of their existence; and this
essence is nothing other than the eternal truths."[41]

Descartes's God is thus an absolutely free God, a deity who is
not guided or limited by any independent laws, principles, stan-
dards, or values. The Cartesian God is bound by no objective
canons of rationality or morality. When God creates truths, He
does so "freely and indifferently."[42] It is, Descartes claims, "self-
contradictory to suppose that the will of God was not indiffer-
ent from eternity with respect to everything that has happened
or will ever happen."[43] Such a God is not rationally determined
to make the choices He makes. He does not do what He does
for objective reasons, because all such reasons—moral, meta-
physical, and logical—are but effects of His will. "The supreme
indifference to be found in God is the supreme indication of His
omnipotence."[44]

Descartes was well aware of the originality and contentious-
ness of his position. He encouraged Mersenne "not to hesitate
to assert and proclaim everywhere that it is God who has laid
down these laws in nature just as a king lays down laws in
his kingdom," but he also asked Mersenne "not to mention my
name."[45] Although he eventually abandoned this caution and
explained the doctrine in letters to others and even in some of
his published writings, his hesitations were justified. His view
became so controversial in the second half of the seventeenth
century that even some of his most devoted followers could not
accept it.[46] No one before or after Descartes was willing to go

so far and to defend, with so much confidence, such a bold and radical position on God's power.

––––––––––

At the foundation of Descartes's mechanistic cosmos lies an arbitrary divine power. God's omnipotent creative will is beyond reason and operates in a manner that bears no resemblance whatsoever to rational human agency.[47] At the same time, Descartes insists in the *Principles of Philosophy* that despite this infinite divide between God and creation and between the human and the divine, he can through reason alone understand God's nature and use that knowledge to further his scientific project.

Descartes seems not to have been aware of any tension between these two doctrines. If God is an arbitrary agent that is truly beyond human rationality, how could one possibly conclude anything with certainty about what God *must* (or even might) do in creating the world? But Descartes's theological critics were bothered by something more important than a problem of philosophical consistency. They were outraged at the idea that one could logically derive truths about nature from an examination of God's attributes. If the laws of the world follow from God's nature with deductive *necessity*, as Descartes argues, then there is no choice involved, no possibility of God acting otherwise, and this would seem to undermine any freedom that God might have had when creating the world and its laws.

Those critics were even more incensed by the fact that in Descartes's derivation of the laws of nature, divine wisdom and providence apparently play no role whatsoever. For Descartes the scientist, God does not choose the laws of nature because those laws are better than some other set or because they serve some higher purpose at which God is aiming. The philosopher Gottfried Wilhelm Leibniz, for one, believed that a perfectly good God chose "the best of all possible worlds," and that

part of what makes the actual world better—more harmonious, more beautiful—than the infinitely many other possible worlds that God did not choose are the laws that govern it. Descartes, however, will have none of this. In his arguments for the laws governing the mechanical operations of this (or any) world, there are no appeals to any features of God other than His immutability and simplicity. Wisdom, justice, goodness, and providence do not enter into the picture.[48] It is understandable why Descartes's religious opponents objected that his God was a merely hypothetical, philosophical deity.

The most serious theological objections to Descartes's philosophy, however, were directed at further speculations about God's *modus operandi*, speculations that were no less bold than his doctrine of the divine creation of the eternal truths and his theological-metaphysical derivation of the laws of nature. In this case, however, Descartes entered even more dangerous terrain, and he knew it. Against his own better judgment, Descartes violated his policy of not speculating on matters of revealed theology. He thereby exposed himself not only to philosophical and theological concerns about his use of God, but to sectarian religious attack over his account of one of the most sacred and important mysteries of the Catholic faith.

One set of objections to the *Meditations* that Mersenne forwarded to Descartes came from a young theologian preparing to become a member of the Sorbonne, Antoine Arnauld. Still in the process of completing his doctorate when he wrote his objections, and not yet ordained as priest, Arnauld would go on to become one of the most important (and controversial) theological figures of the seventeenth century. He would also become a devoted Cartesian in his own right, and a vehement defender of the new philosophy.

Arnauld came from a prominent Catholic family of the *noblesse de robe*. Over several generations, university-trained counselors

from this aristocratic clan served the French court in various administrative capacities. Many Arnaulds of Antoine's generation were also deeply enmeshed in the French Jansenist movement. Based at the abbey of Port-Royal, the Jansenists defended an austere Augustinian brand of Catholicism and radical views on divine grace. Because of their reforming zeal, anti-Jesuit activism, and refusal to compromise on even the most minor points, the men and women of this movement were relentlessly attacked by their more orthodox (and more powerful) opponents. By the second half of the century, the Jansenists were embattled on many fronts: the French king, the French ecclesiastic establishment, the pope, and even some Reformed theologians all sought to destroy the nuns of Port-Royal, the male *solitaires* who lived nearby and supported them, and sympathetic fellow travelers. Arnauld was the group's leading intellectual, a brilliant but irascible polemicist who showed no mercy in his theological and philosophical disputes.[49] Consequently, he was the prime focus of the anti-Jansenist fury, and eventually he had to flee to the Netherlands for safety.

When he was still a student at the University of Paris's faculty of theology, the twenty-eight-year-old Arnauld had been given a copy of the manuscript of the *Meditations* by Mersenne. Toward the end of his very astute philosophical objections—which Descartes says are "the best of all"[50]—Arnauld turns to what he calls "points which may cause difficulty to theologians."[51] One such point caused him particular trouble.

According to the Catholic Church, when a priest during mass says the words "*hoc est corpus meum*" ("this is my body") over the bread of the Eucharistic sacrament (and "this is my blood" over the wine), the bread is miraculously converted, or "transubstantiated," into Christ's body (and the wine likewise into Christ's blood). However, the sacrament still looks, tastes, and smells like bread. The Scholastic explanation of this myste-

rious phenomenon adopted by the Church in the Middle Ages was couched in Aristotelian terms. When the sacramental blessing is uttered, the *accidents* or nonessential properties of the bread—its visual appearance, its taste, and so on—remain but they no longer inhere in an underlying bread *substance*. But neither could they inhere in the body of Christ, since it would be unacceptable to say that Christ literally has the look, smell, and taste of bread. What God does is suspend these sensible bread properties—which in Aristotelian terms are just "real qualities" or "accidental forms," distinct from the "substantial form" that makes a piece of matter bread[52]—while replacing the substance of the bread with the substance (but not the sensible appearances) of Christ's body. The bread-like sensible qualities persist despite this substitution of the substance of Christ's body, which now lies underneath them. That is why what is now really (in its substance) Christ's body still looks, smells, feels, and tastes like bread.

In the mid-sixteenth century, the Council of Trent, seeking to counter Reformation attempts to reduce Christ's presence in the host to a merely symbolic one, declared that what is absolutely nonnegotiable about the Eucharist is the "real presence" of Christ in the sacrament. Over time, the particular explanation of this miracle through the categories of Scholastic-Aristotelian philosophy became practically just as much a part of Catholic dogma as the "transubstantiation" of the Eucharist itself, so much so that denying the Aristotelian explanatory details was taken to be equivalent to denying the event.

Toward the end of his objections to Descartes, Arnauld wonders how Descartes's theory of matter can possibly be consistent with the Catholic doctrine of real presence.

What I see as likely to give the greatest offense to theologians is that according to [your] doctrines it seems that the Church's teaching

concerning the sacred mysteries of the Eucharist cannot remain completely intact. We believe on faith that the substance of the bread is taken away from the bread of the Eucharist and only the accidents remain. These are extension, shape, color, smell, taste, and other qualities perceived by the senses.[53]

By identifying body with extension, Descartes has eliminated Aristotelian substances and their forms and real qualities from nature. He has also thereby emptied the physical world of many familiar qualitative sensory features, such as color, taste, and smell. These are now only perceptions in the human mind caused by the way the body to which it is united is affected by external material things. What remains in a Cartesian body is only shape, size, and mobility. Thus, the sensible aspects of the bread are only appearances. They are not real properties in the bread but merely mental phenomena caused by matter in motion. The perceived color and taste of the bread—the sensory *experience* of bread—have no existence outside the human mind.

On Descartes's account of the world, then, the notion of sensory qualities like color, smell, and taste subsisting by themselves despite a change in underlying substance (from the substance of bread to the substance of Christ), so central to the Church's explanation of Eucharistic transubstantiation, is ruled out in principle. How is it, then, Arnauld wonders, that after transubstantiation the faithful still perceive bread? He warns Descartes that unless he can reconcile his metaphysics with what the Catholic Church teaches concerning the Eucharist, "he may appear to have endangered the very faith, founded by divine authority, which he hopes will enable him to obtain that eternal life of which he has undertaken to convince mankind."[54]

In his response to Arnauld, Descartes explains why, on his principles, one still perceives, smells, and tastes bread although

the substance of the bread has been replaced by the substance of Christ's body. What affects a person's senses and causes him to have the particular perceptions of color, taste, shape, size, texture, and smell of an external body is solely the material surface texture that constitutes the complete outer dimensions of the body. This surface involves not only the external shape or outline of the body, but also the shape of all the minute gaps between the particles composing the outermost layer of the body. When this textured surface comes into contact with a person's sense organs—directly (by touch or taste) or through an intervening medium (by sight or by smell)—it causes a very specific set of sensations and perceptions in that person's mind. And any parcel of matter whatsoever having that same outer particulate configuration will affect the sense organs, and hence the mind, in exactly the same way, with exactly the same sensory appearances.

What happens in transubstantiation, Descartes proposes, is that through God's action, the bread is changed into Christ's body in such a way that the substance of Christ's body is now contained within exactly the same total surface configuration and dimensions that the substance of the bread formerly occupied. Although what was once bread is now Christ's body, it has the identical particulate texture in its outermost parts. Hence, Christ's body will affect the senses in exactly the same way as the bread did, and this is why it looks, tastes, and smells just like bread.[55]

The ever-perceptive Arnauld, while expressing satisfaction with this account in a letter several years later, nonetheless recognizes that there is a problem of consistency here. If, for Descartes, a body is constituted by its extension alone, by the spatial configuration of its material particles, then if in the sacrament Christ's body takes on the extension and dimensions of bread, it does not just look, smell, and taste like bread—it *is* bread, *real bread*. So what, Arnauld wonders, has become of

"real presence"? Transubstantiation from bread to Christ seems in fact to have become transmogrification of Christ to bread.[56]

Descartes, playing it safe, did not give Arnauld an answer to this question. He says that because the Council of Trent has determined that the way in which Christ exists in the sacrament "can hardly be expressed in words," he would prefer not to put a response in writing. In a follow-up letter, Arnauld presses him: "You will oblige me very much if you would communicate to me something concerning the mode in which Jesus Christ is in the Eucharist."[57] In his letter of reply, Descartes, sensing that there is nothing to be gained by pursuing this issue any further except a good deal of ecclesiastic trouble, does not respond to the request at all.

As Arnauld discovered only many years later, Descartes did in fact have an answer to his question. Ever bold, yet always cautious, Descartes had, by the time of this later correspondence in 1648, already formulated a theory concerning the "mode" of Christ's presence in the Eucharist. Writing to the Jesuit priest Denis Mesland in 1645, just before Mesland departed for missionary work in Martinique and Santa Fe, Nouvelle-Grenade (now Bogota, Colombia),[58] Descartes was willing to present his "conjectures" on this issue, but only on the condition of anonymity.

What constitutes a human body, Descartes says, is not any determinate parcel of matter. The material composition of a person's body is continuously changing over his lifetime; by the time a person is full-grown, it is likely that no part of the matter making up his body belonged to the original set at birth. What gives identity to a human body is not the matter itself, but rather the union of this matter with a particular soul over a period of time. What makes Descartes's body, rather than some other parcel of matter, "Descartes's body" is its union with the soul that is Descartes. "And so, even though that matter changes, and

its quantity increases or decreases, we still believe that it is the same body, *numerically the same body*, provided that it remains joined in substantial union with the same soul."[59]

Digestion and nutrition, for example, take place when the small particles of food that have been ingested become a part of one's body by dissolving in the stomach, passing into the veins and bloodstream, and thereby uniting with that matter which, in turn, is united with the soul. This "natural transubstantiation" is an illustration of the supernatural transubstantiation that occurs in the Eucharistic sacrament. The bread of the host is transubstantiated into Christ's body by means of a union with Christ's soul brought about by God.

> I see no difficulty in thinking that the miracle of transubstantiation which takes place in the Blessed Sacrament consists in nothing but the fact that the particles of bread and wine, which in order for the soul of Jesus Christ to inform them naturally would have had to mingle with his blood and dispose themselves in certain specific ways, are informed by his soul simply by the power of the words of consecration.[60]

When Descartes's friend Claude Clerselier published his collection of Descartes's correspondence in 1657, he wisely did not include this letter to Mesland. He knew that its "novelties" would be found "suspect and dangerous."[61] The problem is that this Catholic philosopher is sounding very much like a Calvinist. According to the Reformed Church, which rejects the Catholic dogma concerning real presence, Christ is present "only spiritually" in the Eucharistic host. It is no wonder that when Descartes tells Mesland that the sacramental bread becomes Christ only because of the presence of Christ's soul (but not his body), he warns his friend, who will soon be explaining transubstantiation to the people of the Caribbean and South

America, that should he communicate it to anyone else "please do not attribute its authorship to me."

In 1663, thirteen years after his death, Descartes's works were placed on the Index of Prohibited Books by the Sacred Congregation of the Index in Rome. It was noted that they were to remain on the list *donec corrigantur*, "until corrected." There is no explicit mention in the notice on the Index of what exactly the Catholic Church's censors found troubling about the *Meditations* and other writings. But scholars have long suggested—and recent research on the censors' reports found in the Vatican's archives confirms—that among the problems were the implications of Descartes's metaphysics for the Eucharist.[62]

———

In the summer of 1644, the discussions over these matters between Descartes and his two priest friends, along with the musical diversions in Ban's rooms, came to an end. Writing in August to Mersenne in Paris, Huygens says that he would prefer "to be able to avoid giving you the sad news of the passing of poor Monsieur Ban, suddenly carried away by a catarrh, followed by a weakness during the night when he thought that he had overcome his sickness. . . . He is mourned by the Graces and the Muses." Huygens's opinion of Ban's talents was somewhat different from Descartes's: "As I have always said, there was something considerable in his principles, although practice did not really flourish in his hands; for it is one thing to know much about poetics, and another thing to be a good poet. Alas, a good friend is lost. But it is God's will."[63]

Descartes, who was in France at the time, was told of Ban's death upon his return to the Netherlands by Bloemaert, although he probably learned about it earlier, while in Paris, from Mersenne.[64]

Baillet says that after this brief French sojourn "Descartes went directly to North Holland, retreating to Egmond Binnen, resolved to shut himself off more deeply than ever in his former solitude and, far from the interruptions of his neighbors and visits from his friends, to apply himself to the knowledge of animals, plants, and minerals."[65] This is certainly an exaggeration. Descartes may have desperately wanted some respite from the disputes over his philosophy now roiling the universities at Utrecht and Leiden. And he was fond of calling his house in Egmond "*mon hermitage*." But it was not only his research that gave him solace at this time. He had quite a few good friends in the United Provinces—including Huygens; Brasset; Alphonse Pollot, a Frenchman and courtier to the Prince of Orange whom Descartes visited in The Hague; and Cornelis van Hogelande, a fellow Catholic and physician in Leiden. There is no reason to think that he did not continue to enjoy their company from time to time. Bloemaert, especially, seems to have remained a valued companion over the years, someone who, even without the diversion of Ban's music, could relieve the dreariness of a Dutch winter and the isolation of scientific research with good conversation.

By early 1649, however, it looked like the quiet life in the country might soon be over. Descartes was being summoned by royalty.

While carrying out his diplomatic duties in Stockholm, Pierre Chanut had brought Descartes's works to the attention of Sweden's Queen Christina. This was done with Descartes's approval. Although he tells Chanut, in late 1646, that "I have never been so ambitious as to desire that persons of that rank [as the queen of Sweden] should know my name," he nonetheless thought that some royal patronage would be a good thing to have in unsettled times. Given recent attacks by "countless

Schoolmen, who look askance at my writings and try from every angle to find in them the means of harming me, I have good reason to wish to be known by persons of greater distinction."[66]

In this same letter, Descartes also remarks to Chanut that, unfortunately, there seems to be little chance that the two of them will have the opportunity to "converse privately" in the near future. "I would count myself extremely fortunate, I assure you, if I could do this with you; but I do not think I shall ever go to the places where you are, or that you will retire to this place."[67]

In fact, within three years Descartes was packing his trunks to visit Sweden. Christina now wished to see the philosopher himself in her court. He really did not want to go. He especially did not want to give up his comfortable and productive routine in Egmond. In the spring of 1649, he wrote to Brasset in The Hague and expressed his reluctance to leave the Netherlands "in order to go live in a land of bears, rocks and ice."[68]

But the queen was persistent. She and Descartes had first corresponded in late 1647, with Descartes responding to her request that he explain "my view of the supreme good understood in the sense of the ancient philosophers,"[69] despite the fact that, as he tells Chanut, "I normally refuse to write down my thoughts concerning morality."[70] Then, in 1648, Chanut gave Christina an advance copy of the *Passions of the Soul*. In this work, published the following year by Elzevier in Amsterdam, Descartes finally fulfills his promise to offer an account of the human soul in its union with the body. After presenting the basics of human physiology (essentially the material from the *Treatise on Man*), he proceeds to examine the relationship between the soul and the body, and especially the ways in which the soul is affected by motions communicated to the pineal gland in the brain by the nerves. He describes the nature of the various human emotions or passions—love, hate, hope, jealousy,

envy, desire, etcetera—as these are manifested both bodily and spiritually, by motions in the blood and by the "agitations" and "excitations" in the mind that they cause.

Queen Christina may or may not have read the treatise, which touches on such topics as friendship, fortune, virtue, and happiness. Given her interest in Descartes's views on ethical matters, she must at least have either asked Chanut to explain its contents or had her attendants study it for her.[71] She wrote to Descartes (nearly a year later) to thank him for the work and to let him know how great was her esteem for him. "These pieces have confirmed me in the good opinion of you that M. Chanut has given me."[72] She was even more intrigued when Chanut introduced her to the *Principles of Philosophy*. Finally, in February 1649, Chanut was asked by the queen to issue a formal invitation to Descartes to visit Sweden, if only for a short time, until the long Swedish winter settled in. Her desire was that he should serve as her tutor in philosophy and provide lessons in Cartesian science.

Descartes was reluctant to go for even a few months. While flattered by the honor, he much preferred to stay in Egmond and continue working on the *Passions* and on the planned additional parts of the *Principles*. He wavered over whether or not to accept the invitation. It was not just a matter of the inconvenience. Never a good traveler under the best circumstances, he told Chanut that he was afraid that on the voyage to Sweden "I shall simply find myself waylaid by highwaymen who will rob me or involved in a shipwreck which will cost me my life."[73] After months of dithering, a conversation with Chanut when the ambassador was passing through the United Provinces in May 1649 finally persuaded Descartes to undertake the journey. He told Princess Elizabeth a month later that "I still intend to go there [Sweden] provided the Queen indicates that she still wishes me to. A week ago Monsieur Chanut, our resident

in that country, passed through here on his way to France. He spoke so glowingly of this marvelous Queen that the voyage no longer seems so long and arduous as it did previously."[74] Descartes procrastinated further, however, and in the end did not actually depart until September, just as the Swedish summer was coming to a close. He would never return to his beloved *hermitage* in Egmond.

———

No one was sadder over Descartes's impending departure than Augustijn Bloemaert. The priest would miss their warm personal friendship and philosophical discourse. Over the past five years, with dear Ban gone, Bloemaert counted on Descartes's visits to Haarlem for company and for intellectual stimulation. Perhaps they still talked about Ban's music and reminisced about his concerts.

Baillet says that on the eve of Descartes's Scandinavian adventure "several of his friends in Holland who wanted to come to Amsterdam [from where Descartes would sail to Sweden] to say good-bye could not leave him without expressing their affliction that [Descartes's] premonitions about his destiny gave them." He adds that "among those who were most touched by [Descartes's departure] was the pious Monsieur Bloemaert, whom [Descartes] saw in Haarlem on frequent and extended visits during his time in Egmond."

Not satisfied with a simple good-bye, and certain that he would never see his friend again, Bloemaert wanted a memento before Descartes set sail. "Monsieur Bloemaert could not let Descartes leave without taking the liberty of having him captured by a painter, in order that he might at least find some light consolation in the copy of an original that he risked losing."[75] The priest was quite familiar with Haarlem's art world, as many of the paintings in his collection were by local masters.

He knew what his town's artists were capable of, where to turn for what kind of a work. But to whom did Bloemaert go for his keepsake? Did he, in fact, seek out the best that Haarlem had to offer: someone whose talents surpassed even those of the late Cornelis Cornelisz (two of whose paintings Bloemaert owned, including a portrait of Christ) and who was now regarded as the premier portrait painter in the city, and perhaps in all of the Dutch Republic?

CHAPTER 8

The Portrait

A Catholic priest wanted a portrait of his philosopher friend before his departure abroad. Did Augustijn Bloemaert turn to Frans Hals for this souvenir of a deeply valued, decade-long companionship? It would not have been that unusual a commission for the Haarlem master, although his orders usually came from a more elite clientele in a time when there was plenty of money for such things.

In Holland in the first half of the seventeenth century, as the Dutch Republic flourished economically, there was a corresponding rise in the demand for portraits. Artists could hardly keep up with what one art historian has called a "rage for portraiture."[1] In particular, those Haarlem painters who enjoyed a high reputation in this genre—Hals, Johannes Verspronck, Jan de Bray, Pieter Claesz Soutman, and others—were enjoying the trickle-down benefits of the province's prosperity. Their commissions increased with the emergence of a class of nouveau riche interested in spending their wealth and marking their social status.

Urban *burghers* with significant incomes decorated their homes with large and impressive paintings on biblical subjects and "history" themes from classical literature, just as the landed gentry did before them. They also had a taste for seascapes and

landscapes (especially local scenes), and for still lifes showing lush arrangements of flowers, fruits, and vegetables, as well as more austere *vanitas* settings.[2] Above all, they wanted to see themselves, and for others to see them. The brewers, textile magnates, and other affluent individuals who now dominated Haarlem's civic life wanted themselves and their families on show for their contemporaries and preserved for future generations. Frans Hals, with his brilliant gifts as a portraitist, was fortunate enough to live just when his city's economy—and the desire for immortality—peaked and when its citizens needed his talents most.[3]

More than half of Hals's paintings are of now-anonymous sitters. Like so many of the portraits from the Dutch Golden Age—and those that are extant are only a fraction of the total number painted; most are long lost[4]—we simply do not know who most of these respectable, well-dressed individuals are. A fair number of Hals's subjects, however, are easily identified; the names of others have been discovered by archival work (including such documentary support as notary records and estate inventories) and through secondary evidence (such as engravings made after painted originals). The results of this historical research provide a good picture of the sources of Hals's patronage.

Hals was most definitely not a court painter. Unlike Van Dyck and Rubens, Hals never received any commissions from royalty. There are no portraits of kings, princes, or their consorts—or even of stadholders—in his oeuvre. He did, however, receive many commissions from the upper economic and social strata of Haarlem.[5] The families who made up the local patrician class— not just owners of breweries and textile manufacturers, but prosperous professionals and merchants as well—constituted the most important set of Hals's clients. He painted individual and family portraits of Haarlem's leading clans and group portraits of the guilds, military guards, and civic organizations

whose ranks they filled. As Seymour Slive says, "what other artists did for kings, Hals did for a citizen of Haarlem."[6]

No family was more prominent in Haarlem society than the Olycans. Members of this large, wealthy clan of brewers—they owned a number of local establishments—played a highly visible and influential role in the city's economic, political, and social life. Pieter Jacobsz Olycan and his brother Cornelis, as well as their many sons and sons-in-law, in addition to keeping the city's beer flowing, took their turns as *burgemeester*, sat on the city council, and served in the civic guard. Hals painted eighteen portraits of members this extended family, either individually or (as in the case of Pieter's son Nicolaes, owner of "The Little Ship" brewery and a lieutenant in the St. Hadrian guard) as part of a group.[7]

Hals painted portraits of many other brewers and their wives, including Johan Schatter (owner of "The Crowned Diamond" brewery), Willem Claesz Vooght, Andries van Hoorn (Pieter Olycans's son-in-law), and Nicolaes van der Meer. He also received commissions from the other major branch of Haarlem's economic elite, the textile magnates, both those of long-standing residence in the city and more recent arrivals from Flanders. There are portraits of Willem van Heythuysen, Tieleman Roosterman and his wife Catherina Brugman, and Lucas de Clercq and his wife Feyntje van Steenkiste, as well as several members of the multi-branched Coymans family. These privileged sitters were clearly pleased with Hals's work, even with his "rough" or loose painting style and relaxed posing, so different from the typical portrait. Word obviously got around—and sometimes even beyond the confines of Haarlem—that for a certain type of portrait *naer het leven* ("according to life") he was the artist to go to.

Not all of Hals's subjects came from the world of business and the upper echelons of society. He painted portraits of preachers (Samuel Ampzing, Jacob Zaffius, Caspar Sibelius), theologians (Johannes Hoornbeeck, Jacob Revius), and historians and writ-

ers (Pieter Bor, Theodore Schrevelius). The historian and poet Pieter Schrijver and his family seem to have been particularly taken by Hals. Not only did Schrijver commission portraits of himself and of his wife Anna van der Aar, but the estate of his son Willem included a number other paintings by Hals: three small pictures from the series *The Five Senses* and three inherited family portraits; it was the second largest collection of Hals paintings in the period.[8] In contrast with the larger, sometimes life-size portraits of wealthy clients, many of the portraits painted by Hals of his religious, intellectual, and literary contemporaries were small, and were destined to be reproduced as engravings to illustrate and promote the works of authors, such as Schrevelius's *Harlemias*.[9] Hals's talents were also appreciated by his fellow artists, and some of his portraits are of other painters, including Haarlem's Adriaen van Ostade and Jacob van Campen, the Amsterdam marine painter Jan van de Capelle (who also owned nine of Hals's works), and, before their falling out with Hals, Jan Miense Molenaer and his wife Judith Leyster.

Hals also, on very rare occasions, painted himself. He certainly lacked Rembrandt's fascination with his own evolving visage and moods—but then again, so did every other artist. There are a small number of likenesses of Hals by his own hand. One is the image of his face inserted among the members of the St. George Militia Company in 1639. There was also an individual self-portrait, a chest-length rendering in which a hat sits jauntily over the same albeit somewhat thinner countenance. This painting, now lost, was most likely done some ten years after the final rendering of the St. George officers[10]—that is, right around the time that Augustijn Bloemaert was seeking a portrait by which to remember his departing friend.

There are five extant original works of art from the seventeenth century that are said to be portraits of the great philosopher

René Descartes and that are datable to within his lifetime: three paintings, one drawing, and one engraving (made after a drawing by the same artist).[11] It is impossible to know with certainty how many of them really *are* of Descartes. There is an undeniable family resemblance among these representations. But there are also enough differences to arouse doubts about at least one of them.[12]

The earliest image of Descartes is an engraving by Frans van Schooten the Younger (ca. 1615–1660). Van Schooten was the son of a mathematics professor at the University of Leiden, Frans van Schooten the Elder, with whom Descartes was acquainted through their shared intellectual interests. The son, likewise a mathematician—he would take up his father's position at the university—and sympathetic to Cartesian philosophy, also had decent artistic skills. Van Schooten the Younger also had a personal relationship with Descartes, and there are a few letters that testify to their friendship. Writing from Egmond in April 1649, Descartes expresses his gratitude to Van Schooten for sending him reading and writing materials:

> I thank you for the books and all the other goods that it pleased you to send me. I have never been as well furnished with pens as I am now; and, provided that I do not lose any, I have more than I will need to continue writing for another hundred years. This will give me cause to think of you whenever I have a pen in hand. And it has been much more easy to divide 12 by 3 . . . than it would have been if I had not had such good pens.[13]

The two men also collaborated professionally. In the 1630s, when Descartes needed illustrations for the scientific and mathematical essays accompanying the *Discourse on Method*, he turned to Van Schooten. The artist-mathematician produced a number of woodcut prints representing, with geometrical preci-

sion, Descartes's theories and experiments. In 1649, Van Schooten translated Descartes's *Géometrie* into Latin, with his own insightful commentary, to be added to the already published Latin edition of the *Discourse* and other essays.[14] Descartes was not overly impressed with Van Schooten's Latin style— "*son Latin n'est pas fort elegant*," he wrote—but did not take the opportunity to review it before publication; that, he says, would have "obliged me to change everything, so I completely dispensed with it."[15]

Thus, the drawing and subsequent engraving that Van Schooten the Younger did of Descartes in 1644, which he later proposed as a frontispiece for his Latin version of the *Géometrie*, were made by someone who was directly acquainted with Descartes, and were probably done from life. One of Van Schooten's pupils, Erasmus Bartholinus, who presumably had met Descartes, said to a friend that this portrait, of which he owned two prints, "represents [Descartes] exactly according to nature, as far as I and others can judge."[16] Descartes himself was not totally displeased by the likeness. Writing to Van Schooten several years later, when the artist sent him the engraved image for the *Géometrie*, he says that "*je le trouve fort bien fait*" ("I find it very well done"), although he adds that "the beard and the dress do not at all resemble [me]." He also did not like the fact that the motto around the portrait mentions his title (as "Lord of Perron") and date of birth—"I have an aversion to all sorts of titles, as well as to those who make horoscopes"—and he preferred that the image not be printed in the book at all, a wish that Van Schooten respected.[17]

Probably around the time that Van Schooten was making his engraving, the painter Jan Lievens (1607–1674) produced a drawn portrait of Descartes. Originally from Leiden, Lievens apprenticed with Pieter Lastman in Amsterdam in 1617, just a few years before his fellow Leidener Rembrandt served the same

FIGURE 16. Frans van Schooten the Younger, *René Descartes*, 1644.

master. Although after his apprenticeship Lievens returned to Leiden to set up his own studio (at the age of twelve!), by 1631 he was in England, followed by periods in Antwerp, Amsterdam, and The Hague, finally returning to end his career in Amsterdam. Lievens was acquainted with Constantijn Huygens, and Descartes might have sat for him while visiting his friend in The Hague, where Lievens (if he was not a resident of the city at the time) would have been carrying out one of his commissions for the Prince of Orange. Lievens's drawing of Descartes, in black chalk and perhaps done just before Descartes left for a trip to Paris, shows the philosopher in a relaxed pose; with his finger in the air, he seems to be making an illuminating point for our benefit.

The Van Schooten engraving is an authentic portrait of the philosopher. This is confirmed by the words on the banner with which the artist surrounds the image of his friend. In the case of the Lievens drawing, the evidence for authenticity is more circumstantial but fairly compelling. Both works were almost certainly done from life.

In 1647 or 1648, Jan Baptiste Weenix (1621–1660?), a Dutch painter of genre scenes, produced a portrait generally supposed to be of Descartes (color plate 10). Weenix's painting shows a somewhat careworn philosopher—pale skin, puffy eyes, and jowly face—holding a book open to a page with the words *Mundus est fabula*, "The world is a fable." This is presumably

an allusion to Descartes's claim that the theory of the cosmos that he presents in *The World* is to be taken as just a story about how things *might* have come about solely by the lawlike interaction of bodies in motion, without the divine design described in the Bible.

It must be said, however, that the individual in the Weenix portrait—with his round, fleshy face—hardly looks like the philosopher who appears in the other works, which are contemporaneous with it; in fact, it is hard to believe that it *is* the same man. Either this is not really a portrait of Descartes—perhaps *"mundus est fabula"* refers to some other thinker's cosmological idea—or it was not done from life. The incongruity with all other known images of Descartes remains a mystery.

Pieter Nason's half-length portrait of Descartes is from 1647.[18] Nason had studied with the Amsterdam painter (and Rembrandt's neighbor) Nicolaes Eliasz Pickenoy, and set up his own studio in The Hague sometime in the late 1630s. Although now regarded as a minor figure in the history of art, he was able to secure some major commissions, including portraits of Charles II of England and an imaginary group portrait of four generations of Princes of Orange. In the painting of Descartes, a gloved hand emerges from the philosopher's black cape to grasp the painted oval frame around him. Although Descartes was in The Hague from time to time and the portrait could be from life, there is no documented connection between Nason and Descartes or any of Descartes's acquaintances, and no evidence that Descartes actually sat for Nason.[19] In fact, the painting so resembles the engraving by Van Schooten that—assuming the painting's 1647 dating is correct—it was possibly copied from it.[20]

This brings us, finally, to 1649, when Descartes is supposed to have sat for a painting so that, as Baillet says,[21] Bloemaert might have his souvenir. But what became of the painting of Descartes made for the Haarlem priest? Where is it? And did

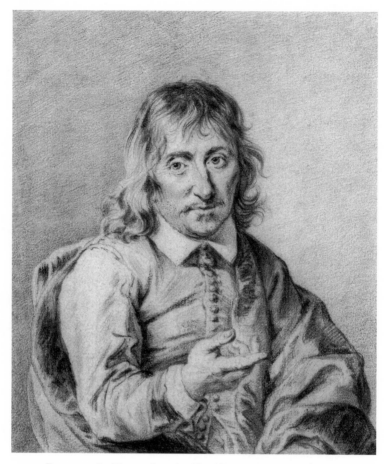

FIGURE 17. Jan Lievens, *Portrait of René Descartes*, ca. 1647, drawing
(Collection Groninger Museum)

Bloemaert in fact go to Frans Hals, his fellow Haarlemer, for this highly personal work?

The Royal Museum of Fine Art in Copenhagen owns two paintings attributed to Hals. One is a life-size, half-length portrait, on canvas, of an unidentified man. The other is a small (19 cm × 14 cm) oil painting on wood panel, said to be a portrait of Descartes (color plate 8).

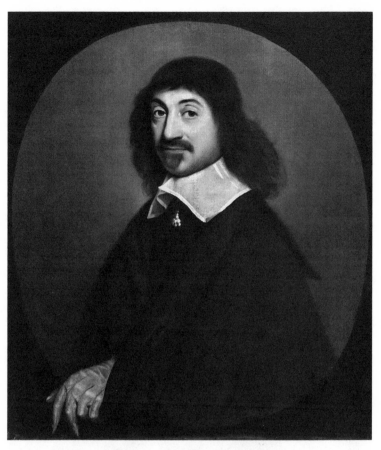

FIGURE 18. Pieter Nason, Portrait of René Descartes, 1647
(Collection of Alfred and Isabel Bader)

While there have been a few scholarly naysayers over the
decades about the artistic authenticity of this panel, the con-
sensus among art historians and curators is that the painting is
indeed by Hals.[22] This determination is supported by stylistic
analysis and informed connoisseurship. It is also what a reason-
ably experienced layperson viewing the painting might expect.
The painting closely resembles other portraits by Hals in this

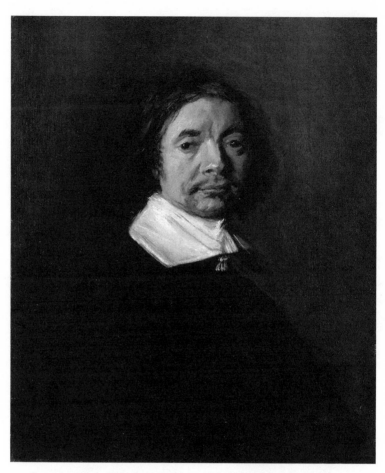

FIGURE 19. Frans Hals, *Portrait of a Man*, c. 1660 (Mauritshuis, The Hague)

period. The "rough" manner in which the paint is handled, the dark setting, the impressionistic rendering of details (especially clothes), even the pose of the sitter and the expression on his face, seem much like those of other late paintings. The burden of proof would seem to be on those who doubt that this is an authentic Hals.

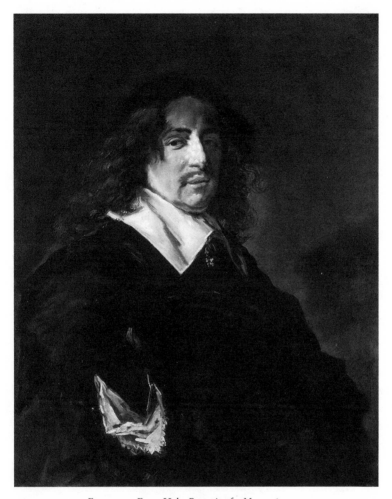

FIGURE 20. Frans Hals, *Portrait of a Man*, 1650–53
(State Hermitage Museum, St. Petersburg)

Is this picture a portrait of Descartes? Absolute mathematical certainty, of the kind Descartes sought for his science, is not to be had on this question. Still, there is no reason to doubt that it is Descartes depicted in the painting, and there are compelling

circumstantial reasons to believe that it is. With one exception—the painting by Weenix—all of the other contemporary portraits that are supposed to be of Descartes, including the one that was produced by an artist-friend and further authenticated by a contemporary who also knew Descartes personally, seem to show the same man, and the portrait by Hals fits well in this family grouping.

Like the other paintings and drawings, the Hals portrait—done within the same five-year period, when Descartes was in his late forties to early fifties—depicts a man in middle age. He has shoulder-length dark hair, tousled with a slight part in the center. His moustache is neatly trimmed, and he has a small patch of beard just under his lower lip. There is a long, prominent nose and heavy-lidded eyes under dark, arching eyebrows. Except for the Weenix portrait, the man in all these works has a fairly thin, bony face. (As if all of this visual evidence were not enough, there is a print with text from the same period that, as we shall see, confirms that the Copenhagen panel is a portrait of Descartes.)

So, there is a portrait of Descartes by Hals—one that is very much like other Hals portraits from the late 1640s and 1650s—and it is now in Copenhagen (acquired at the end of the nineteenth century[23]). Is there any documented connection between this portrait and Bloemaert that would decisively establish that Bloemaert asked *Hals* to paint his friend and that this panel is the result? Unfortunately, there is not.

Baillet does not say that Bloemaert went to Hals for the work. And the most compelling argument on behalf of the thesis that he *did* ask Hals and that the Copenhagen panel is the result of that commission suffers from circularity. The Copenhagen painting is undated. It must have been painted by 1651 at the latest, because a reproduction of it is referred to in a defense of Cartesian philosophy published in February 1652.[24] The precise

1649 dating so often provided for the panel derives only from the assumption that it was done *at Bloemaert's request*, just before Descartes's excursion to Sweden.[25] So one could argue that this is the only known portrait of Descartes that is contemporaneous with his departure from the Netherlands and thus the only one that matches up with the chronology of Baillet's story. But so argued, the 1649 dating is based on the assumption that Hals's painting *was* done for Bloemaert, and so cannot be used in turn to prove that it was.

On the other hand, most of the other extant original portraits of Descartes—by Van Schooten, Weenix, and Nason—are dated well before Descartes was even contemplating a move to Sweden. Thus, they cannot have been done for the priest's benefit on the eve of Descartes's departure.

The dating of the Lievens drawing is less certain; scholars have placed it sometime between 1644 and 1649.[26] It is possible that it was done just when Bloemaert wanted a portrait of the philosopher. Even more tantalizing is the fact that the probate inventory of Bloemaert's estate, compiled by the notary Michel de Keyser, lists two *tronyen*, or small portraits, by Lievens in his art collection.[27] They hung in his "*groote camer*," the "great room." Although no subject is provided for either *tronie*—if the sitter were identifiable, it would likely have been labeled a *conterfeytsel*—it is tempting to believe that one of these is the drawing of Descartes, and therefore that Lievens is the artist to whom Bloemaert went.

However, the inventory does not say whether the Lievens works in Bloemaert's possession were drawings or paintings. Most likely they were paintings, given their prominent placement in the most important room in the house.[28] Moreover, Lievens was living in Amsterdam in 1649, so the plausibility of this hypothesis rests on coming up with a connection at least between Lievens and Haarlem (and then to Bloemaert).[29]

The notary's silence on just who, if anyone, is actually portrayed in Bloemaert's Lievens pieces is especially telling. Descartes was arguably too well known at this point for his portrait to have gone unidentified. Indeed, the inventory also lists among Bloemaert's art works "*drie prenten van de kartes*," or "three prints of Descartes" (by unknown artists), that hung in the "*blauwe camer*" ("blue room") that was Bloemaert's study and bedroom. If one of the two Lievens *tronyen* in Bloemaert's great room was the artist's drawn portrait of Descartes, then the notary De Keyser and Cornelis van Campen, the executor of Bloemaert's estate who assisted with the inventory, would, in light of the identified Descartes portraits in the bedroom, presumably also have recognized and noted it as such. (Of course, the local notary might have been unfamiliar with the world of contemporary philosophy, thus totally unaware of who Descartes was; his identification of the subject of the three prints in the study-bedroom as "*de kartes*" would then likely have been based on text in the prints identifying the sitter as Descartes. Even so, the notary or the executor should still have been able, on this basis, also to identify Descartes as the individual portrayed in one of the Lievens works in Bloemaert's possession, were this the case.) Finally, if either Lievens *tronie* were a drawing of Descartes, it would accordingly have been hanging not on the wall of the great room but in the more intimate place with the three other Descartes *prenten*.[30]

This means that the Hals portrait of Descartes—the oil painting in Copenhagen—is, of the extant portraits, the most likely candidate for the work in Baillet's narrative. Other theories are possible, of course: that there was—and perhaps is, somewhere (hidden away in an attic?)—yet another painting of Descartes by Hals or by some other Haarlem artist that Bloemaert commissioned. Maybe the portrait sought by Bloemaert, from whatever artist, is long lost. But until some evidence of

such a lost work materializes, the Hals oil painting remains the best, perhaps the only, contender. Besides, if what Bloemaert, an art collector who knew Haarlem's painters well, wanted was a lifelike commemorative portrait of his friend, to whom else would he turn except the local artist renowned for his skill in painting portraits *naer het leven*?

Descartes almost certainly did sit for Hals for this portrait. While it is conceivable that what Hals did for Bloemaert was either copy some other image on hand or create something from his imagination guided by Bloemaert's memory, this does not seem likely.[31] Baillet's description of Bloemaert's urgency in "not [letting] Descartes leave without taking the liberty of having him captured by a painter" all but implies that the priest had the painting done from life. While Baillet often takes liberties in what is essentially a hagiography of the philosopher, there is no particular reason for doubting his word on this point. It was easy for Descartes to get to Haarlem—he had been doing it for years, to visit his friends—and it could not have been much trouble for Bloemaert, familiar as he was with Haarlem's art world, to arrange a sitting. Given the speed with which Hals was apparently capable of working—after all, he is supposed to have painted Van Dyck "in a short time," according to Houbraken's apocryphal story; and he reportedly told the members of the Amsterdam Crossbow Civic Guard that he would not need very much time to do their individual portraits for the group piece[32]—it would not have taken him very long to produce it.[33] Working in his typically rough manner, eschewing a fine finish, he would have needed Descartes for but one or two sittings, just to capture the face. Neither artist nor philosopher would have been greatly inconvenienced by Bloemaert's project.

The painting was made sometime that summer, perhaps as late as September, when Descartes finally embarked for Sweden. It must have been done before Descartes went to Amsterdam to

settle some affairs and board the ship to Stockholm. From the
difficulties arising over the unfulfilled commission from the Am-
sterdam militia company in 1633, it is clear that Hals did not
like to travel to carry out his projects, not even to Amsterdam.
So if the painting is from life and Descartes did pose for Hals,
in all likelihood it was done in Haarlem when Descartes's final
departure from Egmond was imminent. Perhaps Descartes, who
did not like to be inconvenienced, cared little for having his
likeness drawn or painted—he was arrogant, but not vain—and
Bloemaert might have had to do some coaxing to get his friend,
who was busy preparing for his journey, to come to town one
last time just for this purpose.

What remains uncertain is whether the extant small oil por-
trait of Descartes was intended by Bloemaert to be the ultimate
product of his commission. Is that all that the priest wanted
from Hals, or was there something more? The panel was in fact
put to further artistic service. But was this a part of Bloemaert's
request, and, if so, what exactly did he have in mind?

An hypothesis proposed by some scholars is that the portrait
in Copenhagen, quickly done, was intended merely as a prepara-
tory study for a larger, more finished painting. For a long time, it
was believed that the life-size canvas in the Louvre *was* that fin-
ished painting; but now that that work has been de-attributed
("*d'après Hals*"), it is considered only a painted copy—one of
several—by an unknown artist. It was done either directly from
Hals's small painting, or from a larger, possibly life-size work
by Hals, or perhaps even from a work by some other artist that
was itself based on the Hals panel or on a larger Hals paint-
ing. However, if Hals did go on to make a larger, more finished
portrait from this panel, it is long lost and not likely to turn up
anytime soon.[34] There is, therefore, no available evidence to sup-
port the idea that Hals intended (either at Bloemaert's urging or
on his own) to make a more polished portrait of Descartes on

the basis of the Copenhagen portrait, the status of which would then essentially be downgraded to a sketch.

Moreover, the Copenhagen panel, as rough as it is, shows all the marks of being a finished work, not a preparatory study. It has the "*hoogsels en diepsels*" ("heights and depths")—essentially white highlights and dark shadows conveyed by deep black accents (especially on Descartes's cloak)—that Houbraken, writing about Hals's technique, identifies as the characteristic final touches in his paintings.[35]

For those who nonetheless remain reluctant to see the small oil portrait, just because of its rough character, as an end in itself, there is another theory, one that may be more plausible than the "preparatory study" hypothesis. Perhaps the panel was intended all along to serve as the basis of a print. This was a common practice, as engravings after paintings were an inexpensive and easily reproducible means for disseminating an image. Many artists in the Renaissance and early modern period relied on engraved reproductions to show (and market) their work. As we have seen, this was something that Hals himself often did with his portraits of writers and other intellectuals, many of which were, like the Descartes panel, small oil paintings. (The paintings themselves would be kept for private use and handed down to family or friends or hung in an institution with which the subject was connected, while the prints served a wider public.)

As a matter of fact, less than one year after Hals painted his little portrait of Descartes, it was reproduced as an engraving by Jonas Suyderhoef (1613–1686). Suyderhoef was a Haarlem artist who often worked closely with Hals. There was also a family connection: Suyderhoef's brother was married to Hals's niece, the daughter of Hals's brother Dirck. Over the years, Suyderhoef made numerous engravings of Hals's paintings—sixteen, by one count.[36] The small portrait of Samuel Ampzing that

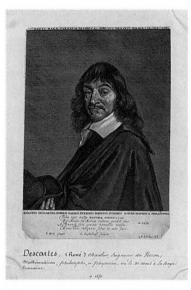

FIGURE 21. Jonas Suyderhoef, *René Descartes*, 1650 (engraving after Hals)

Hals painted around 1630 was engraved by Suyderhoef soon after its completion; so were Hals's portraits of Theodore Schrevelius, Caspar Sibelius, and Jean de la Chambre, as well as his oil portrait of the painter Frans Post[37]—all close in size to the Descartes painting. The Hals-Suyderhoef team was prolific, and did not discriminate against sitters on philosophical grounds. Among the portraits done by Hals and engraved by Suyderhoef is one of the theologian Jacob Revius,[38] Descartes's archenemy in Leiden who led the charge against the heretical new philosophy. Above Revius's head in the engraving is the motto "May the love of Christ be victorious."

Incidentally, Suyderhoef's print offers further confirmation that Hals did indeed paint a portrait of Descartes, as well as that the Copenhagen panel is of Descartes. The text on the engraving explicitly identifies the sitter as "Renatus Descartes, noble Frenchman, lord of Perron, Greatest Mathematician and Philosopher." It also says that the work was "painted by F. Hals, engraved by J. Suyderhoef." In the engraving, the image is shown in reverse from how it appears in the oil painting, but it is obviously the same representation of the same man, although in the print his position is now slightly turned toward the viewer. Is the work by "F. Hals" that Suyderhoef reproduced in the print the Copenhagen panel, as opposed to some other, now lost

painting of Descartes by Hals? To this, the answer is: almost certainly.[39]

Perhaps, then, Bloemaert ultimately wanted an engraved print of his friend's image. It would be a fine portable (and reproducible) keepsake. Engraved portraits with informative and laudatory mottos were a dignified way of keeping an individual's visage in sight and commemorating his intellectual accomplishments. It may be that one of the *"drie prenten van de kartes"* owned by Bloemaert and that hung in the *blauwe camer* was the image that Suyderhoef made in 1651 after Hals's painting. Perhaps even all three of them were.

And yet, the most plausible theory of all—especially given the finished state of the painting—is that Bloemaert's request was not for a life-size, polished portrait, nor for an engraved print, but rather simply for that small oil portrait itself: an intimate, personal, and lovely memento in rich colors. As for the Suyderhoef print from a painting of Descartes by "F. Hals," Hals (and Suyderhoef) must have realized that the painting, once translated into an engraving depicting a famous author, could profitably be put to other uses: for example, by publishers of Descartes's writings. Despite its subsequent history as *modello* for engravings and painted copies, then, the small panel was probably commissioned by Hals's impatient client for its own sake. A quickly done likeness in oil before Descartes left Holland is all that Father Bloemaert sought from the Haarlem master. The painting would be for Bloemaert's private enjoyment; the print, done a short time later, would be for a larger audience.

One might think that such a small and modest painting is all that Bloemaert could afford from an artist of Hals's stature. In the 1630s, Hals was receiving sixty-six guilders for each full-length figure in the Amsterdam militia portrait.[40] A full-size bust portrait of an individual would be somewhat cheaper, but not inexpensive—perhaps thirty-five to fifty guilders. This still

would have been a considerable expense on a Catholic priest's income. However, Bloemaert did not depend solely on his clerical wages for his livelihood. He was, in fact, independently wealthy, coming from a very well-off family, and so was not without significant resources, especially—in the light of his impressive collection of paintings and prints—for the buying of art. It is more likely that Descartes, with his impending departure, simply did not have the time or patience to sit for a larger, more polished portrait. If, as Baillet says, all that Bloemaert wanted was a souvenir for his own use, then the small, rough painting that Hals produced—cheaper and quicker than one of his more elaborate portraits—would have sufficed for that purpose. What Bloemaert got for his money was a fine portrait of his friend, one that we (like his contemporaries) can appreciate as having all the character and valued features typical of a late Hals.

So, is the painting of Descartes by Hals that now hangs in Copenhagen the one that is supposed to have been made for Bloemaert? We may never know for sure. There is no painting by Hals to be found among the works of art listed in Bloemaert's probate inventory. This is not conclusive, however, since there may have been paintings owned by Bloemaert that did not make it into the inventory, either because the priest gave them away before his death or because they were secured by someone after his death but before the inventory was done. Take, for example, the half-length, life-size portrait of Bloemaert himself painted by Verspronck, done in 1658, one year before the priest's death and later paid for (sixty guilders) by the executors of his estate. This work is not listed in the inventory. Bloemaert apparently gave it as a gift to the woman who was caring for him in his final illness (and whom he, in his testament, generously allowed to continue living in his house rent-free for up to three years after his death).[41] Perhaps the Hals portrait of Descartes, whose known provenance goes back only to the late

nineteenth century, was similarly left with someone before the inventory was made. (There is a *"conterfeytsel met een swarte lyst"*—"portrait with a black frame"—that is listed in the inventory without mention of artist or sitter, but this is not likely to be the Descartes painting. It is hard to believe that neither a Haarlem notary nor the executor of Bloemaert's estate, who was a friend of the late priest, would have recognized and taken note of a work by Hals, the city's greatest and most famous master.)

There are, then, good (if not absolutely indubitable) reasons for believing that the Copenhagen panel and the painting mentioned by Baillet are one and the same. If that panel is by Hals, as experts believe and the formalistic evidence strongly suggests; and if it is of Descartes, as seems clear; and if Hals painted only one portrait of Descartes; and if he did so at Bloemaert's request, which it is reasonable to conclude; then yes, the small oil painting in Denmark once decorated Father Bloemaert's rooms in Haarlem. What happened to that painting after the priest's death—and why it is not among the possessions listed in his estate—must remain a mystery.

Descartes never returned to the Netherlands and his quiet retreat in Egmond. In fact, he did not survive his first Swedish winter. Queen Christina insisted on having her philosophy lessons before sunrise. All his life, Descartes was used to lying in bed at least to midmorning. Now, in a bitterly cold land where, he says, "men's thoughts freeze in the winter just like the water," he is being forced to rise at an ungodly hour and traipse in the frigid dark to the queen's chambers to talk metaphysics and morals. In early February he caught pneumonia. He died a week later, on 11 February 1650, just several months after his arrival.

Descartes was a philosopher of high ambition and great hubris. His project was nothing less than to rebuild the structure of knowledge from the ground up, to replace the old intellectual paradigm and put the whole of science on a new, absolutely solid metaphysical foundation. While much of his thought is deeply indebted to prior traditions and he could not entirely break away from the categories and even the substance of Scholastic philosophy,[42] Descartes, at least, saw himself as the first truly original and modern thinker.

This is a philosopher who dared to prove that, although God is an omnipotent and absolutely arbitrary being, beholden to no values or standards independent of His will, He nonetheless, in His infinite perfection, stands as guarantor to human reason; a philosopher who believed that through his divinely guaranteed rational faculty he was able to discover nature's deepest secrets and arrive at explanations for "all the phenomena of nature"; and who derived, *a priori* and simply from a consideration of God's essence, the laws of nature themselves. He also had the audacity to take on the most sacred mystery of the Catholic faith and, discarding centuries of fealty to a particular explanatory theory, reinterpret it on his own terms and consistent with modern science.

And yet, as ambitious and single-minded as Descartes was in the pursuit of his philosophical projects, he was not the aloof, solitary, and misanthropic genius that his contemporary critics and some later commentators have made him out to be. Far from shutting himself off from human contact in order to carry out his researches in rural isolation, Descartes had a broad and diverse circle of personal and professional acquaintances—French and Dutch; Catholic and Protestant; philosophers, mathematicians, scientists, diplomats, and theologians. It was, in fact, the warm, enjoyable company of two local priests that helped make the long northern winters somewhat tolerable for him. The mu-

sical evenings in Haarlem must also have provided Descartes with some comfort in the face of the harsh, often personal attacks from his many enemies, and temporary escape from the interminable battles over his philosophy that raged in the Dutch universities. Descartes was a man devoted to order—both in philosophy and in living—and averse to any disturbance in his routine. Thus, it was only with great reluctance that he gave up his quiet but sociable life in the Netherlands for a burdensome commission in an even colder climate.

Descartes's departure was an especially sad event for one of those friends in Haarlem. As Descartes sailed away, Father Augustijn Bloemaert was more distraught than the philosopher's other Dutch acquaintances. The priest was, however, able to find some consolation in a painting now decorating his home, a small panel (today hanging in the Royal Museum of Art in Copenhagen) that would keep alive the memory of his friend.

Notes

ABBREVIATIONS FOR DESCARTES'S WORKS

AT Descartes 1964–71
CSM Descartes 1985
CSMK Descartes 1991

CHAPTER 1
Prologue: A Tale of Two Paintings

1. Doubts that the Louvre painting is by Hals, in fact, go back to the nineteenth century.

2. In an inventory of the goods that Descartes left with his aunt, from 1634, there is mention of a painting; my thanks to Theo Verbeek for bringing this to my attention.

CHAPTER 2
The Philosopher

1. During this early period of the Dutch Revolt, members of the Calvinist Church constituted only a small minority of the population, even in provinces with a Reformed majority. Most individuals were not formal members of any confessional church; see Pollmann 2002, 54–55. For studies of confessionalism in individual cities, see Spaans 1989 (Haarlem) and Kaplan 1995 (Utrecht).

2. I am grateful to an anonymous reader for the press for bringing this to my attention.

3. This biographical account is drawn from Baillet 1987 and a number of recent biographies of Descartes: Gaukroger 1995, Watson 2002, and Clarke 2006.

4. Descartes [possibly to Debeaune], 12 September 1638, AT II.378; CSMK III.124.

5. *Discourse on Method*, part 1, AT VI.4; CSM I.112–13.

6. *Discourse on Method*, part 2, AT VI.16; CSM I.119.

7. Descartes [possibly to Debeaune], 12 September 1638, AT II.378; CSMK III.123–24.

8. Kolakowski 1969, chapter 2.

9. *Discourse on Method*, II, AT VI.11.

10. The letter is no longer extant, but see Baillet 1987 (I.118), who claims to be quoting from it.

11. Baillet 1987, I.118.

12. Descartes to Mersenne, 11 October 1638, AT II.380. In this letter, Descartes says, referring to Galileo, "je ne l'ay jamais vu, ny n'ay eu aucune communication avec luy" (388).

13. AT I.204.

14. Descartes to Mersenne, 13 November 1639, AT II.623.

15. Baillet 1987, I.117–22.

16. *Les Meteores*, Discourse VII, AT VI.316.

17. Clarke 2006, 71.

18. *Rules for the Direction of the Mind*, Rule 1, AT X.359; CSM I.9.

19. *Rules for the Direction of the Mind*, Rule 2, AT X.364–65; CSM I.12.

20. *Rules for the Direction of the Mind*, AT X.394; CSM I.29

21. *Rules for the Direction of the Mind*, Rule 17, AT X.459; CSM I.70.

22. *Discourse on Method* IV, AT VI.30; CSM I.126.

23. AT VIII-2.110–11.

24. *Discourse on Method* IV, AT VI.31; CSM I.126.

25. Descartes to Mersenne, 4 March 1630, AT I.125.

26. Descartes to Mersenne, 2 December 1630, AT I.191. The "subterfuge" was to be the claim of ignorance. Descartes was, in fact, interested in going to England, to meet with the Hartlib circle there, although he never made the trip.

27. Descartes to Mersenne, 13 November 1629, AT I.70.

28. It is, of course, impossible to generalize over so many centuries of Aristotelian thought and so many different thinkers to come up with *the*

Scholastic account. My intention here is to offer only a summary of some relatively standard features of medieval and early modern Aristotelianism. For an excellent discussion of this, see Pasnau 2011, especially part 5.

29. These qualities or accidental forms were sometimes said to derive or "flow" from the thing's substantial form.

30. *Disputationes metaphysicae*, Disp. XVI.I.4.

31. The seventeenth-century Scholastic thinker Eustachio à Sancto Paulo, a member of the Cistercian order whose textbook *Summa Philosophiae Quadripartita* was studied by Descartes, distinguishes in part 1 of his work (*Dialectica seu logica*, in the Third Treatise: *De categoriis*, section 3: *De qualitate*) five sorts of qualities that "affect the senses": visible, audible, tactile, olfactory, and gustatory. Among the visible qualities he includes color (from the "extremes" of black and white to "intermediate colors" such as green and red), while the tactile qualities include the "motive qualities" of lightness and heaviness (*levitas et gravitas*). According to Eustachio, these qualities "arise from the proportion of the primary qualities" (Eustachio à Sancto Paulo 1614, 122–23. His discussion of the causality of forms appears in part 3, *Physica*, especially III.3.iii, q. 6). Another important early modern Scholastic source are the commentaries on Aristotle produced by the scholars at the University of Coimbra (for example, their discussion of "heaviness" and "lightness" in their commentary on Aristotle's *Physics*, Collegium Conimbricense 1602, VIII.4.i.2). For a discussion of Scholastic modes of explanation, see Nadler 1998.

32. An important discussion on this score is in William of Ockham, *Summa logicae* I.55.

33. I do not intend to deny that there are important differences among these early modern scientists. For example, it is not clear that Galileo would have subscribed to the kind of mechanism adopted by Descartes, nor Descartes to the corpuscularianism of Boyle. And Leibniz insisted on the need for a metaphysical ground of force within bodies (similar, he admits, to Aristotelian forms), while Descartes clearly would not countenance this. Meanwhile, Newton, in some contexts, seems to allow for action at a distance, and on occasion explicitly contrasts his explanations and laws with "mechanical" ones. Nonetheless, in the domain of physics proper, for all of these thinkers the only relevant considerations are matter and motion and the mathematical formulation of the laws governing these.

34. Descartes to Mersenne, 18 December 1629, AT I.85–86.

35. *The World*, AT XI.31–32; CSM I.90.

36. Descartes to Mersenne, November 1633, AT I.271; CSMK III.41.

37. Descartes to Mersenne, February 1634, AT I.281–82; CSMK III.41–42. The work was not published until after Descartes's death, with the appearance in 1664 of two separate treatises: *Le Monde de M. Descartes ou le Traité de la lumière* and the *Traité de l'homme.*

38. Descartes to Balzac, 5 May 1631, AT I.202–4.

CHAPTER 3
The Priest

1. Israel 1995, 203.

2. Israel 1995, 676; see also Kaplan 2002, 22–23.

3. The case of Jews was quite different, especially in Amsterdam; see Bodian 1997 and Swetschinski 2000. By 1615, the States General authorized resident Jews to practice their religion. Meanwhile, the States of Holland had set up a commission to consider the legal status of Jews in the province. While it continued to regard Jews as a "foreign group," the States of Holland rejected any restrictions upon Jewish-gentile relations and concluded that each town should decide for itself whether and under what conditions to admit Jewish residents. By the 1620s, there were three well-established congregations in Amsterdam, each with its own synagogue.

4. Gans 1971, 27.

5. For a study of religious activity in this period in Haarlem, see Spaans 1989. The term "experiment" to describe this situation is from Spaans, chapter 2.

6. Spaans 1989, chapter 3.

7. Prak 2002, 162.

8. See Israel 1995, 380–82.

9. Israel 1995, 382.

10. Cerutti 2009, 27.

11. This is how he is described in the *Acta Missionis Hollandicae* of 1620.

12. This biographical sketch of Bloemaert is drawn from Cerutti 2009, Sterck 1935, and Taverne 1965. See also the *Nieuw Nederlandsch Biografisch Woordenboek*, part 10, p. 81 (http://www.inghist.nl/retro boeken/nnbw).

13. Taverne 1968, 84.

14. Cerutti 2009, 38.

15. Sterck 1935, 301. Bloemaert's sermons were eventually collected and published; see Cerutti 2009 (49–56) for a listing and summary of these.

16. Taverne 1968, 85.

17. Sterck 1935, 301.

18. The poem (and engraving) is from 1659:

> De Hollantsche Augustijn zagh met eene afgekeerheit
> En onbenevelt oogh dees snoode weerelt aen,
> Die hy met bloemen van godtvruchte godtgeleertheit
> Aen 't Sparen heeft bezaeit, daer zijn voetstappen staen,
> En wijzen langs wat wegh men Gode moet genaecken.
> Dees print verbeelt u slechts de schaduwe des mans.
> De kunst kon 't wezen der verheve deught niet raecken.
> De ziel van Bloemaert blinckt nu noch met schooner glans.

My thanks to Rob Howell for his help in translating this poem.

19. Some recent scholars suggest that in fact "the so-called Muider-kring" is more a "persistent myth" than a reality, and that "Vondel was never present at Hooft's more festive gatherings" (Smits-Veldt 1997, 25).

20. For biographical information on De Kater, see Baillet 1987, II.111–12, and Verbeek 1995.

21. My thanks to Pieter Biesboer for this information.

22. This biographical sketch of Ban is drawn from Graaf 1873, Walker 1976, and Rasch 1983. See also the entry in the *Nieuw Nederlandsch Biografisch Woordenboek*, part 8, pp. 45–46.

23. The work, *Dissertatio epistolica de musicae natura, origine, progressu, et denique studio bene instituendo*, is part of a collection of didactic treatises, *Hugonis Grotii et aliorum de omni genere studiorum recte instituendo dissertationes*, pubished in Leiden in 1637. My thanks for Theo Verbeek for this information.

24. For a discussion of Ban's musical theory, see Rasch 1983.

25. Quoted in Walker 1976, 234.

26. "Keure ende ordonnantie teghens de stouticheyt der paus-gesinden ende der selver excessen," issued on 18 July 1639.

27. Davidson and Van der Weel 1996, 127.

28. See the probate inventory list compiled after Bloemaert's death by the notary Michel de Keyser, Haarlem Municipal Archives, Archief Bloemart, fonds 1. A list and analysis of the collection is also in Cerutti 2009, 57–58. He also owned about a dozen prints (Cerutti 2009, 64), and it is unclear whether the Lievens *tronyen* were paintings or works on paper.

CHAPTER 4
The Painter

1. Doc. 1, Thiel-Stroman 1989, 372.

2. Doc. 2, Thiel-Stroman 1989, 373.

3. Doc. 1, Thiel-Stroman 1989, 372.

4. Braudel 1984, 143.

5. Marnef 1996, 124.

6. For accounts of the early stages of the Dutch revolt in the Southern Low Countries, see Israel 1995, chapters 8–10, and Geyl 1958.

7. Geyl 1958, 200–201.

8. Doc. 4, Thiel-Stroman 1989, 373. It could be that the family converted to Protestantism when it moved to Holland, or even just had its younger, Holland-born son baptized as a Calvinist.

9. For example, in the marriage banns between Hals and his second wife, Lysbeth Reyniersdr, in 1617 and, one month later, the baptism record of their daughter Sara; see Docs. 23 and 24 in Thiel-Stroman 1989, 378.

10. Briels 1976.

11. For these social aspects of Haarlem politics, see Biesboer 1989, especially p. 23.

12. Biesboer 1989, 23–26.

13. Slive 1970, I.2.

14. Quoted in Slive 1970, I.2.

15. On the Guild of St. Luke in Haarlem and elsewhere in the Netherlands, see Hoogewerff 1947.

16. Van Mander 1604, fol. 229 recto. Part of Van Mander's work is available in a facsimile edition with English translation; see Van Mander 1994.

17. Van Mander 1604, fol. 206 recto: "Dat te Haerlem in Hollandt van oudts oft seer vroegen tijdt zijn geweest seer goede, oft de beste Schilders van het gantsche Nederlandt, is een oudt gherucht, dat niet logenachtigh is te schelden oft te bestraffen." See the discussion in Slive 1970, I.2–4.

18. Van Mander 1604, fol. 205 verso.

19. For a study of early painting in Haarlem and the emergence of its distinctive style, see Snyder 1960a and 1960b.

20. See Israel 1995, 559–60.

21. Chong 1987, 116; North 1997, 99.

22. Van der Woude 1991, 315.

23. Montias 1991, 341–42.

24. Slive, by comparing the extant painted bust portrait of Zaffius with Van de Velde's print and assuming that the print was made after that painting, claimed that the extant portrait initially contained a skull, and was thus cut down from its original size (Slive 1970, I.23–4). He later concluded, however, on the basis of further evidence, that the Van de Velde print in fact depicts a *different* Hals portrait of Zaffius, and suggests that the extant portrait was either a model for or a copy of the larger painting (Slive 1989, 130).

25. It may be that they are suffering from the "embarrassment of riches" that Schama (1987) has argued was characteristic of Golden Age Dutch life.

26. The reckoning is by Slive 1970, I.18.

27. The later painting is in the Musées Royaux des Beaux-Arts, Brussels. For a discussion of these paintings of Heythuysen, see Biesboer 2008, 98–101.

28. Slive 1970, I.21.

29. On the development of group portraiture in sixteenth- and seventeenth-century Dutch art, see Riegl 1999 and Adams 2009, chapter 5 (on civic guard portraits).

30. Doc. 116, Thiel-Stroman 1989, 400.

31. Doc. 41, Thiel-Stroman 1989, 382.

32. There is some debate as to the extent of the appreciation of Hals's style. In contrast with Slive, for example, Broos (in a highly critical review of Slive 1970) says that "Hals' very original manner of painting was recognized and appreciated in the seventeenth century, albeit within a limited circle of admirers, mostly in Haarlem, and during a particular time" (Broos 1978–79, 121). He suggests, in fact, that "by contemporary standards Hals didn't achieve the goals that an artist ought to set for himself . . . it doesn't seem to me that Hals's artistic personality was always positively regarded." Moreover, Slive and Broos agree, in the final decades of Hals's life, aesthetic tastes "shifted . . . to the smooth manner" (Slive 1970, I.153; Broos 1978–79, 122).

33. While the rough method characterizes his genre paintings throughout his career, it came to dominate his portraits only somewhat later. As Atkins (2012) notes, "Initially, Hals worked in two divergent modes—one smooth and refined for portraiture, and one rough and unblended for generic types. Hals maintained this stylistic differentiation for nearly twenty years before transferring his painterly manner to portraiture in

the 1630s, the same time he stopped producing genre pictures" (14). The "rough" style is what Atkins calls Hals's "signature" style.

34. Gombrich 1995, 416. For an especially insightful discussion of Hals's brushstroke style, see Atkins 2004 and 2012; see also Levine 2012.

35. Jowell 1989, 63.

36. Doc. 163, Thiel-Stroman 1989, 409.

37. Slive 1989, 252–55.

38. See Van Eeghen 1974.

39. Doc. 74, Thiel-Stroman 1989, 389.

40. Doc. 75, Thiel-Stroman 1989, 390.

41. See Bijl 1989 for a study of the finished painting as a source of information on Hals's use of materials and working method.

42. Docs. 70 and 71, Thiel-Stroman 1989, 388–89.

43. Houbraken 1753, I.90–91.

44. Houbraken 1753, I.93.

45. Houbraken 1753, I.93.

46. For example, Jowell 1989, 62, and Slive 1970, I.10. There is the claim, made by one of Hals's contemporaries, that he was "somewhat lusty in his youth" (quoted in Slive 1970, I.10), but this is so vague a statement as to be practically meaningless.

47. These are the students mentioned by Houbraken. Based on their painting styles, Leyster and Molenaer may also have been Hals's students.

48. Broos (1978–79, 120) notes, however, that Hals received this honor only once, while many others received it two or more times (Pieter de Molijn, for example, served eight times as guild officer).

49. Data on mean prices in Amsterdam inventories from the Getty-Montias database are in Van der Woude 1991, 319. North (1997, 99), on the other hand, says that portraits commanded the lowest price in the period, averaging less per painting even than genre pieces and still lifes.

50. Slive 1970, I.9.

51. Van Eeghen 1974.

52. Biesboer (1989, 37) suggests that Hals's financial straits were in fact due to a decrease in commissions, which in turn was due to the general decline in the Dutch economy during the first two Anglo-Dutch wars between 1655 and 1665. Atkins (2004, 300) attributes it, as well, to new competition in the world of Haarlem portrait painting (Jan de Bray, in particular) and changing aesthetic tastes.

53. Doc. 22, Thiel-Stroman 1989, 378.

54. Doc. 64, Thiel-Stroman 1989, 387.

55. Docs. 174–85, Thiel-Stroman 1989, 411–13.

56. Doc. 189, Thiel-Stroman 1989, 414.

"Once in a Lifetime"

1. According to Baillet (1987, II.368), this is from a letter to Picot, 21 February 1649; see AT V.280.

2. According to Baillet (1987, II.368), this is from a letter of 26 February 1649; see AT V.280.

3. Van de Ven 2003.

4. Baillet 1987, I.308–9.

5. Descartes to Mersenne, 2 November 1646, AT IV.555.

6. Descartes to Chanut, May 1648, AT V.183.

7. This is the view promoted by Popkin 1979 and Curley 1978, among others.

8. This history is reviewed in Popkin 1979.

9. Baillet 1987, I.162–63.

10. Cited at Baillet 1987, I.163. For a critical discussion of the story, see Watson 2002, 142–47.

11. As he tells Mersenne, "these six Meditations contain all the foundations of my physics" (28 January 1641, AT III.298; CSMK III.173).

12. There are many fine and highly detailed scholarly studies of the *Meditations*, including Carriero 2009, Kenny 1968, Williams 1978, and Wilson 1978.

13. Preface to the French translation of the *Principles of Philosophy*, AT IX-2.14; CSM I.186.

14. Preface to the French translation of the *Principles of Philosophy*, AT IX-2.14; CSM I.186.

15. *Meditations*, Synopsis, AT VII.2; CSM II.9.

16. Seventh Replies, AT VII.481; CSM II.324.

17. *Meditations*, First Meditation, AT VII.17; CSM II.12.

18. These are the two different ways of understanding the dream argument, suggested (respectively) by how Descartes describes it in the First Meditation (AT VII.19; CSM II.13) and in his recap in the Sixth Meditation (AT VII.77; CSM II.53). The difference is discussed by Wilson (1978, 13–31) in her analysis of the argument.

19. *Meditations*, First Meditation, AT VII.19–20; CSM II.13.

20. *Meditations*, First Meditation, AT VII.21; CSM II.14.

21. Descartes was, in fact, a fan of this sort of literature, and Cervantes's story may have played an influential role in the way in which Descartes conceived the doubts of the First Meditation; see Nadler 1997.

22. *Meditations*, Second Meditation, AT VII.25; CSM II.17.

23. *Meditations*, Second Meditation, AT VII.28; CSM II.19.

24. *Meditations*, Third Meditation, AT VII.41; CSM II.29.

25. *Meditations*, Fifth Meditation, AT VII.66; CSM II.46.

26. *Meditations*, Fourth Meditation, AT VII.53; CSM II.37.

27. AT VII.71; CSM II.49.

28. AT VII.62; CSM II.43.

29. Second Replies, AT VII.141; CSM II.101.

30. *Meditations*, Sixth Meditation, AT VII.78; CSM II.54.

31. *Meditations*, Sixth Meditation, AT VII.79–80; CSM II.55.

32. *Meditations*, Sixth Meditation, AT VII.80–81; CSM II.56.

33. In the second edition, published in 1642, this is changed to "in which are demonstrated the existence of God and the distinction between the human soul and the body."

CHAPTER 6

A New Philosophy

1. To Mersenne, 30 September 1640, AT III.183–84; CSMK III.153.

2. Descartes to Mersenne, 28 January 1641, AT IIII.297; CSMK III.172.

3. AT III.647.

4. Descartes to Constantijn Huygens, 31 January 1642, AT III.523; CSMK III.210. *Le Monde* was originally written in French.

5. Descartes to Mersenne, 30 September 1640, AT III.185; CSMK III.153–54. Among the Jesuit authors he names are Francisco Toledo (1552–1596), Antonio Rubio (1548–1615), and the Coimbrian commentators on Aristotle.

6. The *Principles* was originally conceived as a six-part work, including a part 5 on plants and animals and a part 6 devoted to the human being; it may be that ethics would have been consigned to this final part.

7. *Principles* I.51.

8. *Principles* I.9.

9. *Principles* II.4.

10. *Principles* I.65.

11. *Principles* I.68.

12. *Principles* II.3.

13. Actually existing bodies also have impenetrability, a necessary but not essential feature of body. All bodies necessarily have impenetrability, because being impenetrable necessarily follows from being extended. But it is extension, not impenetrability, that makes something a body.

14. *Principles* II.16–18.

15. *Principles* II.20.

16. *Principles* I.23.

17. *Principles* I.28.

18. *Discourse on Method*, part 5, AT VI.43; CSM I.132. He is referring to what he does in *Le Monde*, chapter 7.

19. It is a very problematic argument. Why, for example, might not an immutable God have willed that there be a constant rate of change of quantity of motion?

20. *Principles of Philosophy* II.36, AT VIII-1.61–62; CSM I.240.

21. *Le Monde*, AT XI.43; CSM I.96.

22. Garber (1983) argues that Descartes intends this law to apply only to inanimate bodies, so as to allow the human mind (which is not a subject of motion) to move its body.

23. *Principles of Philosophy* II.39, AT VIII-1.63; CSM I.242.

24. *Principles of Philosophy* II.40, AT VIII-1.65; CSM I.242.

25. Some of the rules (presented in *Principles of Philosophy* II.46–52) are, as Leibniz and even some later Cartesians discovered, incorrect.

26. *Discourse* VI, AT VI.76; CSM I.150.

27. AT I.563; CSMK III.87. For a discussion of Descartes's use of "hypotheses" in the *Discourse*, see Garber 1978.

28. *Principles of Philosophy* IV.203, AT VIII-1. 326; CSM I.289.

29. *Principles of Philosophy* III.19, AT VIII-1.86; CSM I.251. The bracketed words were added in the French edition published in 1647.

30. *Principles of Philosophy* III.28, AT VIII-1.90; CSM I.252.

31. *Principles of Philosophy* III.30, AT VIII-1.92; CSM I.253.

32. For Descartes, gravity is still a force operative only on terrestrial phenomena. He did not yet realize, as Newton did later, that gravity operates on *all* bodies in the cosmos—for example, to keep the planets in their orbits.

33. *Principles of Philosophy* IV.188, AT VIII-1.315; CSM I.279.

34. *Principles of Philosophy* IV.197, AT VIII-1.321; CSM I.284.

35. In a Latin version; the French edition, *Traité de l'homme*, was published in 1664.

36. *Treatise on Man*, AT XI.142.

37. *Treatise on Man*, AT XI.202; CSM I.108.

38. *Principles of Philosophy* IV.188, AT VIII-1.315; CSM I.279.

39. AT IX-2.11; CSM I.184.

40. Descartes's use of the term "deduction" to refer to the progress from first principles to particular explanations in physics should not be regarded as a claim by Descartes that all of science can be done *a priori*, as a matter of logical deduction without resort to the gathering of empirical data and the performance of experiment. This outmoded and unjustified caricature of Cartesian science (both theory and practice) has been well refuted in the literature; see Garber 1978; Gaukroger 2002; Clarke 1982.

41. *Principles of Philosophy* IV.199, AT VIII-1.323; CSM I.285.

42. *Principles of Philosophy* IV.201, AT VIII-1.324–25; CSM I.287. The bracketed words were added in the 1647 French translation of the Latin original.

43. Newton 1999, 943.

44. See Israel 2001b.

45. For a study of book censorship in the seventeenth-century Dutch Republic, see Groenveld 1987 and Weekhout 1998.

46. See the chart on Groenveld 1987, 74.

47. Descartes to Mersenne, 24 December 1640, AT III.265; CSMK III.163. See Clarke 2006, 206–7, for a discussion of Descartes's frustration over losing control of the publication of the first edition of the *Meditations*.

48. Descartes to Mersenne, 17 November 1641, AT III.448; CSMK III.198–99.

49. AT II.152.

50. Descartes to Huygens, 12 June 1637, AT I.638.

51. Descartes to [Brasset], 23 April 1649, AT V.349.

52. Descartes to Regius, December 1641, AT III.460; CSMK III.200.

53. Verbeek 1992, 18.

54. Descartes to Regius, January 1642, AT III.492; CSMK III.205.

55. Descartes to Regius, January 1642, AT III.510.

56. Verbeek 1992, 19.

57. Clarke 2006, 226.

58. Verbeek 1992, 19. For the documents in this debate, see Verbeek 1988.

59. Verbeek 1992, 35.

60. Verbeek 1992, 46–47.

61. Descartes to Elizabeth, 10 May 1647, AT V.18.

62. Descartes to Elizabeth, 10 May 1647, AT V.15–16.

CHAPTER 7
God in Haarlem

1. Descartes to Chanut, 6 March 1646, AT IV.377–78.

2. Descartes to Mersenne, 4 March 1641, AT III.332.

3. See the letter to Huygens of 11 March 1646, AT IV.786–87.

4. 6 March 1646, AT IV.376–77.

5. AT IV.377.

6. Theo Verbeek has said, in correspondence, that he believes that in 1637–38 Descartes was in fact living in Santpoort; his argument is based on his study of letters to and from Descartes in those years. I must confess that I remain unconvinced; it would be odd to refer to Santpoort as "near Alkmaar," since it is much closer to Haarlem (only six kilometers or so) than it is to Alkmaar.

7. Descartes to Huygens, October 1639, AT II.583–84.

8. AT II.153. The letter is from 15 January 1638.

9. Rasch 1983, 82.

10. Descartes to Huygens, 12 December 1639, AT II.699. In another letter to Huygens (13 November 1646, referring to his role in the Ban-Boësset competition explained below), Descartes describes himself as someone who "never learned to sing 're, mi, fa, sol, la' nor how to judge if someone else was singing it well" (AT IV.788).

11. Descartes to Huygens, 12 March 1640, AT III.747.

12. The two men had been put in contact by Constantijn Huygens.

13. Walker 1976, 234.

14. On the background of this competition, see Walker 1976.

15. Walker 1976, 233 (translation mine).

16. Walker 1976, 234.

17. AT III.826–27. An abstract of Ban's critique of Boësset is in AT III.826–29.

18. Descartes to Huygens, 30 November 1646, AT IV.788.
19. In a letter from 1640, AT III.829–34.
20. Descartes to Mersenne, December 1640, AT III.255.
21. Baillet 1987, II.17.
22. Descartes to Huygens, October 1639, AT II.684.

23. This, at least, was the postal arrangement when Descartes was living in Santpoort; it is unclear if it continued after Descartes moved to Egmond.

24. See chapter 3, n. 26. My thanks to Theo Verbeek for this suggestion. Sterck (1935, 302), on the other hand, suggests that it was a matter of requesting either that more priests be allowed to settle in the Netherlands or permission for establishing another Catholic mission.

25. Descartes to Huygens, October 1639, AT II.683–85.
26. First Set of Objections, AT VII.91–101; CSM II.66–73.
27. First Set of Replies, AT VII.101; CSM II.74.
28. First Set of Replies, AT VII.109–10; CSM II.79.

29. IV.206, AT VIII-1.328–29; CSM I.290–91. The bracketed phrase was added in the French translation of the Latin original.

30. All three of these scientists were, of course, religious individuals who regarded the order of the world and the regulation of its phenomena as the result of God's will; Newton, for one, speculated that the ultimate cause of gravity is God. But none of them went so far as Descartes to incorporate theological premises into their scientific thinking, and they self-consciously kept metaphysics separate from physics.

31. See, for example, Sixth Replies, AT VII.425–26; CSM II.287.
32. Descartes to Mersenne, 15 April 1630, AT I.145; CSMK III.23.

33. There is a great deal of variety among earlier philosophers as to what exactly is and is not independent of the divine will. The medieval English thinker William of Ockham, for example, tended to regard moral and metaphysical essences (but not, like Descartes, logical and mathematical ones) as dependent upon God. In this regard, however, he went further than practically all other philosophers.

34. Descartes to Mersenne, 27 May 1630, AT I.152; CSMK III.25.
35. Descartes to Mersenne, 15 April 1630, AT I.145–46; CSMK III.23.
36. Descartes to Mesland, 2 May 1644, AT IV.118–19; CSMK III.235.
37. Sixth Replies, AT VII.432, 435–36; CSM II.291, 294.
38. Descartes to Mersenne, 6 May 1630, AT I.149; CSMK III.24.
39. Descartes to Mersenne, 27 May 1630, AT I.152–53; CSMK III.25–26.

40. For Arnauld, 29 July 1648, AT V.224; CSMK III.358–59.

41. Descartes to Mersenne, 27 May 1630, AT I.151–52; CSMK III.25.

42. Descartes to Mesland, 2 May 1644, AT IV.118; CSMK III.235.

43. Sixth Replies, AT VII.431–32; CSM II.291.

44. Sixth Replies, AT VII.432–33; CSM II.292.

45. Descartes to Mersenne, 15 April 1630, AT I.145; CSMK III.23.

46. See Schmaltz 2002 for a study of the legacy of this doctrine among Cartesians.

47. I examine this issue in Nadler 2008.

48. It should be noted that Descartes is willing to appeal to divine providential aims when discussing certain particular and regular arrangements among natural phenomena—for example, the relationship between states of the body and sensory states of the mind in a human being; see, for example, the discussion of sensation in *Meditations on First Philosophy*, Sixth Meditation, and in *The Passions of the Soul* II.146.

49. Arnauld was involved in two long but very rich philosophical debates in the 1680s: one with the Cartesian Nicolas Malebranche, and another with Leibniz; for a study of these relationships, see Nadler 2008.

50. Descartes to Mersenne, 4 March 1641, AT III.331.

51. *Meditations on First Philosophy*, Fourth Objections, AT VII.214–18; CSM II.151–53.

52. By late medieval philosophy, these accidental forms would become "real accidents," to denote their capacity to persist, substance-like, without inhering in any substance. For an account of this development, see Pasnau 2011, 185–94.

53. Fourth Objections, AT VII.217; CSM II.152–53.

54. Fourth Objections, AT VII.218; CSM II.153.

55. Fourth Replies, AT VII.248–56; CSM II.173–78. For a discussion of the history and complexities surrounding Descartes and transubstantiation, see Armogathe 1977.

56. Arnauld for Descartes, June 1648, in Arnauld 1773, XXXVIII.73.

57. Arnauld for Descartes, July 1648, in Arnauld 1773, XXXVIII.83. For a study of the role the problem of transubstantiation played in Arnauld's relationship to Cartesian philosophy, see Nadler 1988.

58. Contrary to Watson 2002 (256), who insists that this exile was a punishment for Mesland's association with Descartes, Ariew 1999 (154) argues that it was in fact a reward for a seventeenth-century Jesuit.

59. Descartes to Mesland, 9 February 1645, AT IV.166; CSMK III.243.

60. Descartes to Mesland, 9 February 1645, AT IV.167–68; CSMK III.243–44.

61. Clerselier to Desgabets, 6 January 1672, AT IV.170.

62. See Armogathe and Carraud 2005.

63. AT IV.148.

64. This is Baillet's suggestion (1987, II.248).

65. Baillet 1987, II.248–49.

66. Descartes to Chanut, 1 November 1646, AT IV.537; CSMK III.299.

67. Descartes to Chanut, 1 November 1646, AT IV.537; CSMK III.300.

68. Descartes to [Brasset], 23 April 1649, AT V.349; CSMK III.375.

69. Descartes to Queen Christina, 20 November 1647, AT V.81–86; CSMK III.324–26.

70. Descartes to Chanut, 20 November 1647, AT V.86–87; CSMK III.326.

71. This, Descartes says, is how she "studied" the *Principles*; see the letter to Elizabeth, 22 February 1649, AT V.283; CSMK III.368. We also know that Chanut helped her understand the *Principles*, perhaps by reading it or summarizing it to her; see Chanut to Descartes, 12 December 1648, AT V.253.

72. Christina to Descartes, 12 December 1648, AT V.251.

73. Descartes to Chanut, 31 March 1649, AT V.329; CSMK III.371. For a discussion of the invitation to Sweden, see Clark 2006, 380–84 and chapter 14.

74. Descartes to Elizabeth, June 1649, AT V.359–60; CSMK III.378.

75. Baillet 1987, II.387.

CHAPTER 8
The Portrait

1. Slive 1970, I.15. For a discussion of how these economic changes transformed the art market, and the demand for different genres of painting, in Holland, see Biesboer 2008.

2. See Loughman and Montias 2000 for a study of the collection of paintings in seventeenth-century Dutch homes.

3. Biesboer 1989, 26. This essay is an invaluable source for information on Hals and his clients.

4. The climate and the interior conditions of seventeenth-century Dutch homes—unventilated, with smoke from cooking fires and candles—were not conducive to the preservation of works of art.

5. For a study of Hals's clientele, see Biesboer 1989.

6. Slive 1970, I.53.

7. Biesboer 1989, 27–29.

8. Doc. 175, Thiel-Stroman 1989, 409–10.

9. Many of Hals's works, large and small, were reproduced as engravings.

10. Slive 1970, I.14. There are several copies of this self-portrait extant.

11. I am excluding from this list images of Descartes that, while produced during Descartes's lifetime, we know with certainty are derivative from other works—for example, an engraving by artist x that was made after a painting or a drawing by artist y. For discussions of portraits of Descartes, see Rodis-Lewis 1993, Slive 1970, I.163–68, and Watson 2002, 174–76.

12. The similar paintings of Descartes in the Louvre and in the Hälsingborg Museum of Stockholm, both by unknown artists (having been downgraded by experts to the status "after Hals") and of unknown date, and an engraving by Jonas Suyderhoef are all clearly copies of the Hals painting in Copenhagen. There is also the well-known portrait of Descartes by David Beck, a Dutch painter from Delft who was asked by Queen Christina to provide her with a portrait of the philosopher. That painting, which now hangs in the Royal Academy of Science in Stockholm, was done just after Descartes's death and probably from his death mask; for a discussion of this work, see AT V.581–86.

13. AT V.336.

14. These had appeared in 1644.

15. Descartes to Carcavi, 17 August 1649, AT V.392.

16. AT V.46. The editors of AT believe that Bartholinus is referring here to the Suydenhoff engraving after the Hals portrait; but Slive (1970, I.166–67), following Nordström (1957–58), correctly (to my mind) believes he is referring to the Van Schooten image.

17. Descartes to Van Schooten, AT V.338. The image did not appear in the Latin *Géometrie* until the second edition in 1659.

18. The painting is in the Alfred and Isabel Bader Collection, in Milwaukee; the catalogue of Dutch and Flemish paintings in this collection dates the Descartes portrait to 1647.

19. One can speculate that the Princes of Orange William II and Frederik Hendrik actually sat for their part in the group portrait by Nason, and this may have put Nason in touch with Huygens, their secretary, who in turn would provide a link to Descartes.

20. De Witt 2008, 227–28.

21. Baillet 1987, II.387. Baillet's biography of Descartes is notoriously unreliable. He was a great admirer of the philosopher, and there is a good deal of hagiography in his account. He sometimes gets his facts wrong, and often, to fill in gaps, he simply makes things up. However, there is no particular reason to doubt what he says about Bloemaert's desire for a painting before Descartes's departure.

22. In the "no" camp are Grimm 1972, Ekkart 1973, and Montagni 1976; Grimm believes the Copenhagen panel, like the Louvre canvas, to be a copy of a lost original (108), and Ekkart, in his review of Grimm's book, concurs. In correspondence regarding the process of de-attribution of the Louvre portrait, Jacques Foucart, former curator of Netherlandish painting at the Louvre, tells me that he does not believe the Copenhagen painting to be by Hals either. In the "yes" camp are Nordström 1957–58, Valentiner 1923, and (in my estimation, definitively) Slive 1970, I.166–68, and 1989, 314–16.

23. The painting's provenance before its appearance in Copenhagen is unknown.

24. The book *Defensio Cartesiana* is by Johannes Clauberg; see AT V.587–88.

25. See the discussions at AT V.589–90, and Slive 1989, 314.

26. Sumowski 1979, v. 7, 3698; Wheelock 2008, 252.

27. De Keyser's list compiled after Bloemaert's death was recently discovered by Wim Cerutti in the Haarlem Municipal Archives, Archief Bloemart, fonds 1; see Cerutti 2009, 56. My thanks to him for sharing his complete transcription of the inventory with me.

28. I am grateful to Wim Cerutti for suggesting this to me in correspondence.

29. Hynes (2010, 586–87) says that "the evidence seems to suggest" that the image produced at Bloemaert's request is not the painting by Hals but one of the *tronyen* by Lievens owned by Bloemaert. Hynes (who says that "Lievens certainly knew Bloemart [*sic*]") claims to find the needed connection between Lievens and Haarlem in the fact that Lievens was married to Cornelia de Bray, the granddaughter of the Haarlem

painter Solomon de Bray (two of whose works Bloemaert owned). However, Lievens did not marry Cornelia until 1648, and she belonged to an Amsterdam family (her father was the notary Jan de Bray). This does not warrant the conclusion that Lievens had long-standing and close connections to Haarlem, much less an acquaintance with Bloemaert.

30. These three Descartes prints owned by Bloemaert were almost certainly acquired *after* Descartes's departure, and thus cannot serve as candidates for the portrait discussed by Baillet. One good reason for this conclusion is that had Bloemaert owned the prints before Descartes left Holland, he would not have been so anxious to have the philosopher's portrait done.

31. Nordström (1957–58) argues that Descartes did not sit for Hals, and that the painting was either done from imagination or copied from Van Schooten's engraving, which he believes is more likely. Grimm (1972, 108) seems to believe that Descartes did sit for Hals, but that the Copenhagen panel is not itself the product of that session.

32. Slive 1970, I.18; unfortunately, Slive does not provide any documentation for this.

33. This is not to suggest that Hals typically worked quickly. We know that in many of his portraits Hals slowly worked up his image, painting on top of dry paint; see Groen and Hendriks 1989 and Atkins 2012, 51–53. Atkins surmises that "Hals did not dash off painted sketches, but he encouraged viewers to think that he had" (14).

34. The hypothesis of a more finished portrait by Hals is entertained by Rodis-Lewis 1993 and Valentiner 1923, and is implied by all who considered the Louvre portrait to be by Hals himself. Slive says that "the possibility that an original life-size portrait of Descartes based on the small Copenhagen panel may turn up cannot be excluded" (1989, 314), but he does not appear to think this likely. Foucart (see note 22 above), who rejects the attribution of the Copenhagen painting to Hals, believes the Louvre painting to be a copy of a long-lost Hals painting of similar size and quality. In his catalogue of Flemish and Dutch paintings in the Louvre, he notes that it "*très probablement*" was this lost portrait that was done at Bloemaert's request (Foucart 2009, 150).

35. Houbraken 1753, I.92. My thanks to Pieter Biesboer for bringing this to my attention.

36. This is Slive's estimate (1970, I.155).

37. Slive 1970, I.125–27; 186.

38. See Slive 1970, I.198.

39. Foucart dissents from this idea (2009, 150) on the grounds that the aesthetic quality of the Copenhagen painting falls too far short of that of the image in the Suyderhoef engraving; he believes the engraving was done after a more finished Hals portrait of Descartes.

40. Slive 1970, I.9.

41. The portrait of Bloemaert painted by Johannes Cornelisz Verspronck (which does not appear on the Bloemaert inventory) appears in the estate inventory of Angenel van Akersloot, the lay sister who cared for Bloemaert when he was dying and who, on this theory, took possession of it sometime before the Bloemaert inventory was made; see the inventory of her possessions in Biesboer and Togneri 2001, 205–6 (among which is included "een conterfeytsel van pater Blommert met een swarte lijst gedaen door Versprongh"). Wim Cerutti, however, finds this implausible, and in correspondence with me offers a different account of how Akersloot came to own this painting: he believes that the original hung not in Bloemaert's house but in the portrait gallery of the *schuilkerk* "Bernardus in de Hoek," and that Verspronck made two copies of it: one for Akersloot, and one for the *Broodkantoor* (on the relationship between Van Akersloot and Bloemaert, see also Cerutti 2009, 60–62).

42. See, for example, Ariew 1999.

Bibliography

Adams, Ann Jensen. 2009. *Public Faces and Private Identities in Seventeenth Century Holland: Portraiture and the Production of Community*. Cambridge: Cambridge University Press.

Ariew, Roger. 1999. *Descartes and the Last Scholastics*. Ithaca, NY: Cornell University Press.

Armogathe, Jean-Robert. 1977. *Theologia Cartesiana: L'Explication physique de l'Eucharistie chez Descartes et Dom Desgabets*. The Hague: Martinus Nijhoff.

Armogathe, Jean-Robert, and Vincent Carraud. 2005. "The First Condemnation of Descartes's *Oeuvres*: Some Unpublished Documents from the Vatican Archives." *Oxford Studies in Early Modern Philosophy* 1: 67–110.

Arnauld, Antoine. 1773. *Oeuvres de Messire Antoine Arnauld*. 43 vols. Lausanne: Sigismond d'Arnay.

Atkins, Christopher. 2004. "Frans Hals' Virtuoso Brushwork." In *Virtus: Virtuositeit en Kunstliefhebbers in de Nederlanden, 1500–1700*, ed. J. de Jon, D. Meijers, M. Westermann, and J. Woodall. *Nederlands Kunsthistorisch Jaarboek* 54: 281–307.

Atkins, Christopher. 2012. *The Signature Style of Frans Hals: Painting, Subjectivity, and the Market in Early Modernity*. Amsterdam: Amsterdam University Press.

Baillet, Adrien. 1987. *La Vie de monsieur Descartes*. 2 vols. New York: Garland. [Originally published Paris 1691].

Biesboer, Pieter. 1989. "The Burghers of Haarlem and Their Portrait Painters." In Slive 1989: 23–44.

Biesboer, Pieter. 2008. *De Gouden Eeuw begint in Haarlem*. Haarlem: Frans Hals Museum; Rotterdam: NAi Uitgevers.

Biesboer, Pieter, and Carol Togneri. 2001. *Collections of Paintings in Haarlem, 1572–1745*. Los Angeles: J. Paul Getty Trust.

Bijl, Martin. 1989. "'The Meager Company' and Frans Hals's Working Method." In Slive 1989: 103–8.

Bodian, Miriam. 1997. *Hebrews of the Portuguese Nation: Conversos and Community in Early Modern Amsterdam*. Bloomington, IN: Indiana University Press.

Braudel, Fernand. 1984. *Civilization and Capitalism, 15th–18th Century*. Volume 3: *The Perspective of the World*. New York: Harper and Row.

Briels, Jan. 1976. "De Zuidnederlandse Immigratie in Amsterdam en Haarlem omstreeks 1572–1630." Ph.D. dissertation, Universiteit van Utrecht.

Broos, B. P. J. 1978–79. Review of Slive 1970. *Simiolus: Netherlands Quarterly for the History of Art* 10: 115–23.

Carriero, John. 2009. *Between Two Worlds: A Reading of Descartes's Meditations*. Princeton, NJ: Princeton University Press.

Cerutti, Wim. 2009. *De "Haerlemsche Augustyn": Pastoor Bloemert (1585–1659) en zijn Broodkantoor*. Haarlem: Spaar en Hout.

Chong, Alan. 1987. "The Market for Landscape Painting in Seventeenth-Century Holland." In *Masters of Seventeenth-Century Dutch Landscape Painting*, ed. Peter C. Sutton, 104–20. Amsterdam: Rijksmuseum.

Clarke, Desmond. 1982. *Descartes's Philosophy of Science*. Manchester: Manchester University Press.

Clarke, Desmond. 2006. *Descartes: A Biography*. Cambridge: Cambridge University Press.

Collegium Conimbricense. 1602. *In octo libros physicorum Aristotelis*. Coimbra.

Curley, Edwin. 1978. *Descartes Against the Skeptics*. Cambridge, MA: Harvard University Press.

Davidson, Peter, and Adriaan van der Weel, eds. 1996. *A Selection of the Poems of Sir Constantijn Huygens (1596–1687)*. Amsterdam: University of Amsterdam Press.

Descartes, René. 1964–71. *Oeuvres de Descartes*. Edited by Charles Adam and Paul Tannery. 12 vols. Paris: J. Vrin.

Descartes, René. 1985. *Philosophical Writings*. Translated by John Cottingham, Robert Stoothoff, and Dugald Murdoch. 2 vols. Cambridge: Cambridge University Press.

Descartes, René. 1991. *Philosophical Writings*. Volume 3, *The Correspondence*. Translated by John Cottingham, Robert Stoothoff, Dugald Murdoch, and Anthony Kenny. Cambridge: Cambridge University Press.

De Witt, David. 2008. *The Bader Collection: Dutch and Flemish Paintings*. Kingston, Ontario: Agnes Etherton Art Centre.

Ekkart, R.E.O. 1973. Review of Grimm 1972. *Oud Holland* 90: 252–55.

Eustachio à Sancto Paulo. 1614. *Summa Philosophiae Quadripartita de rebus dialecticis, moralibus, physicis, et metaphysicis*. 3rd edition. Paris: Chastellain.

Foucart, Jacques. 2009. *Catalogue des peintures flamandes et hollandaises du musée du Louvre*. Paris: Gallimard/Musée du Louvre editions.

Frankfurt, Harry. 1970. *Demons, Dreamers, and Madmen: The Defense of Reason in Descartes's "Meditations."* Indianapolis: Bobbs-Merrill.

Freedberg, David, and Jan de Vries, eds. 1991. *Art in History. History in Art*. Santa Monica, CA: The Getty Center.

Gans, Mozes Heiman. 1971. *Memorboek. Platenatlas van het leven der joden in Nederland van de middeleeuwen tot 1940*. Baarn: Bosch and Keunig.

Garber, Daniel. 1978. "Science and Certainty in Descartes." In *Descartes: Critical and Interpretive Essays*, ed. Michael Hooker, 114–51. Baltimore: Johns Hopkins University Press.

Garber, Daniel. 1983. "Mind, Body and the Laws of Nature in Descartes and Leibniz." *Midwest Studies in Philosophy* 8: 105–33.

Garber, Daniel. 1992. *Descartes' Metaphysical Physics*. Chicago: University of Chicago Press.

Gaukroger, Stephen. 1995. *Descartes: An Intellectual Biography*. Oxford: Oxford University Press.

Gaukroger, Stephen. 2002. *Descartes' System of Natural Philosophy*. Cambridge: Cambridge University Press.

Geyl, Pieter. 1958. *The Revolt of the Netherlands, 1555–1609*. 2nd ed. London: Benn.

Gombrich, Ernst. 1995. *The Story of Art*. New York: Phaidon.

Graaf, J. J. 1873. "Jan Albert Ban." *Bijdragen voor de geschiedenis van het Bisdom van Haarlem* 1: 29.

Grimm, Claus. 1972. *Frans Hals: Entwickelung, Werkanalyse, Gesamtkatalog*. Berlin.

Groen, Karin, and Ella Hendriks. 1989. "Frans Hals: A Technical Examination." In Slive 1989: 109–25.

Groenveld, S. 1987. "The Mecca of Authors? States Assemblies and Censorship in the Seventeenth-Century Dutch Republic." In *Too*

Mighty to be Free: Censorship and the Press in Britain and the Netherlands, ed. A. C. Duke and C. A. Tamse, 63–86. Zutphen: De Walburg Pers.

Hoogewerff, G. J. 1947. *De Geschiedenis van de St. Lucasgilden in Nederland*. Amsterdam: P. N. van Kampen and Son.

Houbraken, Arnold. 1753. *De Groote Schouburgh der Nederlantsche Konstschilders en Shilderessen*. 3 vols. The Hague: Boucquet and Gaillard.

Hsia, R. Po-Chia, and H.F.K. van Nierop, eds. 2002. *Calvinism and Religious Toleration in the Dutch Golden Age*. Cambridge: Cambridge University Press.

Hynes, Darren. 2010. "Parallel Traditions in the Image of Descartes: Iconography, Intention and Interpretation." *International History Review* 32: 575–97.

Israel, Jonathan. 1995. *The Dutch Republic: Its Rise, Greatness and Fall, 1477–1806*. Oxford: Oxford University Press.

Israel, Jonathan. 2001a. *Radical Enlightenment: Philosophy and the Making of Modernity*. Oxford: Oxford University Press.

Israel, Jonathan. 2001b. "The Publishing of Forbidden Philosophical Works in the Dutch Republic (1666–1710) and their European Distribution." In *The Bookshop of the World: The Role of the Low Countries in the Book Trade 1473–1941*, ed. Lotte Hellinga, Alastair Duke, Jacob Harskamp, and Theo Hermans, 233–43. Houten: Hes & De Graaf.

Jowell, Frances S. 1989. "The Rediscovery of Frans Hals." In Slive 1989: 61–86.

Kaplan, Benjamin. 1995. *Calvinists and Libertines: Confession and Community in Utrecht, 1578–1620*. Oxford: Oxford University Press.

Kaplan, Benjamin. 2002. "'Dutch' Religious Tolerance: Celebration and Revision." In Hsia and Van Nierop 2002: 8–26.

Kenny, Anthony. 1968. *Descartes: A Study of His Philosophy*. New York: Random House.

Kolakowski, Leszek. 1969. *Chrétiens sans église: La Conscience religieuse et le lien confessionnel au XVIIe siècle*. Paris: Gallimard.

Levine, David A. 2012. "Frans Hals and the Vernacular." In *The Transformation of Vernacular Expression in Early Modern Arts*, ed. Joost Keizer and Todd M. Richardson, 179–203. Leiden and Boston: Brill.

Loughman, John, and John Michael Montias. 2000. *Public and Private Spaces: Works of Art in Seventeenth-Century Dutch Houses.* Zwolle: Waanders Uitgeverij.

Marnef, Guido. 1996. *Antwerp in the Age of Reformation: Underground Protestantism in a Commercial Metropolis 1550–1577.* Baltimore: Johns Hopkins University Press.

Montagni, E. C. 1976. *Tout l'oeuvre peint de Frans Hals.* Paris: Flammarion.

Montias, John Michael. 1991. "Works of Art in Seventeenth-Century Amsterdam: An Analysis of Subjects and Attributions." In Freedberg and De Vries 1991: 331–76.

Nadler, Steven. 1988. "Arnauld, Descartes, and Transubstantiation: Reconciling Cartesian Metaphysics and Real Presence." *Journal of the History of Ideas* 49: 229–46.

Nadler, Steven. 1997. "Descartes's Demon and the Madness of Don Quixote." *Journal of the History of Ideas* 58: 41–55.

Nadler, Steven. 1998. "Doctrines of Explanation in Late Scholasticism and in the Mechanical Philosophy." In *The Cambridge History of Seventeenth-Century Philosophy*, ed. Michael Ayers and Daniel Garber, vol. 1, 513–52. Cambridge: Cambridge University Press.

Nadler, Steven. 2008. *The Best of All Possible Worlds: A Story of Philosophers, God, and Evil.* New York: Farrar, Straus, and Giroux.

Newton, Isaac. 1999. *Mathematical Principles of Natural Philosophy.* Translated by I. Bernard Cohen and Anne Whitman. Berkeley: University of California Press.

Nordström, Johan. 1957–58. "Till Cartesius Ikonographie." *Lychnos: Lärdomshistoriska samfundets årsbok,*194–250.

North, Michael. 1997. *Art and Commerce in the Dutch Golden Age.* New Haven, CT: Yale University Press.

Pasnau, Robert. 2011. *Metaphysical Themes, 1274–1671.* Oxford and New York: Oxford University Press.

Pollmann, Judith. 2002. "The Bond of Christian Piety: The Individual Practice of Tolerance and Intolerance in the Dutch Republic." In Hsia and Van Nierop 2002: 53–71.

Popkin, Richard. 1979. *The History of Skepticism from Erasmus to Spinoza.* Berkeley and Los Angeles: University of California Press.

Prak, Maarten. 2002. "The Politics of Intolerance: Citizenship and Religion in the Dutch Republic (Seventeenth to Eighteenth Centuries)." In Hsia and Van Nierop 2002: 159–76.

Rasch, Rudolf. 1983. "Ban's Intonation." *Tijdschrift van de Vereniging voor Nederlandse Muzickgeschiedenis* 33: 75–99.

Riegl, Aloïs. 1999. *The Group Portraiture in Holland*. Los Angeles: The Getty Research Institute for the History of Art and the Humanities. [Originally published as "Das holländische Gruppenporträt," *Jahrbuch des allerhöchsten Kaiserhauses* 22 (1902): 71–278.]

Rodis-Lewis, Geneviève. 1993. "Quelques portraits de Descartes." In Geneviève Rodis-Lewis, *Regards sur l'art*, 157–67. Paris: Beauchesne.

Rodis-Lewis, Geneviève. 1995. *Descartes: Biographie*. Paris: Callman-Lévy.

Schama, Simon. 1987. *The Embarrassment of Riches: An Interpretation of Dutch Culture in the Golden Age*. New York: Knopf.

Schmaltz, Tad. 2002. *Radical Cartesianism: The French Reception of Descartes*. Cambridge: Cambridge University Press.

Schneiders, W. 1993. "Ein unbekanntes Descartes-Bild?" *Studia Leibnitiana* 25: 113–16.

Slive, Seymour. 1970. *Frans Hals*. 3 vols. New York: Phaidon.

Slive, Seymour, ed.. 1989. *Frans Hals*. Exhibition Catalogue, National Gallery of Art, Washington, DC; Royal Academy of Arts, London; Frans Hals Museum, Haarlem. Munich: Prestel-Verlag.

Smits-Veldt, Mieke. 1997. "Images of Two Dutch Women: From Seventeenth-Century Ideal to Nineteenth-Century Myth." *Caans/Acaen: Canadian Journal of Netherlandic Study* 18:19–28.

Snyder, James E. 1960a. "The Early Haarlem School of Painting: I. Ouwater and the Master of the Tiburtine Sibyl." *Art Bulletin* 42: 39–55.

Snyder, James E. 1960b. "The Early Haarlem School of Painting: II. Geertgen tot Sint Jans." *The Art Bulletin* 42: 113–32.

Spaans, Joke. 1989. *Haarlem na de Reformatie. Stedelijke cultuur en kerkelijk leven, 1577–1620*. The Hague: Stichting Hollandse Historische Reeks.

Sterck, J.F.M. 1935. "Pastoor Augustijn Bloemaert en de Jezuieten." *Bijdragen voor de Geschiedenis van het Bisdom Haarlem* 52: 301–6.

Sumowski, Werner. 1979. *Drawings of the Rembrandt School*, 10 vols. New York: Abaris Books.

Swetschinski, Daniel. 2000. *Reluctant Cosmopolitans: The Portuguese Jews of Seventeenth-Century Amsterdam*. London: The Littman Library of Jewish Civilization.

Taverne, E.R.M. 1968. "De Hollantsche Augustijn: Een Portret van Augustinus Alstenus Bloemert, 1585–1659." *Numega* 15: 81–93.

Thiel-Stroman, Irene van. 1989. "The Frans Hals Documents: Written and Printed Sources, 1582–1679." In Slive 1989: 371–414.

Valentiner, W. R. 1923. *Frans Hals: Das Meisters Gemälde.* 2nd ed. Berlin and Leipzig: Deutsche Verlag.

Van de Ven, Jeroen. 2003. "Quelques données nouvelles sur Helena Jans." *Bulletin Cartésien* 31: 10–12.

Van der Woude, Ad. 1991. "The Volume and Value of Paintings in Holland at the Time of the Dutch Republic." In Freedberg and De Vries 1991: 285–330.

Van Eeghen, I. H. 1974. "Pieter Codde en Frans Hals," *Amstelodamum: Maandblad voor de Kennis van Amsterdam* 61: 137–40.

Van Mander, Karel (1604). *Schilderboeck.* Haarlem.

Van Mander, Karel (1994). *The Lives of the Illustrious Netherlandish and German Painters,* ed. Hessel Miedema. 5 vols. Doornspijk: Daveco.

Verbeek, Theo. 1988. *La Querelle d'Utrecht: René Descartes et Martin Schoock.* Paris: Impressions Nouvelles.

Verbeek, Theo. 1992. *Descartes and the Dutch: Early Reactions to Cartesian Philosophy, 1637–1650.* Carbondale: Southern Illinois University Press.

Verbeek, Theo. 1995. "The First Objections." In *Descartes and His Contemporaries,* ed. Roger Ariew and Marjorie Grene, 7–20. Chicago: University of Chicago Press.

Walker, D. P. 1976. "Joan Albert Ban and Mersenne's Musical Competition of 1640." *Music & Letters* 57: 233–55.

Watson, Richard A. 2002. *Cogito Ergo Sum: The Life of René Descartes.* Boston: David Godine.

Weekhout, Ingrid. 1998. *Boekencensuur in de Noordelijke Nederlanden: De vrijheid van drukpers in de zeventiende eeuw.* The Hague: SDU.

Wheelock, Arthur. 2008. *Jan Lievens: A Dutch Master Rediscovered.* New Haven and London: Yale University Press.

Williams, Bernard. 1978. *Descartes: The Project of Pure Inquiry.* Harmondsworth: Penguin.

Wilson, Margaret. 1978. *Descartes.* London: Routledge and Kegan Paul.

Index

Alkmaar, 11, 49, 87–89
Ampzing, Samuel, 78, 176
Amsterdam, 15, 23, 27, 28, 34–35, 44, 64, 113, 131–34
Antwerp, 55–59
Aristotelianism, 13, 29–31, 109, 112, 135, 140–41, 163
Arminius, Jacob, 16
Arnauld, Antoine, 21, 161–66
art guilds, 62–63

Baillet, Adrien, 20, 92, 172, 189, 218n21
Balzac, Guez de, 21, 34
Ban, Johan Albert, 50–51, 53–54, 144–51, 168
Bartholinus, Erasmus, 179
Beeckman, Isaac, 19
Bloemaert, Augustijn, 44–54, 144, 168, 181, 186–96; art collection of, 53–54, 172–73, 194, 203n28; and Broodkantoor, 47; and Descartes, 144, 148–49, 151, 169, 172–73, 174; family, 44; friends of, 47–53; as priest, 44–47
Boësset, Antoine, 146–47
Boyle, Robert, 31, 153, 201n33
Brasset, Henri, 136, 139–40, 169
Brouwer, Adriaen, 83
Buytewech, Willem, 63

Calvinism, 9–11, 16–18, 38–40, 58, 88–89. See also Dutch Reformed Church
Cassini, Giovanni, 23
Catholicism, 9–11, 38–44

Chanut, Pierre, 90, 169–71, 214n71
Christina, Queen of Sweden, 169–71, 196
Clerselier, Claude, 167
Codde, Pieter, 80
Copernicanism, 32–34, 125. See also heliocentrism
Cornelis Cornelisz (Cornelis van Haarlem), 53, 61, 74, 173

Descartes, René: on body, 106–9, 114–15, 137, 166–67, 209n13; *cogito ergo sum* argument, 101; on creation of eternal truths, 154–60; daughter, 87–88; death of, 196; domiciles of, 12, 28, 34–35, 87–89; education, 12–14, 113; epistemology, 91–102, 104–6, 152; family, 12; and Helena Jansdr, 87–88; on immortality, 109, 137; on laws of nature, 116–22, 124; life in The Netherlands, 5, 12–16, 87–90; mathematics, 19, 24–25, 122; metaphysics, 93–94, 106–9, 113–14, 116, 123–24; method, 24–26, 91, 94–95, 113, 116; on mind, 106–9, 114, 126–27, 137; portraits of, 2–7, 177–98; science, 28–33, 93, 109–10, 115–30, 152–53; and transubstantiation, 161–68; travels, 14–16, 18–22
—Works: *Dioptrics*, 112, 122–23; *Discourse on Method*, 90–91, 101, 109, 112, 117, 122–23, 136; *Geometry*, 112, 122, 179; *Meditations on First Philosophy*,